Lettering

For
Students
&
Craftspeople

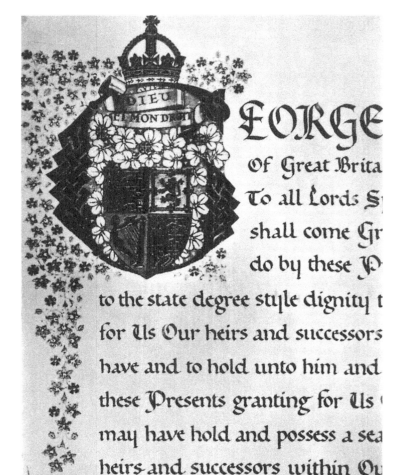

EORGE Of Great Brita To all Lords S shall come Gr do by these P to the state degree style dignity t for Us Our heirs and successors have and to hold unto him and these Presents granting for Us may have hold and possess a sea heirs and successors within Ou aforesaid successively may enjo

THE ILLUMINATED INITIAL LETTER OF A PATENT OF NOBILITY.

The 'G' is of burnished gold and encircles the richly coloured Royal Coat-of-Arms. The surrounding floral decoration is a delicately toned spray.

Written and Illuminated by the Author and Miss I. D. Henstock.

Lettering

For Students & Craftspeople

Graily Hewitt

Dover Publications, Inc.
Mineola, New York

To Frederick V. Burridge
Principal
London County Council
Central School of Arts
and Crafts I who have
taught there many years
dedicate this summary
of my Endeavor

Bibliographical Note

This Dover edition, first published in 1993 and reissued in 2018, is an unabridged republication of the work originally published under the title *Lettering: For Students and Craftsmen* by Seeley, Service & Co., Ltd., London, in 1930. The copy reproduced in the present edition was No. 249 of 380 copies, signed and containing "two specially designed and hitherto unpublished alphabets by the Author." These alphabets appear on unnumbered pages following pages 136 and 216.

Library of Congress Cataloging-in-Publication Data

Names: Hewitt, Graily, 1864–
Title: Lettering : for students and craftspeople / Graily Hewitt.
Other titles: Lettering for students and craftsmen
Description: Mineola, New York : Dover Publications, 2018. | Originally published: Lettering for students and craftsmen. London : Seeley, 1930.
Identifiers: LCCN 2017053589| ISBN 9780486275185 (paperback) | ISBN 0486275183 (paperback)
Subjects: LCSH: Lettering.
Classification: LCC NK3600 .H4 2018 | DDC 745.6/1—dc23
LC record available at https://lccn.loc.gov/2017053589

Manufactured in the United States by LSC Communications
27518302 2018
www.doverpublications.com

LIST OF CONTENTS

LIST OF ILLUSTRATIONS

DECORATED ALPHABETS BY THE AUTHOR

PREFACE

LL who are interested in lettering are acquainted with Edward Johnston's classic. To him, as my first teacher, I owe more than most.

This book presents a point of view and a settled policy in regard to writing, with my reasons for the choice. Any restatement of familiar matter or figure is here only employed where the clarity and continuity of my observations or modifications have seemed to me to call for it.

To the late Edward F. Strange I am also indebted for his book on Alphabets, which as an introduction to the craft and general survey remains as delightfully and constantly useful as any I know; and I wish to make the most grateful acknowledgment for the kindness of the late J. P. Gilson, M.A., Keeper of the MSS. in the British Museum, in giving me permission to reproduce here so many photographs from the Facsimile series of the Palæographical and New Palæographical Societies. To Sydney C. Cockerell, also, for the photograph on page 61; and to C. H. St. J. Hornby for that on page 49.

CHAPTER ONE

INTRODUCTORY

HE object of writing is to be read; but its manner of gaining this end varies with occasion. The poem and the poster call for different manners. I have attempted an examination of 'legibility' later in this book. It might seem more reasonable to define the end first and examine the means afterwards; but it happens that the means have, in this matter, created and affected the end, and no theoretical assertions are applicable without attention to the tools, materials, and practices which have provided human eyes with the necessary elements of a code. Legibility is not an abstraction; but, as language depends upon our physical apparatus and conventional methods, so has writing been developed by apt tools and agreement over their productions; the means and the end acting and reacting through the centuries, with the means always a bit ahead.

For some years past serious endeavour has been directed towards the improvement of writing — our alphabet's technique. Our lives are littered with lettering, our walls plastered with it, our skies ablaze with it. We have imagined this more endurable if better done. But in considering the bettering of it we have taken certain standards too much for granted, without weighing their applicability to our modern purposes; and are now becoming aware that too often they are inadequate. We have presumed that the scholar and the artist, and now the scientist, are fit judges of the essentially legible. We have overlooked the advertiser. His legibility is not

always theirs. If refinement may assist his purpose, which is to sell something, well. But that he catch your eye is the important point. Advertisement is competitive. Exceptionally a quiet sobriety may attract notice in a noisy crowd, but only so long as isolated by singularity. If all our lettering, crowded as it is, were 'in good taste,' it would fail commercially. For the essence of advertisement is to compel attention. The lettering must assist this —somehow. The classic style does not admit this premiss. How, then, can we improve our commercial lettering by reference to classic standards ? The question must be answered by reference to other than these. It is being so answered.

Any student of the craft needs to examine the common delusion and find his own answer. For commerce has occasion yet for art and scholarship. But already our convention of legibility has been modified by abuse and puffery. Our letters are now fatter than of old. They are no longer marks upon a surface, but projections from it. They can be even meteoric. And if fitness for their purpose be the test of 'goodness' they are good. No other test is appropriate. So that 'purpose' is all-important in considering their legibility. The craftsman needs to define his purpose and perform accordingly. He will recognise that while in isolation his refinement might be legible enough, the uproar and hurry amid which it has almost invariably to be read may render it quite insignificant and consequently unfit. It is futile to 'hope for the best' in applying his miscalculated delicacy upon any and every occasion. Rather will he convince himself, and what others he may, that it is our inconsiderate and disorderly use of lettering that needs bettering, and that we have not yet placed advertisement and its alphabets aright while we permit them to render civil speech publicly inaudible. As it is, when he would set a fine inscription upon a public building he must

either make it ' tell ' against the hubbub of the hoardings by adopting their competitive standards, or be content to know that it would beautifully assist the architecture it is adapted to adorn, supposing they were not there.

This is the difficulty. The competitive standard is the real hindrance to improvement. The analogy of speech is most apt. The student does not learn voice production in order to ' drown ' his neighbours. And while I do not presume to deal with the difficulty, but only to state it, I am hoping this book may be useful to those who care to study the traditional methods of the craft as practised by a modern for modern purposes. I must warn others that it provides no dodges for ' capturing the public eye,' no short cuts for trouble-saving, but only a workmanlike method of pleasant performance to-day of the abiding conventions which have come down to us for civil intercourse.

CHAPTER TWO

THE PEN'S STANDARD

ERMINOLOGY connected with the craft is all too scanty and confused. We have used up many of its words for special purposes. An outstanding example is 'scripture,' which is now useless to the craft. A 'writer' means an author, though he may never use his pen except to sign his name. 'Scribe' and 'scrivener' are almost by-words; dated too. Driven to borrow, we allow our ideas to become clouded. There has latterly been some hand-written imitation of printed characters in our schools, which has been called 'printing' to differentiate it; a term the architects have long used, rather unfortunately, for the careful writing on their plans. Our printing is, however, the mechanical imitation or adaptation of the Italian fifteenth-century book-hand, the best writing of the early days of the press. Those now, therefore, who imitate print imitate an imitation of the original, instead of the original itself. To copy the original and call it writing would seem more sensibly preferable.

But this does not describe the sort sufficiently. And we meet the expression 'print-script,' or 'manuscript-writing,' or 'script writing,' vainly discriminative; as if there were other handwriting which is not. At the same time the terms do assist somewhat, since the reference is to classic examples which the sign MSS. somehow imports. Again, Mr. Edward Johnston, to whom as my first teacher I owe so much, found it necessary to call his book *Writing, Illuminating, and Lettering* (as if there might be lettering which is not writing, directly or derivatively),

because writing is intelligible in such general sense as
to leave one in doubt about the ground covered, and
lettering is now commonly used to connote the sort of
writing we may perform otherwise than with pen and
ink, and mostly in capitals rather than ' small ' letters.
The learned have given us a few extra words, such as
palæography for ancient writing, ideogram for the graphic
representation of an idea, phonogram for that of a sound
or syllable, epigraphy for the writing on stone or bronze,
and so on. But in general we are at a loss for words,
and confuse the few we have by stretching them into
various misapplication rather than seek modifying or
explanatory epithets.

And with regard to the very letters we make, we are
at a loss to describe an element of persistent form in the
individuals which seems independent of the particular
tool making them or material receiving them, an element
conceivably independent of any technique. For this we
have no name at all. Mr. Johnston calls it ' essential
form,' perhaps begging the question (for no form seems
so stable, no convention so permanent, as the epithet
implies). ' Skeleton form ' might also serve, implying a
structural or organic necessity, but rather overstating the
case. Yet we all recognise that our capitals IO VL AH
MW have these ' essential ' characteristics, I and O of
one ' stroke,' V and L of two, A and H of three, and
M and W of four ; and in these positions generally, quite
independently of any technique of thick and thin or finish
at the ends we may give them.

Even the word ' stroke ' is inadequate. It implies but
one direction. The Italians have the word *tratto* to
imply all that the hand draws without pause or leaving
the paper, in which case M and W, and of course V and
L, might be drawn with one *tratto*, while we would
hardly describe this as one stroke. The schoolboy might,
however, happily say ' one go.'

And yet again we have for popular use no words to differentiate conveniently between capitals and 'small' letters unless we adopt, with some humiliation, the printer's 'upper-' and 'lower-case' for our purpose. For small may refer to size as well as sort. In this book I venture to use the terms majuscule and minuscule, which, despite their stilts, serve admirably and correctly to distinguish the sorts, of whatever size and however made; retaining, however, the word capitals as alternative for majuscule where insistence on the other might seem too portentous.

Our confusions have arisen from the application of writing in the many crafts it so well assists, other than that in which it is directly concerned, and the various techniques these crafts involve in the representation of the traditional (or essential) forms; until paternity is lost sight of, obliterated by the immediate concern. The stone-cutter, wood-carver, engraver, printer, embroideress, and now also the advertiser (a most determined Gallio) are all making letters, derivatively pen-letters, with too little heed of the traditions outside their own business; and involving the consideration of the matter in a maze of 'practical convenience,' 'new departure,' or frank irresponsibility. And the very handwriting we are teaching our children, since we have become discontent with the degraded 'secretary' hand we were taught, is too often but the dodge or makeshift of an ingenuity, which on looking into the business recognises that a serious review of it would take a great deal more time and trouble than other educational demands seem to allow, or the possession of typewriters perhaps to justify.

This general confusion may, however, be turned to account. It may incline teachers, craftsmen, and students the more favourably and readily to consider the suggestion this book would make for clearing the air and ordering the whole matter into some pretence of unity

and system. For every expression of words by means of tools and materials may be referred to one or two ancestral methods, and relationships re-established. It but needs we compare our particular performance with others, bear with the restatement of some things forgotten or disregarded, and admit in practice what we so readily admit in theory, the reasonable effect of history. Writing has been a growth like language. We cannot use language independently of tradition. We do not expect to be impressive, or even intelligible, with sudden and ingenious mispronunciations, or 'jabberwocky' originalities—except in fun. But we too often endeavour to be 'original' in the rendering of our written words, achieving our 'characteristic' illegibilities with self-satisfaction, or maybe contempt.

And the history of writing, for us, is not too complicated or laborious for effective, even if short, study. The hindrance lies rather in this admission of the need for our several performances. It is hard for the sign-writer to admit that his brush has had nothing whatever, for the stone-carver to admit how little his venerable chisel has had to do with the technical development of the Roman alphabet ; for the printer to discover that, except perhaps for his title-page, his machine has evolved nothing, and has achieved nothing original or successful, which has not been a close imitation of fifteenth-century penmanship ; and this despite just upon five hundred years of opportunity and endeavour.

Indeed, the story of writing, for us whose sole concern may be said to be the Roman alphabet, resolves itself into the story of but one tool, the Pen. And when one turns to the modern copy-book, to the ultimate achievement of this tool (in point of time), one may well appreciate the attitude of craftsmen in general towards a seemingly intolerable impertinence, their reluctance to acknowledge dependence upon a craft which could ' come to this.'

Yet here again is a misconception. The pen which produced and preserved the Roman alphabet was not the sort of pen we put into the hands of children to learn with to-day—or at least until yesterday. We give them a pliable-pointed thing and bid them press upon it. The classic pen was not a point, it was an edge ; and a stiffish one too, and was not pressed upon appreciably, not intentionally as a rule.

The fact of this edge we recognise, unconsciously maybe, every time we think of our letters. For in spite of what has just been said about essential form we do not think of the word HOPE so (see Fig. 1), but as in Fig. 2, however roughly performed ; and this in spite of the typewriter and the advertiser perpetrating their 'block' letters daily. This instinctive standard of contrast (of thick and thin) and of gradation (from thick to thin) is the result of some two thousand years of penmanship in their expression. It need not have been so. No artistic perception ordered it to start being so. It came about naturally and conveniently, and our admission of it is now set and involuntary. It is one of the characteristics of the craft, and its successor, the press, which may pass—which is indeed threatened. How often are we not already required to put our names, etc., into 'block capitals'? The question arises and may not be too far off to need serious decision, whether we can permit the typewriter, the advertiser, and other influences to affect this fine and venerable convention ; the beauty of which, and its natural propriety, it is the aim of this book to uphold. At present it is sufficient to say that the convention is generally admitted and stable enough for all literary and dignified purposes. The classic pen is the cause.

HOPE

HOPE

Fig. 1.

HOPE

Fig. 2.

Moreover, the admission of this matter of contrast and gradation in our conception of letter forms is not the admission of its presence only, but of relative position also. So that HOPE, as in Fig. 3, outrages convention at once. Our perpendiculars, in fact, tend to be thick and our horizontals thin. Not only are we agreed that our letters are theoretically the performance of an edge, but an edge working fairly parallel with the horizontal. This is the natural effect of such a pen held comfortably to progress from left to right. In writing from right to left, as in Arabic, the perpendicular tends to be the thinner stroke, a change more probably dependent upon the fact that what are pulled strokes with us become for such writers pushed strokes, than upon any æsthetic consideration.

Fig. 3.

It is in such matters as these that improvement is concerned, the natural primitive things too often overlooked or taken for granted without regard for their inevitable effects upon legibility. The multifarious details of the styles seem to me comparatively unimportant. An appreciation rather of the principles affecting the elements belonging to them all alike is needed for the establishment of any clear theory of legibility or the improvement of our writing of every sort. At the beginning hardly too much stress can be set upon the fact that with whatever tool, upon whatever material a writing may be produced, our recognition of its agreeable readableness is dependent upon its deference to the standard set and preserved by this ancient edged tool, the classic pen.

This tool was certainly established by the third century B.C., and was most usually made of reed (though metal pens of Roman make have been found), or of quill, the first mention of which, however, does not occur till the fifth or sixth century A.D.[1] The reed was no doubt

[1] Maunde Thompson; seventh century, Isaac Taylor.

preferred for its softness and ease in writing upon the current material, papyrus. As soon as parchment, in quantity, became available the quill, with its greater durability and finer texture, superseded it in general use.

The cutting of the reed to an edge seems to have been a deliberate, if gradual, choice. Previously it was cut to a point and frayed to the likeness of a small brush. But this was discarded by the time our standard of writing may be said to have arisen.

Preceding either was no doubt a tool for scratching or cutting stone or bone, which became that chisel with which the magnificent Greek and Roman inscriptions were executed. But the influence of this upon our writing has concerned the forms rather than the doing of our letters. In only one detail of their draughtsmanship is the chisel's effect now evident, in what we call the serifs, or little finishing touches to heads and feet. This detail of 'finish' is the only one in which the pen, recognising the extra beauty such accessories give, has adopted for its help the suggestion of another craft ; and permanently since the time of Augustus. In all the rest of the expression of chisel-cut letters pen character is plainly observed though frequently reduced in amount. There was no occasion for the chisel to make strokes thin and thick except to conform to the standard set by the pen ; and, indeed, we see that in the earlier Greek inscriptions, before this standard was acknowledged, the strokes are not so, but fairly uniform in thickness.

But as regards the forms of our letters the chisel has been almost as important as the pen, its influence chiefly conservative. It rendered the retention of our capitals, the majuscules, assured. The pen's comparative speed and preference for curves might otherwise have eliminated these severe and more angular forms, and might have substituted the easier minuscule for all purposes.[1] The

[1] As some moderns have thought desirable.

minuscule form, called the half-uncial, arose from the pen's action upon the uncials, which themselves seem to have been a result of that pen action upon their angular predecessors.

And one more tool has been concerned with the development of our forms, though unaffecting their technique, a sort of survival of the primitive scratcher or marker, the Roman stilus, used for everyday purposes upon tablets of wax. Its influence has been certain, if somewhat obscure. It modified all the forms it rendered in the direction of greater speed, changing their shape more or less, and even eliminating whole parts of them. It assisted the pen thereby towards the development of that half-and-half sort of hand called the half-uncial, which was the forerunner of our minuscule.

It was the tool of the Roman cursive (or common domestic) writing, the pen being dedicated to the more sedate and finished business of writing books, or rolls. It immediately introduces the consideration of speed into the whole matter : a consideration which in our day is allowed to be paramount. And it seems necessary at once to give heed to a problem which is in consequence the stumbling-block of all teachers.

Writing has always endeavoured to be speedy. Nearly all modifications have been introduced for speed's sake, utility rather than beauty ; a certain speed of performance being, however, always advantageous for that very element of beauty, evenness. But other qualities were valued also, according to the purpose for which the writing was intended, and speed only admitted to the degree which effected that purpose appropriately. But we think, by some jugglery, to write the Book of Kells at the pace of Sir Isaac Pitman. It cannot be done. When we teach a child to read we do not take out a stop-watch.

We rather need to learn (and teach) a method which can admit, according to the pace of performance, certain qualities besides speed, to a greater or less degree appropriately to the purpose in hand, and to know what they are. Our alphabets demand attention to certain details of expression for the sake of clearness and beauty; and these cannot be rendered without that attention. But attention to them can be reduced or increased for the occasion and the sake of speed, and the 'hand' varied accordingly and appropriately. It is this variation of method, with an invariable standard, which this book endeavours to propose—rather to reintroduce.

For the method is old. The conception of one standard, the application of which shall vary with occasion, and the instrument rendering it, would be the solution of much of our difficulty.

As it is we learn a 'hand' (for daily use) which can never be beautiful, however slowly performed, that we may have something with which we can at all events put on the pace. It may console us to reflect that the Roman cursive was not beautiful. Something better was needed for their books. They supplied it with their pens. We do not, because we have the printing press for that sort of work. So that we have lost sense of scale or graduation for our performances. It is the realisation of this varying degree of execution which may help us again, the varying degree kept consistent with a constant standard of form. We are too apt to be perplexed with what seems to us a jumble of styles to choose from, when the acknowledgment of but one style, permitting degrees of elaboration in execution according to circumstances would unravel the whole matter.

This is the remedy suggested here. The tool which developed and preserved for us so magnificent an achievement as the Roman alphabet may well be trusted for the performance of our modern needs also, the expressions

of that alphabet which especially concern us. After a
short summary of its doings on the way, and the technical
bearings of these, the expressions of the traditional
standard, suitable for various occasions, will be examined
separately.

RITING has very naturally been affected by the materials commonly available in any country. In Greece much was written or scratched upon marble without monumental intention. In Egypt, with papyrus in quantity, and the limestone unfitted for facility of inscription, the pen for ordinary purposes was the common tool three hundred years earlier. The forms of the letters the Romans adopted were consequently inscriptional forms in process of modification by pen usage; with apparently the admission, out of respect for Greek culture, that these, as being more sedately executed, were somehow the standard forms, the pen's expression of them but a conveniently speedier way of making them. All the forms were 'capitals' or majuscules, whether written on stone, bronze, papyrus, or wax. The early Roman Empire knew no minuscules. The everyday cursive on wax was abbreviated imitation of majuscule writing. These capitals are called square capitals from the rectangular nature of the junctions of strokes and the generally rectilinear formation, which the chisel prefers. Two thousand years have not affected their applicability, their 'conventionality' in our eyes. The highest expression of them is usually admitted to be that of the period of the Trajan column of the beginning of the second century A.D. The earliest pen-form example of them subsisting is in a few leaves of a Virgil[1] of the

[1] I must beg the reader's indulgence in regard to the reproduction of this and other MSS., mostly worn and faded, which are set here for technical illustration only.

PARETAMORDICTISCARAEGENA
EXVTETGRESSVGAVDENSINIC
ATVENVSASCANIOPLACIDAMI
INRIGATETFOTVMGREMIODE
IDALIAELVCOSVBIMOELISARA
FLORIBVSETDVLCIADSPIRAN
IAMQBATDICTOPARENSETD
REGIAPORTABATTYRIISDVCE
CVMVENITAVLAEISIAMSERA

Fig. 4. 'SQUARE' CAPITALS. VIRGIL. FOURTH OR FIFTH CENTURY. ACTUAL SIZE.

Fig. 5. Greek Uncials. Codex Sinaiticus. Fourth or Fifth Century. Actual Size.

end of the fourth century; of which Sir E. Maunde
Thompson remarks that 'it may be regarded as a
survival of the style first employed at an early period to
do honour to the great national Latin poet.' So that
this pen-imitation, for important books, of inscriptional
forms may be taken to have been contemporary with
their similar expression in inscriptions in Latin, as we
know it was, from various examples, in Greek.

Owing to the greater antiquity of the latter, and the
longer influence of the pen upon it, we find another sort
of majuscule evolved for Greek writing long before our
era, the uncial hand. This only appears in Latin (examples
come down to us) about the third or fourth century. It
is a rounded hand as compared with the previous squared
hand, more typically a penman's hand, its characteristic
difference being readily observable in the forms (Fig. 6).
It shows at once the beauti-
ful power of the pen in
adapting standard forms to
its convenience, and its
natural preference for cur-
vilinear over rectilinear statement. No hand since
developed has been so thoroughly adapted for pen
expression ; and it is a matter for extraordinary regret
that it is not at the present day, owing to historical
reasons to be mentioned presently, included within our
modern convention. It was a much more rapid hand
than the squared majuscule, and shows admirably that,
in masterly use, consideration for speed is no bogey
of inartistic utilitarianism. No hand was ever more
beautiful.

The everyday cursive, however, attacked it, like the
other, with continuous modification for yet greater speed,
and by the end of the fifth century the so-called 'half
uncial' is well established for the writing of books and
documents.

SEDQUONIAMUIR
RITASTISONINTRA
OMNESTISADUER
SARIISEXACERUAS
TISENIMEUMQU
UOSFECITDNM
AETERNUMSACRI
FICANTESDAEMO
NIISETNONCO
ITEMAPOSTOLUS
ADROMANOS
DICENTESENIM
SEESSESAPIEN
TESSTULTIFACTI
SUNTETMUTAUE-
RUNTGLORIAM·
INCORRUPTIBILIS

Fig. 7.

LATIN UNCIALS. SPECULUM OF S. AUGUSTINE. SEVENTH CENTURY.
ACTUAL SIZE.

MEUM·ANTE
QUAMPSALMI
INCIPIANTUR·
POSTEXPLETIO
NEMTRIUMPSAL
MORUMRECITE
TURLECTIOUNA
UERSOETCYRI
AELEISONETMI
SAS·TERTIAUE
ROSEXTAETNO
NAIDEMEOOR
DINECELEBRE
TURORATIO·ID
ESTUERSUM

Fig. 8.

LATIN UNCIALS. RULE OF S. BENEDICT. EIGHTH CENTURY.
ACTUAL SIZE.

Contemporary with both square and uncial capitals was another majuscule hand, not so carefully elaborated as the squared, nor so rounded as the uncial—the so-called RUSTIC CAPITALS (see Fig. 9), some examples of which remain to us of the fourth and fifth centuries. This is a monumental hand also, like the square capitals, and rendered in stone as with the pen, though it is more truly a pen-formed hand than the other. For it is quicker and easier, and the pen requires no alteration of position to render the details. It has the essential weakness that its limbs are thicker than its stems, always a constructional defect in any alphabet. And thus it is a narrower hand than either of the others. This narrowing seems to me to have been intentional, designed for the convenient writing of the Latin hexameter, of the Roman Bible, Virgil. Hexameters take space laterally, and a hand which could render them in a narrower compass was no doubt invaluable. And it may be that this writing of Virgil gave a sort of sanctity to the hand, just as in later times we have attributed a sanctity to uncial writing, and later still to Black Letter, on account of their association with our Scriptures and ecclesiastical use. For we find these Rustic Capitals continued for headings and titles long after they had passed away as a text hand.

From the fifth to the eighth century uncial writing was the ordinary book-hand of the first rank, superseding the Rustics before the seventh century and itself degenerating by the ninth century, gradually superseded by the half-uncial, which encroached upon the privileges of parents or contemporaries alike. And this half-uncial became the general book-hand of the Roman Empire.

As long as this Empire remained the central power dominating her colonies and subject nations, the Roman script in all countries, however far apart, continued much the same. Wherever the Latin language was adopted the Roman form of writing accompanied it as a matter

'RUSTIC' CAPITALS. VIRGIL. THIRD OR FOURTH CENTURY. ACTUAL SIZE.

cuius et cetera dicerent monebantur;;

Deniq; oportebit dicitur; rei in orbem

inicientum ex praedicat euangeliu?

ut euangelicae praedicationi uefragiu

proferent et. toto domini conuenie

in cum semredionbegestorum. Est

igitur catciamentum nuptiale euange

li caepraedicatio. Sed de hoc coponitur iurat

quid indulit explicauimus praeuerbapt

zabit inspiritco. et igni. habent uentila

brum in manu sua. et purgabit uream in

fiam. et congregabit triticum in nonneg

fium. paleautautem comburit igni in eg

tinguibil. habent uententil abnuminmaur.

of course. But when the Empire was broken and inde-
pendent nationalities arose, the handwriting learned from
their Roman masters gradually assumed distinctive
characteristics, and finally developed into several national
book-hands. And so were moulded on the Continent the
three national hands known as *Lombardic* (in Italy),
Visigothic (in Spain), and *Merovingian* (in France). Our
own Anglo-Irish hand was doubtless formed from the
half-uncial character of the books of the Roman mis-
sionaries, and by circumstance of isolation remained more
formal and literary than the others, its development
following a slower and rather different course. When
the wave of Continental styles came over with the Norman
conquest this conservative hand reacted upon them and
gave our subsequent national hand distinctive features of
solidity and stateliness.

And, indeed, its merits had been recognised a couple
of centuries earlier, when Alcuin of York was invited
to Tours to superintend the work of the revision and
writing of the Church books during the great revival of
learning, after the devastations of the Dark Ages, under
Charlemagne in the eighth century.

What models were taken it were difficult to define. A
survey was no doubt made, and the advisability of various
characteristics compared. And in the resultant hand
we see that one element was certainly considered, as was
very natural at a time when the multiplication of the
means of learning was of supreme importance—the
element of speed of production. The hand, known as the
Caroline or Carlovingian hand, became the literary hand
of the Frankish empire and extended its influence during
the next two centuries over neighbouring countries also.
In consequence of its greater speed it has a more cursive
look than any previously adopted as a book hand, not
much elaboration of detail, and a slight slope. It was
usually widely spaced and freely flowing, and again

ne uolumtate di pat

lis est uestri autem (

es numeratis sunt:· H

multo magis passe

-uos:· O mnis ergo qu

coram hominibus con

coram patre meo qui

Qui autem negauerit

bo & ego eum coram (

lis est Holite arbitra

pacem interram mitt

cem mittere sed gladi

Fig. 11.

ANGLO-IRISH HALF-UNCIALS. GOSPELS OF S. CHAD, NOW AT LICHFIELD.
END OF SEVENTH CENTURY. ACTUAL SIZE.

puerum et matrem eius. Et ueniet in terram isrt̄.

Audiens autem quod archelaus regnaret in iudæa

pro herode patre suo. timuit illo ire. Et admonitus

in somnis secessit in partes galilæe. Et ueniens

habitauit in ciuitate quæ uocatur nazareth ut ad

impleretur quod dictum ē. per prophetas. qnm

nazaræus uocabitur

IN DIE BUS AUTEM ILLIS UENIT IOH

baptista p̄dicans in deserto iudææ et dicens. pæni-

tentiā agite. appropinquabit enim regnū cælorum

Fig. 12. CAROLINE MINUSCULES. GOSPELS, NOW AT LAON. NINTH CENTURY. ACTUAL SIZE.

illustrates the fact that speed is not inconsistent with clearness and beauty, duly apportioned. Indeed, this hand rivals the uncial in all that is implied in penmanship ; and to us (with allowance made for the presence of a few archaic forms) is as legible as our modern print, with which, indeed, it is directly connected. For our convention of to-day is derived from the Italian scribes of the fifteenth century basing their standards on the rounded Italian models of the twelfth century, which in turn were Italy's adoption of the Caroline minuscule. Our italics even took that slope which is first noticeable, as a marked characteristic, in the Caroline hands.

A further important fact about this hand is that the method of ordering or arranging it set the precedent, already fairly established, of all subsequent arrangement, and our conventions as regards the page to-day. The principle of starting with a large initial letter dated from further back, no doubt, into centuries before Christ. But now arose the systematic arrangement of the large initial followed by a few lines of lesser majuscules, most usually uncials, the initial itself being drawn by the aid of several strokes composed and flooded together, and not drawn simply with a broader pen. From this the writing steps down by the uncial capitals into the body of the text. The method still prevails in our prayer books, where each prayer passes from a large capital through lesser capitals to the minuscule.

Until that time the blending of majuscule and minuscule into this combined service had not been observed. And even then the separation of words is not quite completed, until the eleventh century.

This Caroline hand, with its method, was imported into our own country as elsewhere and affected our conservative Anglo-Irish hand, and was in turn affected by it, to produce that noble hand associated with our Winchester School, extremely clear and dignified.

& predicatione uos faciat implere digna con
uersatione. A M E N

Edum communis refurrectio uenerit hic
patronus uefter cunctgenus fcm doctoribus
unis· uos non adiudicium fedadmifericordiā
dei perducat· &tremendo examine peracto·
illorum comitante fuffragio· oues fuas paftor
bonus adcaeleftia. pafcua. introducat· A M E N

Quod ipfe preftare· A M E N

Fig. 13.

WINCHESTER SCHOOL. BENEDICTIONAL. BIB. NAT. PARIS. ELEVENTH CENTURY. ACTUAL SIZE.

;luoi folo pienamente a vare legnanea lefcienue. Jmpao che
in uoi fitruouano tutte legnanc vefanu. Vauccgognia vi noe x.
l'afecela vabaam. Lacóltozença vifaac. Laluigamnata vi ia
cob. Lafoftenenca vi morfe. Lultabuluta vi iofue. Latruouone
velta. Lapfecuone velufeo. Labenignuta vibauto. ꝯ ulfeño vi fa
lamone. Lapauenua vi iob. La caltua vidaniel. Laficonoua
illene parlare vifuia. La prefeueranta vigreuemia. Queltec
granc collaure uutu vefanu abuuno pienamenue nella noft
fantua. Jncoa fece literatifimo nelle feteara uberah. Jn
fuenue ecclefiaftche ꝯ in legi fauiffimo. Jn ouuuta ꝯ imo
raua vouiffimo. Et pao fu vegna cofa che labenignuta noftra
uuelfe quefto prefenue lauouo nelquale quafi vuuuc fcien
te alcuna utiua fi contiene. Douunque effento có uoi i anu
occia ꝯ auento trouam quefta preuofiffa maigtrua vifilo
fofia. Piacque alla noltra fignoua che fuffe trâflatato vi lin
gua arabica ꝯ faracina in latina. Et io vifictanuc alluoftro

Fig. 14.

ITALIAN. SECRETA SECRETORUM. A.D. 1425.

Written out by Sér Bartolomeo di Lorenzo. Actual Size. Now in Brit. Mus., Add. MS. 39844.

After this our national hand, as also those elsewhere, in spite of the grand period of the twelfth century, a period of large folios with large writing and much use of bold capitals, by many considered the finest period of all, gradually assumes an angularity which through the thirteenth and fourteenth centuries increases ; until by the fifteenth the writing has the appearance rather of rows of heavy palings, now almost illegible to our eyes—the ' black letter.'

Of this black letter one needs perhaps to give some reason for disregarding it. It is not legible to eyes accustomed to rounder methods. And to those accustomed to rounder writing it is technically inconvenient and less adapted to free use of the pen. Its decorative qualities have always been great and tempting. But it is spiritually as well as technically removed from us. Its smoothness in spite of cramped angularities came of the extraordinary perfection of accomplishment in monastic scriptoria, inspired by extreme devotion and a mental attitude to us almost unintelligible and certainly irrecoverable.

Italy alone preserved the rounded hand through this Gothic period, and in the Renaissance finally rejected all these angular developments. Our modern convention of form and method dates from thence ; and considering that the choice was self-conscious and made by so gifted a people technically and intellectually and artistically as the compatriots of Leonardo and Petrarch and Michael Angelo one may well rest content with the magnificent inheritance they have restored to us from the Roman Empire.

The Renaissance, however, has cost us one grievous loss, that of the uncials. These persisted, as ' built up ' or ' spliced ' initials through Gothic times, and one may suppose were included in the general condemnation of the hand they accompanied by the fifteenth-century

studium erga uos remq̄ p̄ fatis subleuare. Nunc uideo ullum circumuentum m...

desertum a quibus minime conueniebat. Itaq; un luctu et squaloxe sum: qui pro...

uince: qui exercitui presum: qui bellum gero. Q̄ uae quoniam nec ratione...

nec maioᵽ nostrueᵽ clementia administrastis: non erit mirandum si uos penit...

bus: etiam mobili in me meosq; esse animo non sperabam. Me interea nec do...

mesticus dolor. nec cuiusq̄ iniuria ab re p̄ abducet.

ARCVS TVLLIVS M. Fi. CICERO. Q. metello. Q. fi. cclen pro...

cons̄ sat. p̄. d.. Si tu exercituisq; ualeas bene est. Scribis ad me te c...

...stinasse pro mutuo inter nos animo et pro reconciliata gratia n...

q̄ t̄ a me ludibrio lesum in: Q̄uod cuiusmodi sit: satis intelligere non possu...

Sed tamen suspicoᵹ ad te esse allatum me in senatum quom disputarem per...

multos esse: qui rem p̄ a me conseruatam dolerent: dixisse a te: propinquos t...

tuos quibus negare non potuisset impetrasse. Vt ea quę statuisses tibi insna...

Fig. 15.

ITALIAN. CICERO'S EPISTLES. A.D. 1444.

Written out by Johannes Andreas de Colonia. Brit. Mus., Add. MS. 11928. Actual Size.

reformers; who in their zeal for the purely classic reverted for their majuscules to the severer Roman squared capitals, and seem to have ignored the fact that

patet q̄ bonum aliquod omnes coniectant.
Maxime uero pncipaliffimum oium que é
pncipaliffima et cetas omis complectit̃. Et
autem hec illa que ciuitas appellatur et ciuil'
focietas. Quicunq̄ uero putant gubnatori'
ciuitatis et regis patrisq̄ familias et domi
eandem ce rõnem. non bene dicunt. Multitu
dine enim et paucitate. fed non fpecie illoru̅
fingulos putant differre. ueluti fi paucorum
quidem dominu̅ fi uero pluruim patremfa
lias: fi etiam pluruim gubnatorem ciuitatis.
uel regem. quafi nib differat magna domus
et parua ciuitas. gubnatorq̄ ciuitatis et rer.
Quando quidem icem pfidet rer. qn uero fm
rõnem talis fcientie in parte pfidet et in parte

Fig. 16.

ITALIAN. POLITICS OF ARISTOTLE. A.D. 1451.

Written out by Gaspar Gariuberto at Milan. Now in the Library of C. W. Dyson Perrins, Esq. Actual Size.

the uncials were Roman classics too. The squared capitals, as mentioned above, were never so well adapted for penmanship as the uncials. And the fact remains, as a consequence, that our conventional capitals of to-day,

by reason of our inheritance from the Renaissance, are not the pure pen-forms they might well have been, but still chisel-forms as imitated by the pen—with some reluctance, as instance A M E N V.

Of the Italian fifteenth-century book-hands here advocated three more illustrations may suffice, since our museums possess many examples which can be readily consulted ; two of the upright ' Roman ' character, the other of the ' Italic.'

Fig. 17.

ITALIAN. LATE FIFTEENTH CENTURY.
Psalter, now in the Library of C. H. St. J. Hornby, Esq.
Actual Size.

T will have been observed in the examples illustrated that the pen, for these formal writings, has always been the edged tool spoken of, that is a tool which without appreciable pressure upon its two nibs has drawn the forms with the width of its whole edge (or thereabouts) for downstrokes and the thinness of its edge for lateral strokes, the gradations between being inimitably supplied by the tool itself in its passage from one to the other. Moreover, the downstroke is generally fairly thick, evidence of pleasure at the contrast of thick and thin and the gradations automatically provided. This feature is ever THE essential of penmanship, the pleasure deeply instinctive, and involved in the appreciation of variety in nature by human nature. Indeed, in the Gothic period this pleasure so reacted upon the script that the pen's edge was broadened to exaggerate the breadth of the stroke, as is evident from the very name ' black letter ' to describe the writing.

Accompanying the formal hands throughout the centuries has been a contemporary cursive, into the history of which it is not the purpose of this book to enter, since for us our present cursive handwriting is only concerned with its descent (and degradation) from the Renaissance. And though the same remark applies to the formal, this was related more directly or more evidently to its predecessors, while the cursive at the Renaissance took a fresh start, and in relation to the formal rather than to any previous cursive. Even of old, as in Anglo-Saxon times, the cursive was much the same as the hand em-

ployed for literary productions, just lacking its care and precision. And as the pen took the place of the stilus, the modifying influence of which seems to have passed with the Roman Empire, the cursive writing ever tended towards the freer performance of the formal minuscule it accompanied, and gradually to lay aside the separate models—if they can be called models—it originally

Fig. 18.

ITALIAN. BEGINNING OF SIXTEENTH CENTURY.
De Assumptione Virginis. In the Author's possession. Actual Size.

derived from the Roman cursive and its 'official' descendants. But at the Renaissance the connection and dependence became marked and strict as never before; as to which Sir E. Maunde Thompson remarks (p. 505): 'What saved Europe from this diversity of current handwriting was the welcome which was given to the beautiful Italian cursive hand of the Renaissance, a form of writing which stood in the same relation to the book-hand of the Renaissance as the modern printer's italics do to his ordinary Roman type. . . . The introduction and wide

Fig. 19.

SANCTISSImo Patri, ac Domino nostro, D. PAVLO PP. IIIJ, Diuina pꝰuidentia Pontifici Maxi: MARIA, Dei gratia, Regina Angliæ, Franciæ, Neapolis, Hierusalem, Hiberniæ atꝗ æternam Salutem et humillimam nostri Obedientiam. Tantum nobis possicemur, ac una in nos Paterno amore atꝗ pietate, ut nihil existimemus posse nobis læti accidere, quod non summo are gaudium afficiam Sⁱ afficerētur sit. Itaꝗ, nihil prius faciendum nobis esse duciᵐus, ꝗ uⁱ nostris literis, Sⁱ significemus, ꝗ facili nobis, ꝗ facili nostris, paritu, Deus nos hoc tempore beauit, qui optatiß Filium, mirifica sua in nos benignitate, nobis dedit. Rooamus 1ⁱ: Sᵗᵉᵐ Sⁱ ut, quemadmodum certam lætitiam ex hoc nro gaudio, Sⁱˢ Sⁱ capiet, ita pias uras preces, pro hoc nobis concesso beneficio, apud Deum, una nobiscū communicare velis. DEVS Sⁱ Antistⁱ conseruet ExRegia ura, Hamptoniæ.

ENGLISH. WRITTEN BY ROGER ASCHAM FOR QUEEN MARY TO THE POPE. A.D. 1555.
In Record Office. ¼ Actual Size.

acceptance of the Italian hand has constituted a new starting-point for the history of modern cursive writing in Western Europe.' With us our looped Tudor style in the sixteenth century was, within a hundred years, almost entirely superseded by the Renaissance standards adopted by R. Ascham and others from Italian models; very evidently adaptations of the book-hand for the freer and quicker use of every day. The change is abruptly marked in parish registers, where the loop and tangle of the previous hand is displaced by a trim sort of ' italic.'

The needful speed of the cursive, however, always demanded a finer and more pliable pen than the formality of bookwork and its sedater performance claimed, and at all times has been freer and more flexible, even frailer in appearance as a result. It has also, with the pen, tended to have, what stilus work could not have, a continuity of line running through the words—a matter for discussion later.

From the time of the Ascham reform of the sixteenth century our writing has gradually deteriorated, owing not so much perhaps to the exactions of speed, as to the fact that since the invention of printing we have had no strict occasion for the preservation and practice of formal writing, and have had consequently no stabilising influence to counteract any frivolity, ineptitude, or carelessness that might befall. Our formal writing is our printers' type, and this fact and the proper connection with our cursive is befogged with nigh on five centuries of the machine.

In particular there is no doubt that the copper-engravers (Pepys' Cocker and others) who produced our early copybooks had a wholly evil influence upon our cursive, with the loops and lashes and twirls, which their delight in the ingenuity of their own craft invited the pen, with no recognised standard to steady it and counteract the mischief, to imitate.

The printers have been ever more loyal to tradition.

They have preserved the penmanship of the fifteenth
century visibly in our types of to-day—and this without
the writers' reason for doing so. For there seems no
inherent necessity for our types to remain imitations of
that or any penmanship. But so conventional are we in
our veneration for it that no ' original ' departure from it
by the ingenious experimenter is ever attended with
success.

From consideration of this and the real desire for the
bettering of our writing, which is evident enough in these
days, the suggestion is put forward in this book that the
connection between cursive and formal (even if the latter
be not studied and practised) must be readmitted, if only
for the improvement and preservation of the cursive and
the avoidance of ridiculous incongruities. It is this ad-
mission which those who advocate the imitation of print
seem to acknowledge. Unfortunately they do not ac-
knowledge enough. They have not readmitted the pen
to its own, even while they are imitating the imitations
of its most masterly performances. The subdued refine-
ment of these has served to obscure the contrasts and
gradations of stroke upon which the characteristic, the
essential, beauty of writing depends. The modern print
imitation is rendered as with a slate-pencil or a match-
end ; and all the virtue of the pen-method negatived by
an unconvincing misapplication.

Nor can the benefit of the admission be assured by the
use of any chance tool which, disregarding this charac-
teristic expression and taking the letter forms only as of
importance, precludes the learner from any approximation,
on slow and careful occasions, to the effect of a detailed
and deliberate formal hand. The advantage of the one
appropriate tool lies in this, that the user can on such
occasions add dignity and importance to his performance
by a natural development of detail. The matter becomes
to him one of degree, not of kind. At present the criticism

of our hand has been that ' but few gentlemen can write
their native language in a well-formed hand for everyday
use, while for any occasion demanding dignity or formality
they have nothing to use at all.'

The standard we adopted from Italy in the sixteenth
century was precisely this standard, involving different
degrees of elaboration for different occasions, not allowing
any suggestion of difference in kind. And of the Italian
cursive hand of the Renaissance Sir E. Maunde Thompson
observes that it stood in the same relation to the book-hand
of the period as the modern printer's italics do to his
ordinary Roman type.

Both are available to-day as in Ascham's day. We have
but to determine the amount of detail appropriate for the
particular occasion ; as thus in the case of the minuscules
m b u. These can for common cursive be made with one
tratto each, as in Fig. 20. And
noticeable at once (with most) is the
desire for the slight slant which swift
penmanship has preferred for comfort
and ease. This is due to physical
cause. The right hand, resting for stability on the
wrist and little finger, finds the easiest direction for the
movement of the other fingers and thumb, holding a
pen, the direction which one may call (by a convenient
reference to maps) N.E. by N. to S.W. by S.

A more precise method of making these same forms,
which one may call semicursive or semiformal, would be
as shown in Fig. 21 (three
tratti for m and two for b and
u). Or again, the completer
formal method would be that
of Fig. 22, giving extra detail
and precision to heads and feet. But no difference of
standard in the letters themselves is involved thereby ;
only variation of amount of detail, while a stiffer and

usually broader pen might be preferable for the last, and
an upright stance certainly given to the letters as more
befitting formal occasion. Finish by means of the serifs
is especially noticeable. In the cursive these hardly
appear, in grades between they are more or less slurred.

And here a technical matter of great importance needs
stating—the position of the pen's broad edge with regard
to the horizontal. If this is cut at right angles to its
slit, the natural manner of holding the hand so that the
writer may see what he is doing, as well as have his hand
at ease, sets this edge at an angle of from 30° to 45° from
the horizontal. And the vast majority of the scribes of
all ages have written with their pens cut thus and held so.
And certainly all the cursives may be said to have been
written with the pen's edge ' at an angle,' whether the
writing itself be upright or sloped. Only in some of the
formal scripts do we notice that the pen's edge was kept
parallel with the horizontal ; as with the later uncial, the
half-uncial, the Anglo-Irish, and some of the superlative
Renaissance book-hands. With a straight-cut pen this
involves a cramped position for the hand as well as its
interference with the eye. And this difficulty was obviated
by cutting the pen's edge obliquely across the slit, so that
the shaft came away, pointing as usual beyond the writer's
right shoulder, but the edge still lay along the horizontal.

Even so the method is less
natural ' or comfortable, certainly
for rapid work, than the other; and
only severely determined perform-
ance has adopted it.

Its effect may be said to be
rounder, opener, as well as more
majestic than that of the canted pen with its sug-
gestion rather of grace and liveliness. I prefer to call it
' flat-pen ' writing, the word flat conveniently reminding
of the pen's edge's position ; and call the more usual

Fig. 23.

method that of the ' canted-pen,' with which have been
written the far greater number of the manuscripts that
have come down to us, including all the Gothic from the
eleventh century to the fifteenth, whether formal or
cursive, and whether upright or sloped.

But the actual angle of the edge has varied from a
slight cant of some 10° or 20°, as in some of the Win-
chester books of the eleventh and twelfth centuries, to an
angle of even 60°, as in the Lombardic so-called ' broken '
hands of the eleventh and thirteenth centuries, imitating
the position of the pen's edge that performed the early
Rustics of the fourth and fifth centuries. Generally for
the ' black letter ' an angle of 45° was adopted ; but the
writings in which the angle was not more than 30° are
preferable to our eyes, as preserving the rounder character
of the half-uncials or Caroline hands, without the Gothic
tendency to angularity or narrowness, with added charm
and liveliness. For a canted pen may still write a beauti-
fully rounded hand ; and writers are always the more
successful who can retain the roundness of their curves
instead of ' snagging,' as shown in Fig. 24 rather than
as in Fig. 25. The angle of
30° (or, of course, 20°) has
the further advantage that
with it are retained the com-
parative thicknesses of downstrokes compared with side
or horizontal strokes ; and our instinct for stronger
trunks than branches seems to accept this treat-
ment as more natural than the adoption of even
thickness for both, as with the angle of 45°,
and certainly than the angle of 60°, whereby
stems support unnaturally disproportionate
branches. A capital T with a thin stem and a
thick crossbar violates our sense of fitness. And
a hand written even at an angle of 45° (which
keeps them equal) yet tends *en bloc* to an

m u h

Fig. 24.

m u h

Fig. 25.

Fig. 26.

appearance of spottiness or spikiness, owing to the waists of the letters lacking fullness, and the tips of all ascenders and descenders running to sharp points. Fig. 29.

The beautiful dexterity with which scribes so often have avoided these defects, while retaining the convenience of the canted position for ease of performance, is only to be appreciated on careful study and like endeavour. A jumpy, broken hand can only be smoothed by attention to the little points and snatches that come of disregard for details ; which seemingly unimportant, yet by multiplication down a page or even along a line, make for a general disturbance and unpleasantness out of proportion with the individual defect. In particular is it noticeable how accomplished scribes of round hands rarely permitted the pen's edge to travel along the line of the angle, even with the cross-bar of the letter e (Fig. 30). Although canted to 30°, the pen travels rather along the horizontal, whereby this stroke takes a certain thickness. The movement is ever vertical or horizontal, except when making the curves, and these are rounded arches, like those in Fig. 31 instead of those in Fig. 32. This matter can hardly be sufficiently stressed, or, with students, too often recalled.

Fig. 27.

Fig. 28.

Fig. 29.

Fig. 30.

Fig. 31.

Fig. 32.

With the ' flat ' hands the danger lies in too great breadth of letters, which often gives a squat appearance greatly to their disadvantage. They are more difficult to most writers—as indeed previous ages seem to have found. They do not also permit of such variety of strength of stroke, as practice and varying taste have

certainly succeeded in according the canted hands. A
classic refinement, and even some heaviness, seems ever
to pervade their performance, though the Book of Kells
might be instanced to the contrary ; with less individuality
of choice possible. They even seem to dictate the litera-
ture which may be written so, the solemn rather than the
gay ; while the canted hands accept scripture, ' classic,'
fairy-tale, or modern prose and poetry equally well.
Moreover, a practical cursive may hardly be founded
upon them. The cursive manner is out of keeping with
their stateliness and deliberation.

In the next few chapters I propose to deal with the
canted pen first, and its use for (1) cursive minuscule,
semicursive minuscule, and formal minuscule ; (2)
majuscules or capitals, formal and cursive ; and then (3)
the flat pen hand, minuscule and majuscule.

CURSIVE MINUSCULE

his hand (Fig. 33) drawn from fifteenth-century Italian sources is closely associated with the formal hands of the same period (as Sir E. Maunde Thompson observes), but it was written at a slight slope (hardly more than 5° from the perpendicular) instead of, as the formal, upright. There are extant by good fortune in the hands of Mr. Sydney C.

aa bb c e gg h ij k l m n oo qq r

s u vorv worw y ory and z

dd forf pp t xor jc x and e e

cursive minuscule

Fig. 33.

Cockerell, Cambridge, and in the British Museum, examples of the performance of one scribe, Mark of Vicenza, in either manner (see Fig. 34).

The hand spread over Europe, and on its introduction here is usually associated with the name of Roger Ascham. It displaced the previous Tudor cursive, though we find Bacon still using the Tudor for common purposes, but addressing a letter to the king in the manner associated at its inception with the Court. It is the origin of our

hostes: seu qui militant contra
inuidiam diabolorum. aut
qui uotum uouerint domi.
no cantare cotidie integrum.
psalterium. et non possunt.
aut qui ieiunant et ieiunio
nimium debilitantur. et q̄
festa solennia non custodiut
et qui animam suam salua
uolunt facere secundum mi
sericordiam dei. Et uitam
eterna uolunt habere. assidue

ita temptatus. moderatusq̄, moribus ut summa
cum humanitate ungeret. Sed ut hui? p. su
me moderationis testimonium reddamus
hec tam memorabile ai tempinetum strictim
in medium afferamus accersime cum vivo q̄da
plebeio. Vendraminus inteq princeps creat
ect defenserat ita ut cor a iure dignoscendo p
festa conuento ad graues testium q̄, inimicias
progressa ect loqtur cū paulo post dux creatus r
ect utq̄, id ille conclamari audisset coniuibus r
ad eos qui cum illo erant turbato uultu q̄ id
egre ferret, in publica lectus ē Q̄ue in hui?
P. atq̄, in nostru, p̄ris dedccus redundarent.

Fig. 34.

ITALIAN. THE WRITING OF MARK OF VICENZA. LATE FIFTEENTH CENTURY.

On the left his formal hand in a book of Psalms and Prayers in the possession of Sydney C. Cockerell, Esq. On the right his hand, '*calamo volanti*,' in a funeral oration. Brit. Mus., Add. MS. 1906i. Both Actual Size.

late copy-book hands; but unfortunately has been degraded not only by the *tours de force* of seventeenth and eighteenth-century writing masters, but also the inappropriate influence of metal engravers, until the connection is hardly recognisable. The trim, definite action of the broad pen has been superseded by the loop and flourished frailty of the fine pliable pen, imitating the dexterities and ingenuities of another craft. Much has also been sacrificed to the mistaken notion that continuity of line through the words, the invariable connection of the letters, is of the first importance towards speed rather than a simple performance of the individual letters.

The method here returns to the fifteenth and sixteenth-century models. In action it is exceedingly uniform, and the value of uniformity of method is shown later in the chapters on legibility; that is, similar details in different letters receive similar treatment. There are also but few details, which makes for simplicity. I have drawn on the authority in particular of the Book of Giovan Battista Palatino of Venice, 1588. He divides the minuscule alphabet into two groups, those letters to be made with one *tratto*, and those with two, as shown in the example heading this chapter. His pen breadth is about one-fifth the height of the letters' bodies.

The letters requiring two strokes are *d f p t* and *x*, to which may be added an alternative *e* in case the form with one stroke tend to a blotted lobe. The second stroke is no hindrance to speed when made habitually (Fig. 35);

em er ex

Fig. 35.

and, as a matter of fact, is already adopted by many writers, the possible disadvantage being a tendency to miss the juncture with the upper curve and make the letter look too

em er

Fig. 36.

Greek (Fig. 36); *d* and *p* certainly necessitate the two separate strokes, but with *f* and *t* the cross-bars often continue from the preceding or into the

next letter, and so become hardly so much separate
strokes as connecting links, thus : (Fig. 37) where the
stroke follows the making of *f*'s stem and
precedes that of *t*, doing for both, or (Fig. 38)
where the cross-bar is run into the *u* and
from the *r* and so on. With *x* the thin

after

Fig. 37.

stroke similarly may follow
easily from the previous
letter if its end happens to turn up, as

tur art

Fig. 38.

Fig. 39.

In general all curves should be
rounded, but the letters rather narrower than they are
high. And snagging should be avoided (see Fig. 25), a
fault easily arising from over-narrowing. The
ascenders all begin with a little hook. Some
sixteenth-century examples begin with this
reversed (Fig. 40), and very beautifully ; but

ax ix

Fig. 39.

this is not so easy to perform, and leads to
overdoing and malformation and slovenliness
(Fig. 41). These hooks one way or the other
seem necessary, though extreme simplicity
might suggest dispensing with them ;

Fig. 40.

for they not only give a taste of ' finish '
to the stroke, but also assure the pen's ' speaking '
on touching the paper, and help to regulate the
stem strokes. These hooks in the formal hands,

Fig. 41.

to be examined later, become definite constructions with
an added bit of stroke as (Fig. 42). In the cursive they
need to be made smartly and uniformly, and
not to be over curved or over pointed. The
height of the ascenders and length of de-
scenders depend upon the manner chosen for

Fig. 42.

the particular writing. If the lines are wide
apart, that is if an open effect be aimed at, they may
be fairly long, that is (say) three times the height of
o. But for general purposes twice the height of o, or even

rather less, is sufficient. They should never be allowed to tangle between the lines.

Children should not, even at the beginning, be set to make the letters too large. Half an inch or one-third for the minuscule o is quite big enough. And the making of the letters can be learnt not in alphabetical order, but that of ease of construction, beginning with *i* as the simplest, which only demands the representative action of hooked stroke and under curve. The next might be *n*, and then the *c*. This demands that the pen begins with a push to the left, which is always more difficult for beginners than any pulled stroke. Then follow all such letters as demand this commencement, as *a d e o q s* and *f g* and *y*, which need it both at top and bottom. Children find this as difficult as any, and need continual supervising lest it become habitually misformed. Their pen's edge's angle of 30° also needs such supervision. It is ever tending towards 60° instead, with great hindrance to the formation of a hand. It is good practice for them to make a simple cross at the angle of 30 before commencing each line of letters.

An advantage of the broad pen is attested by the children's prompt and pleasurable recognition of its help in the work. It gives them thicks and thins and gradations from one to the other as it moves—surprisingly ' of itself.' Instinct towards craftsmanship is immediately awakened.

But another instinct needs to be guarded against. Most children seem to take pleasure in producing loose ends, tails especially, into spirals (Fig. 43). In general, curves ending thus loosely should be rendered severely, to check this tendency; and something of an angularity assists their good appearance, especially with *f g y j* (Fig. 44). Of other individual letters h m and n need to

Fig. 43.

be restrained from becoming h, m and n (Fig. 45); *k*'s limbs should be kept level with the *o*; thus *ko*, or it may become too like a majuscule; *r* should not be snatched at all, but a pony's tail considered, even with double *rr* (Fig. 46); *s* should not be snagged as in Fig. 47, a very common fault. The alternative straight *y* is useful for such terminations as -*ology*, one common in our tongue. The first *ff* shown in Fig. 48 is preferable to the double curved forms set beside it. In many of the more cursive fifteenth and sixteenth-century hands we see that all the letters which end in the upturn tend to run on into the next as in Fig. 49. And from this is evident that it is easier and quicker to continue the pen on the paper *in certain cases* where these natural ligatures occur. But in such combinations as *od ob go*, etc., no such reason exists.

In all times of careful writing the letters were joined together into words, but rather by being made to touch than by continuity of stroke. In the formal hands this method of compacting the words is observed (Fig. 50). Here between p and l and s and e, which provide no loose end, are the only gaps.

Fig. 44.

Fig. 45.

Fig. 46.

Fig. 47.

Fig. 48.

Fig. 49.

Fig. 50.

But whenever the writing becomes rapid gaps between letters begin to arise. In cursive these gaps could often be conveniently bridged by the connecting stroke. And from an endeavour to import this effect into unaccommo-dating couples have arisen the awk-wardnesses of Fig. 51, as well as that unpleasant habit of looping, as Fig. 52. A malformation of the letter forms also often occurs in consequence with the introduction of a confusing sort of half letter, as in Fig. 53, Fig. 54 which might be Fig. 55, and Fig. 56 which might be Fig. 57. This continuity of line is partly the result of our fine flexible pens. For the flexible pen pressed upon for the downstroke does not leave the paper instantly on release

Fig. 51.

Fig. 52.

Fig. 53.　　　Fig. 54.　　　Fig. 55.　　　Fig. 56.　　　Fig. 57.

of pressure and turn for the upstroke, while the stiff pen rising leaves the paper at once; so that a stiff pen makes *el* so (Fig. 58), while the flexible pen auto-matically tends to looping *el* so (Fig. 59). Both travel the same distance, so that pace is not affected, and the loop of running line is not, as is commonly thought, of itself a help towards speed. The running line, moreover, is apt to part letters farther than need be, and letters so parted are not read more easily, our recognition of words regarding rather the bunches of them that make the words, which is delayed by spreading them out. Legi-bility is also affected by the disagreeable secondary slant with which the incessant stringing disturbs the tranquillity of reading. It introduces something like

Fig. 58.

Fig. 59.

a shower of diagonal rain into the web of the necessary work.

From all such impediments the stiff classic pen safeguards us, making the letters separately and setting them close side by side without loss of space or pace, or any superfluity. Many writers also have discarded continuity in their incessant practice, going to the pains of unlearning much that they laboriously learnt by youthful copy-books, and dropping it for the sake of that very speed which they were led to believe they were acquiring by performing it. There remains, however, the fact that the pen is somewhat helped towards pace by a certain ease of continuity of touch which it gains by not leaving the paper. And this certainly applies to what I have called the natural ligatures.

These are, however, constantly obscured even in fifteenth and sixteenth-century writing by another tendency, owing to a certain difficulty we all experience in changing direction from what I may call the overhand action to the underhand, or vice versa, which is instanced in writing *mu* (Fig. 60) or *am* (Fig. 61); that is, from the action of

mu *am* *mmm* *uuuu*

Fig. 60. Fig. 61. Fig. 62. Fig. 63.

Fig. 62 to that of Fig. 63 or the reverse. Constantly we find numerous writers adopting the one for all, with

mmmmmy *uuuuuuy* *mummy*

Fig. 64. Fig. 65. Fig. 66.

obscurity, as Fig. 64 or Fig. 65 for Fig. 66, though as the overhand is more difficult than the other, we find the adoption of the underhand for all the more frequent.

A way out of the difficulty is also often observed in the angling of all the curves as Fig. 67. In the early intro-duction of the hand here we observe

mummy

Fig. 67.

this angling in the writing of Roger Ascham (Fig. 19, p. 52) and others. It is a rather disagreeable character-istic in any hand founded on a rounded convention, but seems almost inevitable in consideration of speed. And no teachers that I have known seem to have dealt with or even recognised this fundamental physical hindrance. I fear I have no suggestion to make with regard to it. To get rid of it one would need to throw over all tradition and recreate a cursive alphabet which would confine its action to one only of the two. In my copy-books[1] I have endeavoured at least to help the matter by showing the representative groups of the natural ligatures, some letters, whose ends turn up, leading naturally into the following, as Fig. 68 into Fig. 69, but I think only those. And at first I would not

acdehiklmnrtuz

Fig. 68.

suggest that even these ligatures be pointed out to children. They should rather, in the Ascham manner, be

ijmnruvwxyz

Fig. 69.

taught to make their letters carefully and separately. But as their hands gain competence they should be allowed to employ them as they discover them for their own convenience. And as to speed, even in these days of hurry it may well be doubted whether this is not con-sidered too importantly. And the commercial man, looking for a clerk, stated the case well, who said : ' I

[1] Oxford Copy-books, 1 and 11.

don't want the man to write fast, I have the stenographer and typist for that. What I want is a man who can make a decent entry in a book.' Hurried writing has always been bad, from the Roman cursive onwards. What is needed is a hand that can be written fast enough for various occasions, and can be consistently performed the better or worse according to the particular demand upon it, having a standard remaining constant and only its action variable ; a hand that can be elevated to the dignity of formality without more than deliberation in the doing, and systematic though slight addition of detail. The method of modern education is greatly to blame, where the exercise of memory is discouraged, and all teaching administered to the accompaniment of note-taking. It may be suggested that this note-taking should not come into the category of writing at all. So long as pupils can adopt a sort of personal shorthand (even by aid of pencil) legible to themselves, that is all that is needed for such a purpose. But this is not writing. We do not teach a child to read and then estimate the ' goodness ' of his reading by the pace at which he can gabble.

And in this matter of standard no finer authority is likely to be found than that of so gifted a people (æsthetically and technically) as the Italians of the fifteenth century, whose method came to prevail over Europe. The method here recommended is but a return to these fifteenth-century models.

In regard to the space between words, clearness is certainly assisted by a comparatively wide one and pace not affected. In formal hands a wide space is not so necessary as in cursive, and in most of such MSS. we find the space equal to the breadth of the o or n. In cursive double this is not too much. Spacing between words at all was a comparatively late improvement. It only became general in the eleventh century.

And to anticipate a small but important matter of

arrangement—the beginning of paragraphs—we now follow the printer's method of ' indenting ' them, but without his reason. Before the time of printing the paragraph initial is either set wholly in the margin or somewhat projecting into it. And this marked such beginnings as well as our present gaps do. But by indenting our initials we make it at once impossible to give them any decorative prominence or enlargement, which their marginal projection would easily allow of and encourage. A reversion to the tradition before printing would not be unreasonable. It will be discussed later when the majuscule letters are dealt with.

It is indeed a much more truly religious duty to acquire a habit of deliberate, legible, and lovely penmanship in the daily use of the pen, than to illuminate any quantity of texts.

Fig. 70.

EXAMPLE OF A CAREFUL CURSIVE.

From *Lectures on Art*, by John Ruskin, No. V., ' On Line,' 143 ; the whole paragraph most characteristic and apposite.

CHAPTER SIX

SEMIFORMAL MINUSCULE

I T is evident that between the two canted pen hands, cursive, Fig. 33, p. 60, and formal, Fig. 79, p. 76, lie a series of graduated hands which may be regarded as semiformal or semicursive. For instance, the cursive alone may be written so carefully and deliberately as itself to rise to the dignity of a formal hand without any change of detail; or with deliberation may be

aa ʰb cc eeſorſ gg ʰhh ʰkk nn

oo pp qq rr ss ˉlt uu vvor vu

yy or yy ∕\x or ꓳcx &. &

cld mm ww ijlz ⅌ &&

semi-formal minuscule

Fig. 71.

added a little more detail which shall yet not amount to as much as be given to a set formal hand, and strokes may be made separately which before were slurred into one. And such hands may be either up-

71

Sopra il salmo

XXVII

Questo sant'huomo eßendo liberato da mol·
ti, et da grandi pericoli da dio, era diuentato
forte et animoso, si, che non stimaua piú ne'
forze, ne inganni de nemici; e't propone que'
sta fidutia per confirmar noi altri, & appreßo
dice de la sua pieta uerso dio, et da lui domâ·
da aiuto contro la importunita de gl'auersa-
rij, & con la speranza di questo aiuto assicu·
ra l'animo suo.

Salmo XXVII

Il Signor'è il lume mio, & la salute'
mia; di chi haurò io paura?
Il Signore è la luce, & la salute mia, di cui
haurò io adunque paura?

Fig. 72.

ITALIAN WRITING, LATE SIXTEENTH CENTURY.

Paraphrase on Psalms, 'Italic' and 'Roman'; Brit. Mus. Harl. 3541. A very
fine example of technique, though too imitative of 'print.'

right or sloped, the cant of the pen's edge at the
angle of thirty degrees, however, being still taken for
granted in all cases, and the general standard of alphabet
preserved.

In a typical hand the following letters will then be
made of two strokes, as shown in Fig. 71 (treating the
corner piece to ascenders
as part of the stem stroke), *c l d m m w w*
namely *a b c e f g h k n o*
p q r s t u v y x. *d m* and
w take three (see Fig. 73),

Fig. 73.

while *i j l* (see Fig. 74) take but one (ignoring dots).

At the foot of *p q* and *y* may be noticed a little pro-
jection, answering to the corner piece of the ascenders,
i j l which if magnified would show the pen's action
performing it to be as in Fig. 75, the ink flooding
into the angle formed. This is a swift method of
adding finish, and may also be given, though

Fig. 74. more restrainedly, to the feet of the first strokes
of *h* and *k* and *r*, and to all the strokes of *m* and *n*.

In such a hand all ligatures may be dispensed with,
the letters being set close but not necessarily actually
joined together. The alternative forms of *a*
and *g* (Fig. 76) may be introduced for *a* and
g (Fig. 77), though if either be used both are
usual. These forms (Fig. 76) are derivatively
uncial, the forms in Fig. 77 derivatively Roman
cursive. Even so, the uncial forms themselves

Fig. 75.

are the Roman majuscules modified by
a a g g the Roman cursive. More development
has happened in the one case than
in the other.

Fig. 76.

It will be observed that in such *a g*
a hand there are fewer upstrokes. The broad pen
prefers downstrokes ; and the greater evenness

Fig. 77.

and uniformity of the hand comes of this construction

no less than from the comparatively slow pace of the writing.

This half-and-half hand is particularised to illustrate the point of view taken in this book that with an invariable standard, having a variable method befitting all occasions, our writing could be simplified and dignified, our ideas clarified, and distracting choice of styles obliterated ; and the attempt made so to correlate cursive with the deliberate formal, which now for most of us subsists only in its imitative form of ' print,' as to steady both towards companionship instead of mutual contempt. The scribe is apt to regard the printer as a mechanical cheap-jack, the printer the scribe as a merely ridiculous ' dug-out.'

The invention of printing resulted in robbing writers of their first-class standard—even while the printers remained loyal to it themselves. This matter of standard is at the root of our trouble, and can only be restored by using the tool which achieved it.

Glory of warrior, glory of orator, glory of song,
 Paid with a voice flying by to be lost on an endless sea —
Glory of Virtue, to fight, to struggle, to right the wrong —
 Nay, but she aim'd not at glory, no lover of glory she:
Give her the glory of going on, and still to be.

The wages of sin is death: if the wages of Virtue be dust,
 Would she have heart to endure for the life of the worm & the fly?
She desires no isles of the blest, no quiet seats of the just,
 To rest in a golden grove, or to bask in a summer sky:
Give her the wages of going on, and not to die.

Fig. 78. Example of Semiformal Minuscule Writing: Tennyson's 'Wages.'

EXAMPLE OF FORMAL ALPHABET
(MINUSCULE)

BELOW is a formal alphabet derived from Italian fifteenth-century models, from which our printed types are also derived. It is consequently extremely legible to us, as the forms are not archaic but what we are accustomed to, and the manner smooth and craftsmanlike, in that no twist of special performance is called upon for any particular letter (Fig. 79).

In writing it the pen's edge is constantly kept at an

aa bb cc cld ee ff gg hh
ij kk ll mm nn oo pp qq
rr ss tt uu vv w/\xyyz
a formal minuscule

Fig. 79.

angle of 30° from the horizontal, and for most ordinary occasions the breadth of this edge should be one-fourth or fifth the height of the body of the letters. But although the pen is held at this angle it should never be allowed to move in the direction of the angle, except as it passes

round the curves. Its action should be perpendicular and horizontal ; and it follows that the perpendiculars it makes are thicker than the horizontals, an important feature in any alphabet. The curves should be rounded above and below, like Norman arches and even waves (Fig.

80a) ; never snagged (Fig. 80b). The general effect will then be of tranquillity and even flowing progress.

m u h
Fig. 80a.

m u h
Fig. 80b.

The bodies of the letters should generally be slightly narrower than high. If square or round they tend to look squat, and if of a greater breadth slovenly. On the other hand, if too narrow they become pinched and poor. An important detail lies in the tops of the ascenders b d h k and l. This is made before the downstroke (Fig. 81) and the downstroke fitted to it with an action shown in Fig. 82, the effect of which is a definite form (Fig. 83), the top of which has two planes. This head should not be rendered as shown in Fig. 84. This form is certainly easier to produce, but if the one recommended is adopted habitually it will greatly assist the smooth appearance of the writing. If performed in the pointed manner, owing to the frequency of these ascenders, a spiky and somewhat agitated look is immediately imparted to the words.

Fig. 81.

Fig. 82.

Fig. 83.

Fig. 84.

In making a the lobe should be drawn first (Fig. 85). This assists spacing. And here immediately comes the need to draw the upper part of the lobe horizontally. Thus Fig. 86 introduces the disturbing diagonal.

cl a
Fig. 85.

a
Fig. 86.

b is drawn thus **b b**

Fig. 87.

c thus C C

Fig. 88.

d thus c l d

Fig. 89.

e preferably thus e e

Fig. 90.

or the lobe (Fig. 91) soon tends to look upwards diagonally. But the cross-bar should not be drawn at all downwards or a heaviness ensues (Fig. 92).

Fig. 91.

Fig. 92.

The cross-bar of f is drawn first, and a little upwards and backwards piece given to it (Fig. 93). This is to impart construction to the cutting of the horizontal and perpendicular, which, without it, may appear too casual (Fig. 94 instead of Fig. 95). This piece of construction was below the cross-bar in f, above it (as will be seen) in t.

Fig. 93.

Fig. 94.

The strokes for f are, accordingly, as shown in Fig. 96, making f as in Fig. 97, the cross-bar aligning with tops of other letters' bodies. But the head may be raised slightly when followed by l. At the foot of the downstroke, to give stability, the pen is drawn just slightly horizontally without leaving the paper (Fig. 98). This may also be given to the ends of the descenders p q y.

Fig. 95.

Fig. 96.

The lobe of g may be less than that of o that room may be given for the tail, a modification the first printers introduced to deal with the scribe's previous exaggeration of this feature (Fig. 99). The horn is important, should be horizontal, and may connect with the next letter (Fig. 100).

Fig. 97.

Fig. 98.

Fig. 99

Fig. 100.

h is marked thus **ꞏꞏh h h** the bottom of the first

Fig. 101.

downstroke having a little pull to the right, hookwise, as occurs later in k m n r.

i j so, the dots placed just above the letters, not so

Fig. 102.

high as ascenders.

k thus **ꞏk k k** no curvature being given to the

Fig. 103.

diagonals, save the little twist upwards at conclusion.

l thus **ꞏl l**

Fig. 104.

m and n thus **m m n** well rounded.

Fig. 105.

o thus **O O ꞏ**

Fig. 106.

p thus **P P** care being taken to drive the lobe back

Fig. 107.

into the perpendicular on finishing, not **P**

Fig. 108.

q thus **q q**

Fig. 109.

r thus **ℾ ℾ** not **ℾ** double r's, thus **ℾℾ**

Fig. 110. Fig. 111. Fig. 112.

s thus **ſ S** . With s one needs admit the diagonal,

Fig. 113.

otherwise the letter is apt to become blowsy, with a

tendency to snag, thus **S S**

Fig. 114.

t thus **⌐t t** the top left-hand corner being filled up

Fig. 115.

with the constructive upward movement of the pen before the downstroke. t is not an ascender, and breaks the line almost accidentally. The cross-bar can run into the follow-

ing letter, it will be found, with no obscurity **ta tr**

Fig. 116.

u thus **u u** well rounded.

Fig. 117.

v **V ʋ v ʋ** or **vʋ** in small work, one or

Fig. 118. Fig. 119.

two 'strokes.'

w thus **uʋ uʋ** well rounded.

Fig. 120.

x thus ⟋⟍ 𝒳 . It will be found convenient to make

Fig. 121.

the thin diagonal first and to start below the line. This

assists junctions, as ℯ𝐱 𝐚𝐱 ı̇𝐱

Fig. 122.

y thus ʮ ʮ well rounded.

Fig. 123.

z thus in one stroke, 𝑍 or 𝖹 curving slightly below

Fig. 124. Fig. 125.

the line.

It will be noticed that the forms w and y are not given. They are discarded in order to reduce diagonals to a minimum. These two letters are exceedingly common in English, and consequently any writing with the forms w and y is much disturbed. It happens also that our common cursive has the rounded forms, so that no illegibility follows making them round here. And diagonals are reduced to those in k s v x and z, and possibly g, though its diagonal being below the line seems never so intrusive. Of these only s is common and v, though less so.

The reason for reducing diagonals arises from consideration of the origin and evolution of our alphabet, which was created to write Latin. In Latin (minuscules) k y v and, of course, w may be said not to occur, k and y being extraordinarily rare, and v being represented by the form u. s and z are perhaps as common as with us, and x perhaps a little commoner. The result is that it is more majestically sedate, the common occurrence of m's n's, o's and u's greatly assisting this, as moreover the rarer

occurrence of the combination of ascender and descender as in our adverbial ly. The true character of the hand then depends on an observance of its smooth, sedate progression, and if the attempt to preserve this true character is made in another language, the technical details which combine to produce the character need attention. This elimination of all possible diagonals involves for us very little disturbance of the customary, and seems accordingly very advisable. The choice is, as it were, between classic calm and Gothic vitality. The hand is classic. It may therefore be as loyally so as possible.

The letters, though made thus separately, are strung together into words by close setting. And this setting can hardly be too close. Special care is needed with the up curves of a d i t u l that they be sufficient, indeed, but do not tend to make gaps after them. In such a word as *tuum, illumination* (Fig. 126), a greater legibility may be observed when the spaces between the letters are less than the letters' breadths than when these are all even like palings (Figs. 127, 128). On the other hand, the curves of e and c need to be drawn well forward, especially before v, that a disconnection be not uncomfortably left visible.

illumination

Fig. 126.

tuum tuum

Fig. 127.

tumultuous tumultuous

Fig. 128.

The space between words has generally been set as the breadth of an o. A little more tends to clarify the work (Fig. 129).

regnum:tuum:tuum

Fig. 129.

The space between lines is variable with occasion. Writing may be intentionally densely packed or parted as in poetry, where each line instead of each paragraph may become the unit to which the page is referred. The various effects of open or close spacing are rather matters of taste than of rule. And involved in such considerations is the comparative length of ascenders and descenders. With dense packing, for brick-wall effects, the evenness of which is good exercise to attempt, the ascending and descending letters may be as short as one and a half times the height of the o, and the lines, consequently, only about twice the height of o apart, and yet tangling avoided. Or with wider spacing, the ascenders and descenders may be one and three-quarters or twice the height of o, or in writing some poetry even longer yet. Or again, as may be observed in some striking classical MSS., the ascenders may be fairly short, but the descenders long. This method, combined with a thick downstroke in the body of the letters, is finely effective.

For most purposes the lines may be three o's apart, say half an inch for writing letters whose bodies are one-sixth of an inch high, or three-eighths or one-third for writing one-eighth of an inch high ; either of which are good sizes for practice.

The hand is agreeably sufficient for all formal purposes. It is, for a formal hand, one of the swiftest. It is economical or workman-like in method, as it calls for no change of position in the edge of the pen for any exceptional letter or combination. It admits of the cutting of the pen finely or broadly, as the taste or occasion may suggest, for it serves equally for delicate or massive effects. Its model may be seen in many of the Italian Renaissance MSS., when it was the most usually adopted of the standard hands, with occasional extra detail given to the feet of some of the letters, as f h m n r.

This consists in a dexterous sort of twitch apparently,

and if done more slowly with sufficient care to render it unmistakable, as in the Great Choir Books, where the letters are comparatively large, becomes too laborious and uneconomical to render its advantage in stabilising the letters practicable for general purposes. For a short

HE whom this scroll commemorates was numbered among those who, at the bidding of their country, left all that was dear to them, endured hardness, faced danger, and finally passed out of the sight of men by the path of duty and self-sacrifice, giving up their own lives that others might live in freedom. Let those who come after see to it that his name be not forgotten.

Fig. 130.

WRITING BY THE AUTHOR FOR REPRODUCTION FOR THE WAR SCROLLS SENT TO THE NEXT-OF-KIN OF THOSE WHO DIED IN THE WAR. Slightly reduced.

essay or single page, or work for photographic or other reproduction it may perhaps be advisable. The stroke is thus, in effect (Fig. 131), where the pen would otherwise behave as in the third stroke of m here. The pen's edge must have been turned at the bottom of the stem stroke on to its left-hand (probably not right-hand) angle, the

horizontal drawn, and the short upturn given, the ink kindly flooding in. (In some instances one sees that the ink was not accommodating.) The twitch was therefore probably as the arrows' directions in the figure below.

A modern writer trying this will find himself hindered greatly, not only by the fidgeting pause to perform this

Fig. 131.

small action to the many stem strokes, but also because he must turn his pen out of his set angle of 30° to do it, and must then recover this angle to proceed—with the result that it is harder to maintain the angle set and invariable. The steadying effect, however, of the feet so produced, if well done, on a page, is certainly remarkable. In some MSS. one surmises that the stroke was assisted by the ruling of the lines with a style, which gave a little ditch on one side and a little ridge on the other side the parchment, both of which probably assisted the ink to run along in the desired horizontal agreeably, with but slight direction by the pen's angle. Fine examples of the effect can be seen in Cicero's *Epistles*, written by Johannes Andreas de Colonia ; B.M., Add. MS. 11928 (see page 46), and Aristotle's *Ethics*, B.M., Add. MS. 21120, in the British Museum.

FORMAL AND CURSIVE MAJUSCULES

HE difference between the formal and cursive majuscules in the fifteenth century was but slight, and lay rather in the freedom of performance in the latter than in any particular modification (or even omission) of detail. If the two alphabets given here are compared all the differences

ЛA ВB CC LD L-E FF
GG HH IJJ KK LL
MM NN OO PPPP
QQ RR SS TTT UU
VV W V/XYY ZZ

Fig. 132.

FORMAL MAJUSCULES.

appropriate will be easily visible. The cursive is slanted $7\frac{1}{2}°$ from the perpendicular, like the minuscules; but of old upright capitals are often found accompanying the slanted minuscules.

The construction of the formal majuscules is as shown in the example above.

 A A

B B

C C , and while the ink is still wet the pen's edge's left angle may be turned and pull the upper curve down slightly and perpendicularly, as

C . And this finish may also be given to the G and S and the upper limbs of E and F. It is not essential, but certainly adds to complete the forms.

L D

L E

F F

G G

H H

I

J.J , the tail part falling below the line.

KK

LL

M M . In this letter the scribes often turned
the pen to make the first stroke thin. But this seems less
craftsmanlike and speedy than keeping the pen as usual
and taking the consequences of a rather thick stroke here ;
which can, however, be thinned slightly by splaying
the M's legs a little, after the inscriptional manner. For
in the majuscules the presence of diagonals is otherwise
fairly frequent and not detrimental.

N N . This letter cannot be splayed, and again
the consistent method of making seems to me to over-
balance the disadvantage of loss of contrast between
thicks and thins. N: to make the letter thus is almost
needlessly uneconomical of performance, and tends to
upset rhythm in writing words.

OO

PPPP

QQ

RR

SS

TT or T

UU

V V

VV W . The interlacing of the V's seems
ever the best way out of the difficulty here. (See later in
the ' compound ' forms.)

\\/X

Y Y

ZZ

ΛΑ A A ΙЗB CC C ΙƆD

ΙƒE EEε FFFF GGGGGG

HHHH IIJJ KKK LLMM

MMM NNNN OOOOO

PPP QQQQ RRR SSSS

TTTT UUUU VVVV W

W VW W W VXXYYYZZ

Fig. 133.

CURSIVE MAJUSCULES.

The cursive forms may be made thus :

ΛΑ tending to A and possibly A

ΙЗB

C or C C

ΙƆD

E E tending to *E* or *Ɛ*

F F tending to *F*

G G tending to *G G*

H H tending to *H H*
I I

J

K K tending to *K*

L tending to *L*

M M tending to *M M M* and possibly *M*

N N tending to *N N N*

O O or *O O*

P P tending to *P*

QQ or QQ QQ

RR tending to R

SS S

TTT tending to T

UU tending to U

VV tending to V

VVW tending to WW

\/X tending to X

YY tending to Y

Z tending to Z

With the majuscules, in both alphabets, trimness, evenness, and alignment are ever of more importance than the individual letters.

With the copy-book capitals at present still in vogue it is impossible to write any such thing as a heading or title, or any general announcement (Fig. 134) without

Fig. 134.

becoming at once ridiculous. And in combination with the minuscules their effect is too disturbing to be decorative. (Fig. 135, on next page.)

Capitals should be packed fairly close together in the words, and for general purposes, when used alone, should be set on lines twice the height of the letters apart (Fig. 136), or as in the Aberdeen epitaph on page 323. But

OUR FATHER WHICH

ART IN HEAVEN

Fig. 136.

their common use is in company with the minuscules, at the beginning of sentences or for proper names. And here they are made of the height of the ascenders of the minuscules ; and even when these ascenders and descenders are allowed some length, the majuscules are best kept under the height of twice that of the minuscule o (see Fig. 137), otherwise they are apt to get out of hand.

The advantage of so simple a method of making the capitals lies not only in their easy performance thus, but

FROM CHIROGRAPHIA BY R. GETHING, 1619, SHOWING THE ILL EFFECT OF FLOURISHED CAPITALS, TANGLING, AND OVER-SLOPE.

Fig. 135.

in the encouragement at once provided towards 'arrange-
ment' (of which more fully later). As above remarked,
our copy-book capitals do not admit of separate use, and

Hallowed be Thy Name

Thy Kingdom come

Thy Will be done

in Earth as it is in Heaven

Fig. 137.

consequently no provision is supplied for the composition
of a page, with title and initial letter ; and the very
beginnings of endeavour towards agreeable arrangement
are checked, the learner being left to one restricted course
of proceeding.

The capitals here given, however, lend themselves (as
of old) to enlargement and decorative uses, and at once
open the field for ' composition ' and ' design.'

FLAT PEN, MINUSCULE AND MAJUSCULE

HE great exemplars of this hand are the Book of Kells and the Lindisfarne Gospels—our insular adaptations of the half uncial hand, or, as some think, our contemporary but independent development of a similar hand from a common prototype. But some of the later hands of the Winchester School also adopt this pen attitude. That of the Benedictional (page 43), is almost flat. And it happens after the Middle Ages in many of the beautiful Italian ' humanistic ' MSS. In the British Museum (manuscript saloon) lie together in one case (D), a Virgil, No. 132, Add. MS. 14815, and a Lucretius, No. 133, Add. MS. 11912 of the fifteenth century, which admirably illustrate the different effect of the flat and canted poses.

For the flat hand it is necessary to cut the edge of the pen (as before mentioned) obliquely, as shown in Fig. 138, seen looking down on the pen in position to write. The degree of obliquity depends (see Fig. 23, p. 56) on the writer's aptitude. If over done the result will be a serrated definition to the right-hand side of most stems owing to capillary attraction acting on the ink between the pen and paper. With the pen cut obliquely and its edge kept in the horizontal, the following (Fig. 139) may be the expression of modernly serviceable letters.

Fig 138.

But it will now be observed that for the letters v w x y the pen must be turned from this position or the expression of contrast will be lost. And this fact points a

defect in craftsmanship for the use of the method with English, small perhaps, but in practice annoying. With Latin it would be only noticeable with the x, as the other forms do not occur. For these the pen must be canted,

flat-pen minuscules

Fig. 139.

and immediately a discrepancy in the writing occurs, since the beginnings (the serifs) of these letters then slightly vary from others, as shown above.

The corner-piece for the ascenders of b d h k l is made and fitted in (Fig. 140), and a similar corner-piece may now be given to the beginnings of the letters i j m n p u w y, or they are apt to appear insignificantly begun, as Fig. 141.

Fig. 140.

Fig. 141.

The somewhat similar foot to the stems of f h k m n p q r y, may be made with a separate touch added

(Fig. 142), or, with practice, it may be made continu-
ously by drawing the pen to the right (after making the
stem stroke) a short way and then
upwards to the left (Fig. 143).
Similarly, I have observed that
some scribes have made the corner-
pieces to ascenders continuously (Fig.
144), and in some cases this has developed into a knob-
like head (Fig. 145). It seems to me ever preferable to
avoid this club-like tendency and to aim at giving the

Fig. 142.

Fig. 143.

Fig. 144.

Fig. 145.

Fig. 146.

appearance rather of a bird's bill (Fig. 146), with a
concavity rather than a convexity to the left.

The length of ascenders and descenders seems again
a matter of taste. In the examples quoted they are
shortish. The matter depends on whether the work is of
the massed or open character, whether prose or poetry.
And the strength of the downstroke will also be appor-
tioned accordingly. Lindisfarne is thicker than Kells ;
and, a notable consequence, the hand tends to a greater
breadth than the latter's.

In general, the order of making the details of the
letters may be the same as for the canted hands, and the
letters strung into words similarly. But the student
will observe a small difficulty with the upturn of the
letters a d i l t u, for this now becomes as shown in
Fig. 147. His following stroke
needs to cover the breadth of this
exactly, as Fig. 148. The ter-
mination of a word should be left
with this breadth showing, and no endeavour made to

Fig. 147.

Fig. 148.

(W)hile thou art in the world, and hast an honest employment, thou art certainly by the order of Providence obliged to labour in it, and to finish the work given thee, according to thy best ability, without repining in the least.

Fig. 149.

A MODERN FLAT PEN WRITING BY MISS I. D. HENSTOCK, ILLUSTRATING THE FOREGOING REMARKS.

graduate it somehow to a hairline. In the books quoted it is indeed sometimes accentuated, as in a sort of defiance (Fig. 150).

With the capitals, or majuscules, the pen has considerably more difficulty than with those of canted-pen hands, and needs often to be turned to the canted position or even to a right angle with the flat pose.

Fig. 150.

/AA ʻBBCCʼDDʻEE ʻFF

orʟEFGʻG ʻFIH ʻIIʼJJ ʻKK

LLʼMM NʼNOOʼPP P

QQʼRR SSTTʼUUVV

VWXXʼYY ZZ

Fig. 151.

FLAT PEN MAJUSCULES.

For A it must be canted for the fine stroke and back again for the serif at its base, and so also with the letters V W X Y, while with the letters M and N the canting needs to be still greater, to render them conventionally fine. With the letters E F and T it needs to deal with the extremities of the lines in an unusual manner also. The whole alphabet may be rendered as shown above. But in practice, especially with small letters, the method

tends to be slurred, as indeed is to be observed in the many Renaissance MSS. which adopt it.

These difficulties hardly appeared before the Renaissance, for of old with the hand bearing such a half-uncial character the uncials naturally served for capitals ; and with such rounded forms no struggle was necessary for the M's, N's, E's, etc.

The hand as well practised is certainly a very fine and majestic one, and has been imitated foundationally in most of the printed forms of to-day, which have the greatest thickness perpendicularly and show the O, for instance, with the maximum due E and W. But it is necessarily slower in execution than the canted hands, and though educationally alone very valuable to students is, I have found, usually discarded with their progress in favour of the comparatively rapid and easier canted hands. In practice the distinction needs careful observance ; indeed I have not known of both hands being successfully performed by the same scribe. If he practises the canted hand, inevitably his rendering of the flat becomes affected, and a sort of clumsy half-and-half hand appears, with all the self-conscious detail of the flat retained superfluously, and the lively character of the free canted hand obscured. So that the choice of one or the other should be made deliberately and adhered to, if a masterly set method is desired for use, and not experiment.

The punctuation marks accompanying the flat hand are best made with the canted pen, however inconsistently. Those shown in Fig. 152 are plainly impossible. But the Arabic figures may consistently be rendered flatly, as in Fig. 153.

Fig. 152.

1234567890 & £

Fig. 153.

The illustration on the opposite page shows a flat pen hand of the Renaissance, ' La felicita del mondo,' B.M., Add. MS. 14817, of the late fifteenth century, with beautiful little capitals in gold, green, blue and red.

CAP. DECIMOSEPTIMO: OVI SI VEDE
DELA SPERANZA DEL SIGNORE: ET
QVANTO: E VTILE SPERAR PER AV
CTORITA ID.

Pcme e un difio certo dafperare
La gloria futura. quale pafce
Per gratia del precedonte mortare:
E fenza fpme merto non po nafce
Ma bcftial prefumption chacora
Lhomo. che di mal operar fi fafce
Gia chi non ara il fundo: e nõ lauora
Sperar non debbe: di cogliere frueto
Sen fua zucha grano di fal dimora

Fig. 154.

'LA FELICITA DEL MONDO.'
Italian Renaissance flat pen hand, late fifteenth century. Brit. Mus., Add. MS. 14817.

BEFORE considering the general matter of arrangement, it is convenient here to mention the numerals ; what are called the Arabic numerals. The Arabs received these from India in the eighth century, and introduced them into Spain, whence they spread over Europe in the twelfth and thirteenth centuries. They were confined at first to mathematical works, and were later employed in the paging of books. By the fifteenth century their use became general, and their shapes very much as they are now. But their placing with regard to the line was rather different (Fig. 155), instead of their being all set on the line and made of one height. They

1234567890

Fig. 155.

have been regarded chiefly as accompaniments to minuscule alphabets, and combine awkwardly with capitals, especially if made of the same height and aligned with them. Fig. 156 is inferior to Fig. 157 ; as

THE YEAR 1943

Fig. 156.

was the former practice, preferable also because more scholarly. Indeed,

THE YEAR 1943

Fig. 157.

the modern way may be compared with the outrage of printing the minuscules *boy* and *girl* as shown in Fig. 158. If regarded

as minuscule forms, 3 4 5 7 and 9 have descenders like *p*
and *q* in the alphabet they accompany ; 6 and 8 ascenders
like *b* and *d*, while 1 2 and o
remain the height of the *i* and *o*. bOY girl
The suggestion may be offer-
ed that if any departure be made Fig. 158.
from this traditional practice it
might be such as appears in Fig. 159, whereby the 2
and 4 are raised to align

1234567890 with the 6 and 8, and
the even numbers thus

Fig. 159. given ascenders, while
the odd numbers are
given descenders, and the 1 and o take the height of *i*
and *o* of the alphabet they accompany and so resemble.
Sufficient respect is thus paid to tradition ; and the figures,
harmonising as well with the minuscules, become perhaps
a little more consistent in action.

The objection lies that, made thus, or strictly tradition-
ally, with the broad pen by children, they are unsuitable
for use in the mathematical classes, owing to the tangling
of ascenders and descenders in long addition or other
crowded sums. In such case one height may be considered
advisable (Fig. 160), yet the child
induced to use them traditionally 1234567890
in any literary connection. Fig. 160.

With the canted pen they can
be made as directly as the minuscules, that is, without
twisting the pen's edge from its angle of 30° for any
part of any figure. And with cursive they can also
share the slant.

For inscriptional work no means of writing these figures
has yet been devised to match the dignity of the Roman
letters used as numerals. And if Fig. 161 may seem
portentous it is handsomer than either Fig. 162 or Fig.
163. Yet the convenience of the Arabics is almost

overwhelmingly in their favour for every use but the most solemn, and strict adherence to the Romans may easily appear pedantic or affected. Besides which their

A: MDCCCCXXXVIII D:

Fig. 161.

correct method is none too clearly established. We are now accustomed to MCM for this century, but without

A: 1938 D: A: 1938 D:

Fig 162. Fig. 163.

certain authority. The precedents of the tenth and fifteenth centuries are against us ; and though the rejection of MCD for the fifteenth may be explained by its similarity to MM, the tenth might have provided CM. But this, I believe, is never found in place of DCCCC. We also never see IL for XLIX nor IC for XCIX, while IM for 999 is unthinkable, or even XM for 990. Indeed this last might be read as 10,000, owing to the use of prefixed letters to express multiplication in certain cases instead of subtraction. Thus VIM = 6000, IIM = 2000, though 5000 is I⊃⊃ as well as VM and 10,000 also X̄ or CCI⊃⊃.

Despite these drawbacks the Roman method has the advantage of the appearance of perfect homogeneity, with capitals especially, while it is never possible to use the Arabics without at once recalling their entirely different origin, and that we are not only writing two languages, but languages whose penmanship runs in opposite directions ; and every printer finds a difficulty in hiding their inconsistency with his Roman founts. It may well be that, since five at least of the Arabics, 2 3 4 5 and 7 seem to

face to the left, while only 6 and 9 face to the right, 1 8
and 0 facing indifferently, while of the minuscules ten,
c d e f g k l q s and t face to the right and only seven,
a b h j p r z, to the left, the remainder perhaps facing
indifferently, this fact partly accounts for an opposition
they seem to import.

In no instance is their decorative inferiority so marked
as in Kalendars. Considering the profusion of these
every Christmas, and the little that seems made of them,
it is not unfair to accuse the Arabics as at least accomplices.
One has but to look at the Kalendar in any mediaeval
Psalter or Book of Hours to note the difference. No
doubt the Roman method of reckoning, with its divisions
of the month, helps them, as does the simple column of
letters A–G (for the fixing of the Sunday Letter and so
the days of the week) instead of our uneven contractions
for our day-names; but it is chiefly the Roman numerals,
and specially the X's, which give their column the par-
ticular grace, headed by the beautiful KL for Kalends.
Perhaps we can no longer tolerate the business of a
Sunday letter each year in determining the days of the
week, despite the advantage of having a permanent
Kalendar, whose very continuity would justify some serious
work spent upon it; and our interest in golden numbers
and epacts is certainly evaporated. But the Arabics still
challenge us to make something better than we see.

The common habit of writing A.D. 1930 as 1930
needs noting. The figures unaccompanied are too col-
loquial for inscriptions, or even title-pages, etc. 'The
year of grace' or 'the Year of our Lord,' or 'A.D.' or
'A.S.' seems necessary, if for no more than civil acknow-
ledgment that our era is not as yet world-wide.

In writing the ordinals by aid of the Arabics it would
seem unnecessary to give them the mark of contraction,
as 4th., 5th., etc. These are not contractions, but substi-
tutes for the written words fourth and fifth. And though

1st, 2nd, and also 3rd are discrepant, they may well be treated also as substitutes like the others. 2nd. Lieut. seems almost as mistaken a use of the contraction mark as the *Alice. M. Jones* one constantly meets in signatures. In inscriptions the dot is often used to separate words, certainly, but chiefly where space is being economised. It is more reasonably used to part Roman letters used as figures from the wording of inscriptions, being set each side of them. The use of the colon for contraction seems preferable, since it is not called upon for such uses; thus, Mr: and Mrs: And as regards contraction in general we have now in English few recognised ones and no system. We have $c^{d.}$ and $w^{d.}$ and & and Co. and Ltd., and a few others; and the lawyer's exs., ads., and $ass^{s.}$, etc., prevail professionally. Our terminations -ing, -ion, -ed, -ous, -ity, and others, sometimes suggest the need for a swifter method. Yet when one has experienced the contractions in some mediaeval manuscripts one may well be content to leave the matter as it is.

The punctuation marks may be made as they are shown in Fig. 164, and if the writing be sloped they should conform. The interrogation and interjection marks need not rise to the full height of the ascenders, especially where these are elevated in 'open' work. Brackets and 'caret' mark may be like those in Fig. 165.

Fig. 164.

Fig. 165.

Most people nowadays disdain punctuation, authors leaving it to the compositors to supply, typists too often considering that a fairly frequent comma serves sufficiently, while for private written correspondence the dash (—) does for all occasions. If the rules as to punctuation were better agreed, better observance would no doubt follow. In inscriptions, or in set arrangements like title-pages,

punctuation may be dispensed with. The matter should, for such purposes, be so clearly and tersely set forth, so devoid of parenthesis, that it should punctuate itself. And the precedent of the legal document may be cited even for work more diffuse than ' inscriptions.' We rely too much on the running explanation of our commas in particular, and clarify our involved prose at the expense of our page's good looks. For punctuation does not beautify. In particular, our inverted commas hinder. The French — seems preferable, where the words ' he said ' or ' said he ' are absent. Where they or their alternatives are present, the persistence of superfluous disfigurements seems unaccountable. Their absence in our Bibles may be cited very appropriately.

THE DOUBLE STROKE

ITHERTO I have considered the writing of letters by what I may call single-breadth action, whereby the stems of the letters are rendered with one stroke of the pen. And this method has always (and naturally) been employed for writing the body (or text) of books, save in a few luxurious cases. I now come to deal with the methods of adding size, importance, and decorativeness to the letters used for the emphasis of initials of various degree, title-headings and such like; which only apply to the capitals or majuscules. And consistently with the consideration of all writing by reference to the care and detail in its execution these methods import no difference of standard of form. But as a box may be made by nailing bits of squared wood together or by nicely fitted joinery, so may the same forms be rendered less or more elaborately.

Our copy-books have obscured this point of view by giving us for capitals another sort of form, derived from the curled figures so tempting to the copper engraver; and their use is now recognised by most of us as plainly impossible, as may be seen by the illustrations on pp. 93, 94. The convention by which we tolerate our visiting-cards is become independent of æsthetic consideration.

Of old, while the majuscules were certainly sometimes represented by mere enlargement or elongation with the usual pen, a flourish being added to some limb or projection, they were far more usually made by strengthening their appearance with an added stroke or by duplicating

the stem stroke. And systems of the method were current, as with the eleventh and twelfth centuries' scriptures and later with the Renaissance ' humanistic ' works. This development of the so-called ' building up ' or strengthening of letters by combination of stroke for special service was as natural as the reason for such special service. To show that a writing starts at a certain place, it is natural to accentuate the start by some means. The Roman Edicts inscribed on bronze have enlarged initial letters. And later the same convention applied to the new paragraph in a book as well as to its commencement and subsequent chapters. The purpose, primarily utilitarian for the assistance of the reader, became decorative ; as so frequently happened of old, when service and beauty joined forces, or were identical. The initial became not only larger but more ornamental.

At first little more is given than the careful expression of the detail. But soon the single stroke of ordinary writing is reckoned insufficient. Two are combined. And, with the added care, the economy of the constant pose for the pen passes, and it is turned about as required for convenience of ' finish.'

This combination of stroke with the same sized pen seems ever to have been preferred to the use, for emphasis, of a larger pen ; which is only employed in the MSS. where text and commentary later suggested this natural means of such differentiation in the body of the work. As if, ordinarily, the work grew ' more of a piece ' when one pen served for all, though the colour of the letters might vary.

Thus Fig. 166 becomes first Fig. 167 then Fig. 168, but not Fig. 169.

Omnipotens Deus

Fig. 166.

Such building up, however, is only justified when itself suggested by the extra size needed. For added detail

without enlargement is as inconsistent as enlargement without added detail, though the latter is perhaps preferable as implying just the swiftness which needed the size

Omnipotens Deus

Fig. 167.

Omnipotens Deus

Fig. 168.

Omĩpotens Deus

Fig. 169.

Omnipotens Deus

Fig. 170.

but could not spare the care for detail. Fig. 170 is rarely to be observed. Consequently a minimum size for such

Fig. 171.

detailed letters could be set at from three to five times the height of the minuscule *o* employed, where the single-breadth capital is about twice the height of this (Fig. 171). And, without making a fast rule, a writing in which such a relation is observed will have an agreeably tranquil and consistent appearance ; any exceptionally important letters being allowed

a yet larger size, though not necessarily a stouter make. The method may be regarded from either point of view. Size needed has called for duplication of stroke to support it—or duplication of stroke has naturally produced larger size. The whole writing thus presents the appearance of having been performed economically and in a workmanlike manner, with but one pen (whatever the colour employed), and so affects the reader with the sense of ease and competence. And this obvious rationale of the method, if kept in mind, will satisfactorily direct the use of these double-stroke letters in general for their appropriate occasions.

This word 'built-up' has been commonly used to describe the technique—and perhaps unfortunately. For since all formal text hands are 'built-up' of detailed pieces fitted together, it might be held to cover their construction also, and merely to differentiate them from the cursive forms made with a more continuous or unbroken stroke. Again we are at a loss for words, but I propose to use rather the word 'compound' for these letters, or even 'spliced.' Spliced certainly implies their being split rather than composed of two strokes, but it does imply the two strokes of which their stems are constructed, and recalls the technique advantageously. Compound, on the whole, is however preferable, as contrasted with the simple or single stroke, by which the stems of the letters have been formed in the alphabets hitherto dealt with.

The method is as old as any feature of manuscript, and has been applied to all the alphabets (except Rustics), square capitals, uncials, and even half-uncials—as in the Book of Kells and Lindisfarne Gospels. And we find two sorts established by the tenth century : those in which the serif is combined with the stem stroke, and those in which it is independently applied (Fig. 172).

These two sorts were at first not clearly differentiated,

for while the pen was imitating the finished manner of stone inscription, the curve of the serif into the stem is copied (as in the ninth century), and only gradually does it find the freer method of simply crossing the tops and bottoms of stems with a hairline only. At first, also, it imitates the square-cut capitals, while later it applies its acquirement to the uncial forms also, and through the 'Gothic' period confines itself almost entirely to these for initials.

Fig. 172.

So that we have two such alphabets, Roman and Gothic, both means applying to the former, and but one to the latter. And if, as is convenient, we classify them by this means of making, we may keep the term 'Roman' for the square-cut letters made with the chisel-inscriptional manner, and use the term 'Versal' (which Colonel E. F. Strange, in his book of Alphabets, seems first to have adopted) for those letters, both square-cut and uncial, which are made in the more facile pen manner. And although the former preceded (in the ninth) and succeeded the latter (in the fifteenth century) it will serve best to deal first with the latter, as they are the easier to make, and moreover disregard the very strict proportions of breadth which the pure Romans demand.

In this free imitation of the square-cut (and other) forms the pen provides a marked expression of its own. It at once asserts its tendency towards strong contrast, as of serif compared with stem, and puts into the letters and fixes it there, this lively element of beauty. The intention primarily was, no doubt, to give finish, perhaps, no more than tidiness, to the ends of the compound stem ;[1]

[1] In the magnificent Winchester Bible the stem strokes may often be observed insufficiently "tidied" thus, projecting here and there above or below.

with the result that a great deal more than tidiness is given, the sort of beauty essentially characteristic of penmanship. The development occurs during the tenth, eleventh, and twelfth centuries ; and the letters in perfection may be seen in the books of the Winchester School, or indeed any fine MS. of the twelfth century. (See p. 42, where the use of such letters in the eleventh century is shown.) After which the uncial form of them continues through the 'Gothic' period to the exclusion of the Roman forms, and with a tendency to greater strength of contrast by prolonging serifs and increasing the breadth of stem-strokes (Fig. 173

Fig. 173.

Fig. 174.

rather than Fig. 174).

Moreover, both breadth and height are variable. No set proportions are constant, as with older representations, but convenience of application in the MS. is considered chiefly, the breadth of letters in the thirteenth-century Bibles being compressed to what would be distortion if it were not so successfully decorative there ; and the heights adopting the uncial inequality, as Fig. 175, with great gaiety and liveliness.

Fig. 175.

Owing, therefore, to the facile penmanship of these Versal or Gothic letters and their freedom from the restraints of the stricter forms of the Roman letters,[1] they are the more convenient for initial practice in the 'compound' manner. They introduce also another delightful

[1] All our letters are derivatively Roman letters, but one lapses into the use of the term for the square-cut inscriptional forms—perhaps too inconsistently —but conveniently.

feature of penmanship, natural technically, and natural also by analogy with other growths. For if a letter be drawn by means of two strokes for the stem, those strokes will freehandedly tend to be drawn like those in Fig. 176 rather than stiffly as in Fig. 177, and at once suggest the spreading growth of happy flower and tree-form. And at the time of their development I like to think that this tendency was welcomed by craftsmen drawing inspiration

Fig. 176.

Fig. 177.

and suggestion from Nature. The suggestion is often exaggerated, and we find the upper serifs lengthened as shown in Fig. 178, without the least sense of loss of stability, any more than a sapling is unstable.

The architecturally more stable form (Fig. 179) with its lighthouse-like taper, which might equally well have been expected, never occurs.

Fig. 178.

Fig. 179.

A steady manner of making them is, of course, desirable, but this should not be allowed to rob them of the freedom or gaiety which is of their essence. They are ever the better left roughly drawn than smoothed and tidied up into feebleness. But they should always be regarded as drawn with two strokes placed side by side as I have mentioned, and never as drawn in outline and flooded in with a brush. This is an important difference. Disregard of it leads not only to the frequent feebleness observable, but also to inequality in the stem strokes. It is plain that if the systematic placing of two strokes side by side, touching at the waist and a little apart top and bottom be adopted, not only is natural liveliness imparted, but the stems through a line or paragraph of such letters will automatically be fairly even, and this without self-conscious effort of the writer to make them so. He can be attending to other matters over the drawing

—a very great gain. With the outline method his attention is chiefly concentrated on getting his stems equal in breadth.

The detailed drawing of these letters in the Gothic manner follows in the next chapter.

AA BB CC DD
EE FF GG HH
II JJ KK LL MM
NN OO PP RR
QQ SS TT UU
V W W X X Y
Y Z Z II V E)(

Fig. 180.

COMPOUND CAPITALS (Gothic Manner, Roman Form).

COMPOUND CAPITALS (GOTHIC MANNER)

HE alphabet is here drawn, observing the several features mentioned in the last chapter. And, as with any alphabet is supremely desirable, an extreme simplicity and economy of detail will be noticed (Fig. 180). A consistent and restricted manner is used, and but few different details, and the pen is ever, generally speaking, in either one of the two positions shown in Fig. 181.

Fig. 181.

The double stroke is used for all occasions on which, with the single-breadth capitals (pp. 86, 89), the single full thickness occurs, as with *l* (Fig. 182), and where in that alphabet the stroke was a thin one (as with lateral strokes) now the single full-breadth is used (Fig. 183), the actual hair-line breadth being now employed for the serifs only, as shown above.

Fig. 182.

Fig. 183.

The stems may conveniently be rendered three pens'

Fig. 184.

Compound Capitals (Gothic Manner, Uncial Form).

breadth at the top, closing to two at the waist and opening to about two and a half at the foot, and the serifs are the stroke of the pen's edge used horizontally or vertically as shown (Fig. 185). After drawing the constructional strokes the open spaces between are flooded in, but this flooding in has been omitted in the alphabet opposite the first page of this chapter that the construction might be seen more easily.

Fig. 185.

The maximum widths of all lobes may be three pens' breadth, consistently with the stems, and the interior line of these should always be drawn first, on account of our eyes' greater sensitiveness to the continuity of curvature there (Fig. 186 ; never as in Fig. 187).

Fig. 186.

Fig. 187.

It will be noted also that to accentuate contrast where a single-breadth stroke meets a serif, that the former is increased with an added stroke, on the right at a base, on the left at a head, as in the case of N (Fig. 188) that is in the same positions as the corner-piece occurs in the former single-stroke letters, as Fig. 189.

Fig. 188.

Fig. 189.

The details required then for all the letters are those only shown in the right-hand bottom corner of the alphabet at the beginning of this chapter.

A nice enhancement of the adornment of the serifs may be given to the letters A H K M U V W and Y by making them like segments of a huge circle (exaggeratedly for demonstration) (Fig. 190). Similarly C E F. The reason is plain. They are smoother than Fig. 191.

Fig. 190.

Fig. 191.

The whole of the alphabets, both Roman and Gothic, may be performed in this ' Versal ' manner. They were employed in the books for initials and the commencement of chapters and verses of the Bible, and of paragraphs in other works. And since their intention was to mark or decorate they were almost invariably written in gold or

Blessed
BE THE LORD
GOD OF ISRAEL:
for he hath visited, and
redeemed his people;
And hath raised up a
mighty salvation for us

Fig. 192.

Arrangement of heading with large initial letter followed by a line of coloured letters, these again being followed by two lines of single breadth majuscules.

colour, and not in black, which would have tended to negative their freedom and gaiety of form and ornamental character.

With their evolution becomes evolved for us also that convention of the general arrangement of books which has lasted to our days, still visible in the formula in our

prayer books, which our printers have reduced to a minimum.

This convention is established in the time of the ninth century Caroline revival, thus : a large initial, followed by a line, or some lines, of these coloured letters, followed again by a line or two of single-breadth majuscules in

B LESSED BE THE LORD
God of Israel: for he hath
visited and redeemed his people;
And hath raised up a mighty

Fig. 193.

A modification of the arrangement shown in Fig. 192.

B lessed be the Lord God of Israel:
for he hath visited & redeem=
ed his people;
And hath raised up a mighty

Fig. 194.

A further modification of the above.

black, and afterwards by the black minuscules, a descent, as it were, by steps into the body of the work (Fig. 192).

The convention implies a certain length or importance in the MS. To step down thus in the grand manner to a single or half-page of subsequent text would be rather portentous or magniloquent. For a single page a modification may be conveniently made by reducing the number

of steps ; say from initial to black single-breadth capitals, then minuscules (Fig. 193) ; or even straight from coloured (or gilt) Versal to black minuscules (Fig. 194).

It is curious to note that a descent from a large capital through a large-sized minuscule to the minuscules of the text was never practised, but always this method of descent through capitals. And so invariable is the practice that even where, as sometimes occurred, the intermediate letters were equal in size to the text minuscules they were still capital forms. So that modern experiments with different sizes of minuscules are unpleasant because so strange, *i.e.* so unconventional—always excepting the cases of text and commentary, where the use of two or more sizes shows that the ancients were well enough aware of the effects obtainable thereby.

And here, anticipating remarks on arrangement in general, the placing of the paragraph initial may well be considered.

The oldest position seems to have been wholly outside the text (Fig. 195), an arrangement which is, to our eyes, a little confusing, since we do not at once grasp to which line the initial belongs. It has the advantage, however, of leaving the block of text intact.

If we insert the initial wholly in the text this advantage is lost, and we have a body of text rather disagreeably bitten into thus, and unequally (Fig. 196). So that a compromise seems advisable, that of placing

Fig. 195.

Initial letters outside body of text.

them half in and half out, thus defining their application and at the same time not too greatly disturbing the text (Fig. 197).

And where many such letters occur, as sometimes in poetry, it is further necessary to regulate their application by centring them to a perpendicular line, as shown in

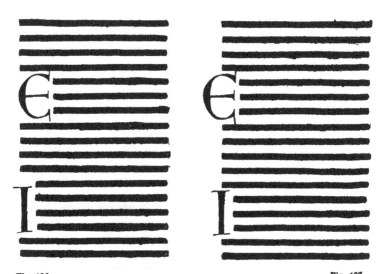

Fig. 196.

Initials completely within the body of the text.

Fig. 197.

The most satisfactory compromise ; the initials half in and half outside the text.

Fig. 198 or Fig. 199, although the second of the alternatives would throw some strain of arrangement on the writing of the text, which takes place first. In the fifteenth century the decoration of poetry thus often proceeds with a ribbon of coloured initials to the left of the text, which, however, draws such letters too far away from their words and seems oddly disconnective to our eyes (Fig. 200). See also the Psalter's verse initials on p. 49.

The appearance to be avoided is somewhat like that of Fig. 201.

As before remarked they need to be applied with gold or colour, and a goose-quill with rather a longer slit than usual, as more pliable, is preferable to the stiffer turkey.

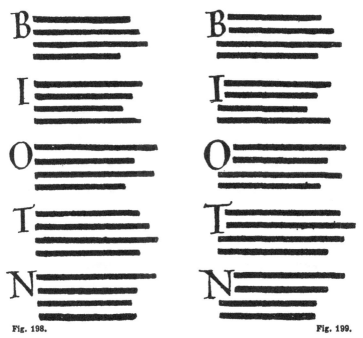

Fig. 198.

Fig. 199.

Initial letters arranged thus should be centred on a perpendicular line.

The writing of the text requires care in arrangement, as it is done before the initials.

The colours need to be pure and good, of which more later, in the chapter on materials; but here I may remark that the heraldic red, blue, and green are all that are necessary (or usual in the MSS.) The Renaissance, indeed, employs crimson and violet, but not so happily as the monastic use. For the verses of Psalms, stanzas of poetry, etc., red and blue can be alternated; red and

green, occasionally blue and green ; or red, blue ; red,
green ; red, blue ; and so on.

I cannot leave this chapter without adding some forms
which their Lombardic development gave these letters.
I feel that with judgment they can be employed again for
appropriate occasion (Fig. 202).

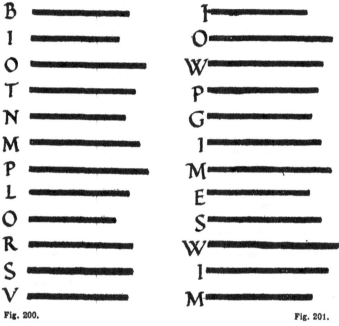

Fig. 200. Fig. 201.

Arrangement of a ribbon of coloured An appearance to be avoided.
letters on the left of the text.

These are taken from a fifteenth-century Bible History
(B.M., Add. MS. 38122) with very true pen construction,
the letters showing much curvature, with exaggeration
of lobes, fatness of stem, ball-ended serifs, and a curiously
delightful (to me) rudder-like form to some lobes most
effective. I think this alphabet is as far as one may safely
go towards 'dressiness' perhaps, of the letters themselves.

All the Gothic forms seem applicable only to book-
work. And, on the other hand, seem to me preferable for
book-work, though the pure Roman Renaissance forms
and method are certainly well applied to a flat-pen hand.
With the canted hands the very freedom and vigour of
these forms seem proper and consistent. There is no
finesse, no excess of care and calculation needed in their

Fig. 202.

LOMBARDIC LETTERS FROM A FIFTEENTH CENTURY BIBLE HISTORY.

use, with the result that the work is ever more likely
to look happy, unself-conscious, neither overdone nor
mechanical. And a scribe might be well advised, if his
aim were to acquire a masterly practice for the use of
book-work, to confine himself entirely to the canted-pen
majuscules and minuscules, with these letters for larger
capitals. His gain in facility and smooth-running and a
certain business-like adequacy would well compensate for
any lack of a pretty variety.
Occasionally it happens that with some special book
a printer wishes the chapter initials to be put in by hand,
as was so often successfully done in the early days of the
press. Free forms are specially suited to such an occasion.

They do not look like a laboured imitation of the rigider printed forms, as the Renaissance capitals (see next chapter) are apt to do when set so closely in comparison with the print they accompany. These freer forms can still impart to a printed book a personal touch and finish, delightful and harmonious.

COMPOUND ROMAN CAPITALS
(RENAISSANCE MANNER)

HE enlargement of letters in the Renaissance manner is more precise and exacting. These letters are our standard capitals, and may conveniently be called Roman capitals, since their pattern is of all the most classic. They are applicable to all kinds of service—the printer's, the signwriter's, the wood- and stone-carver's, the metal-worker's, with what modification may be appropriate to the special tools and materials employing them.

But, as has been said in Chapter III, though their essential forms are inscriptional, their technique has been so affected by the pen that, for whatever purpose and in whatever craft, and of whatever size, the student may be aiming to render them, he will be well advised to begin by thoroughly studying their pen-formation.

It will be convenient to examine the pen's method of making them in this chapter, the proportions of the various letters in the next, and their individual detail in the one after. And if some repetition occurs of what has been said previously in regard to the Gothic method of making them, this is rather for the benefit of such readers as may have considered that in these days the discussion of those freer forms was superfluous.

As with them enlargement necessitates the double stroke for the stems (important occasion having, as before, called for the enlargement). And the two strokes are still slightly curved, whereby a vitality is given the stems rather than the rigidity of mechanics. They still need to

be drawn with the free hand, never by set square. But the breadth at the top may now be 2½ pens' breadth and 2¼ at the base, closing as before to 2 at the waist. The result will hardly show as curvature, only as supple vigour and lack of rigidity. And the method, while giving this grace and vitality, will again serve the ' business ' purpose of keeping the scribe's stems equal throughout his inscription without his special attention to that matter.

But now an important difference from the Gothic manner needs to be observed in making the serifs. These are now no longer made separately, but as part of the stem stroke. The truth and sweetness of the little curve can be preserved by no other manner. It is of no use to draw a hair-line across the top of the stem and then tidy up the angle into a curve. Of the technical differences between Gothic and Roman this is the most important. The Roman stems need to be drawn as shown in Fig. 203, as compared with the Gothic (Fig. 204).

Fig. 203.

Fig. 204.

At the top and bottom of the stem the pen should give a slightly cupped appearance (not to be overdone). The actual length of the serifs may be a matter of taste, perhaps, provided the method be loyally observed ; but an inscription or title of many words will be safer with moderated serifs, though an initial letter may indulge in something like exaggeration without fault. The student should try a short sentence with such restraint and then exuberance in respect of this apparently insignificant feature. He will be surprised at the great changes in character from severity to frivolity he can impart.

The lobes may be made consistently by passing from the thinness of the serif to the greatest breadth of the stem stroke (Fig. 205), drawing the inside stroke continuously first and flattening it rather during the descent,

relying on the additional stroke to come afterwards out-
side to give the needed roundness. This added stroke
should not begin too early. The pen itself will better
supply the beginnings and endings of the
gradations. Lobes made thus throughout the
alphabet will agreeably match the stems.
No disfigurement is worse than, say, a D
whose lobe is twice the thickness of its stem,
or the reverse.

Fig. 205.

Besides these details of the stem, the serif,
and the lobe there is the stroke which in the single-
breadth letter is a hair-line. In this alphabet it is again
represented by the full
breadth of the pen in what-
ever direction occurring, as
Fig. 206. To such strokes
the serifs may be added

Fig. 206.

continuously, *i.e.* without
leaving the paper (Fig. 207).
And throughout the drawing of the letters by the aid of
these details the pen
may be kept in the
positions as before
(see Fig. 181).

There is a matter
needs mention here

Fig. 207.

of the cases where
these letters (or brush or chisel letters) are rendered
of large size—the comparative breadth of diagonals. In
making letters for books this may not be of much con-
sequence. But in large alphabets it is considerable,
though perhaps of the nature of finesse.

If the flat pen is used it is plain that its doubled stroke
drawn perpendicularly is thicker than the N.W. to S.E.
diagonal (Fig. 208), or, if a canted pen is used, the reverse
is the case (Fig. 209).

And a somewhat similar consideration arises with regard to the comparative thickness of the thinnest part of the curves of O C G, etc., with large-sized letters. Made

Fig. 208. Fig. 209.

with a clean-cut pen this line passes from the fineness of the serif stroke to the full width of the pen at which point it is, in these compound capitals, supplemented with the added stroke to form the lobe. But however broad the pen be cut (actually or theoretically), it will still commence the curve with a hair-line; and the contrast may appear extravagant between 1 and 2 (Fig. 210). If, however, a broad pen be taken and a circular stroke be drawn with it a strange modification of the hair-line will be observed at the apex (Fig. 211), and a form shown, giving a flatness the breadth of the pen above and an obtuse angle below by the cutting of the interior curves. The trimming

Fig. 210.

Fig. 211.

of this flat and angle (by the pen, directly, or the brush or chisel imitatively) is at once suggested to make the line flow continuously. And if this be done the letter will be slightly thickened thereby at this part. So that there is theoretic as well as practical reason for abandoning the hair-line at these points in the curves of large letters. Whether the increase should be equal to

the thickness, say, of the horizontals of the alphabet may be doubtful; but at least it should be rendered uniformly through all the curves of its letters. In the case of ordinary book-work the matter is insignificant, owing to their small size.

With these details of construction the whole of the alphabet may be drawn uniformly. And again, in the case of books, they are best done in gold or colour. Though if they be made with great delicacy they are not inadmissible in black, as the forms themselves are soberly refined rather than lively and gay.

But a question may arise as to whether they should be made as with a canted or flat pen. With flat-pen writing they will, of course, be given the appearance of flat penmanship. But to go with canted writing a canted-pen appearance may be called for. I have never found this necessary. The elaboration of construction both of these forms and the previous Gothic has always seemed to me to free compound letters from a necessary uniformity of pen pose. And certain technical difficulties arise in the attempt to render them cantedly that seem to counter-balance any gain of a scrupulous consistency.

For with the stem strokes drawn cantedly a hindrance occurs to the fine formation of the serifs top and bottom, as at *a* in Fig. 212, the heads and feet of letters now

a *b* *c*
Fig. 212. Fig. 213.

becoming magnified as at *b*, instead of, as desired, *c*. While with the lobes it is difficult to cant *all* of them ; and if O and Q are canted (as is commonly done) a serious internal inconsistency arises in the alphabet itself. If

the attempt be made to cant all the curves, B P D tend
to become the forms shown in Fig. 2 1 3, losing the weight
one seems to want towards the S.E.

But no doubt the alphabet may be drawn thus, and a
slight advantage of superior elegance and consistency
attained. I have not found it in practice worth the care
necessary. Yet the curves of the Trajan Inscription are
slightly canted.

N considering proportion the first point is the breadth of the stem stroke in comparison with the height of the letters, both in regard to the particular occasion and general conformity to pleasant standard. It is to be feared that classic elegance is fallen into disfavour, certainly for commercial purpose (and consequently, by force of custom arising from viewing 'the usual,' for other purpose), in that the letters will not 'carry' sufficiently. With regard to this every writer has to make his own decision. A quieter convention is certainly desirable for literary use.

Yet the breadth of classic inscriptional letters may be difficult to determine when represented by flat painting, for we have no examples of the classic use of the latter surviving, unless we take mosaics as sufficiently suggestive. All the classic examples are of incised inscription, or in Renaissance times some few of raised cutting. And though the classic sort were, no doubt, often coloured as well as cut, the proportionate stroke of letters of but two dimensions cannot exactly be determined by such a reference.

The breadth of stroke in such an inscription as that of the Trajan column is, roughly, one-tenth to one-twelfth of the height of the letter. But this breadth, owing to the incision, consists of a light half and a dark half, if lit from the side, both these degrees of light or darkness contrasting with the degree of light on the surface incised. What then shall be the breadth of a flat letter which shall give something of their magnificence ? It is hard to say.

And we might venture to suppose a breadth somewhat less, certainly not more. This, however, would certainly not satisfy an advertiser. One may be content then, perhaps, to put it at one-ninth of the letter's height for general purposes, and possibly more for exceptional use.

Next, as regards the letter's proportion of breadth of form to height. For with Roman capitals, as generally employed, the height is constant (with exceptions to be noted) in all letters but Q and the modern J, and perhaps R, which send a piece of their detail below the line.

This differing proportion of breadth seems to have resulted from convenience of practice rather than any theory. And one may regard the standard of breadth generally as the circle or square, as set by the O or the M. In fact the term ' square capitals ' has been applied to the classic models in comparison with the narrowed Rustics or rounded Uncials. But it is plain that if such a letter as D is drawn within the square, the letter B, which consists as it were of two D's, one above the other, tends to become half the breadth of D, if of the same height, and E F K R P X Y and S on similar grounds, while I J and L (possibly) are independent of the standard altogether. In fact the rationale of convenient technical construction has modified any theoretic form in the hands of the craftsmen of the ages. And following the examples they have set us we find that the alphabet may be thus divided into three or four groups by reference to breadth :

1. In the broadest are to be found the round (or nearly round) letters, those whose breadth is about equal to their height as M, our W, and O Q C D and G.

2. Those whose breadth is about four-fifths of their height, the angular letters, of which H is typical, laterally symmetric, or in a way symmetric by an equal and opposite formation, as A H N T U V Z. It is as if the craftsman, taking O for standard and desiring to fill a similar area with these angular letters of the same height, should

PRINTERS' INITIALS. I
AN ALPHABET OF ROMAN CAPITALS WITH LINE
ORNAMENT, AS USED FOR THE INITIALS TO
THE CHAPTERS OF THIS BOOK: DESIGNED
BY THE AUTHOR AND MISS I. D. HENSTOCK

press the circle from the sides until it became a rectangle (of the same height). Doing this he makes an enclosure some four-fifths of the former breadth and applies his H to this.

3. Another group may be said to consist of those letters like B, mentioned above, vertically doubled. And these form the narrow group with a breadth consequently of about one-half their height. They are B E F R S X and Y, and perhaps K L and P.

But with reference to these last three some prefer to give them the greater breadth of three-fifths of their height, because, perhaps, their limbs need some greater significance to accent them as characteristics. The objection may easily be made that the method lacks consistency, as with H or Z for instance, which might be held to belong to the narrow group of vertical doubles ; but the classification is necessarily a workman's rather than a scientist's, and is convenient technically. And in the case of H and Z their lateral as well as vertical doubling or symmetry seems to justify their extra expanse.

The presence of the vertical doubles introduces into any inscription the appearance of a medial horizontal line ; and this presence requires more attention than is usually given, if tranquillity is to be preserved. One constantly sees inscriptions in which this medial line

AEPBRFGH

Fig. 214.

varies in the height at which it appears, as in Fig. 214. And the consequence is a sort of undulation unpleasantly disturbing. It seems to me preferable to maintain one level, even at the expense of individual letters, which may forgo somewhat of their individuality that the inscription be not so disturbed. Accordingly the centres of standard letters are given (next chapter) at the same height without affecting their legibility.

But at what height shall this centre be placed ? At once one may dismiss such affectations as Figs. 215 or 216. The centre should be what one may call the visible centre, not the geometrical one, recognising that our eyes are deceivers. And again our pen

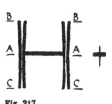

Fig. 215.

Fig. 216.

method is of assistance. For it will be found that if we employ it as recommended it will provide this visible centre. In Fig. 217, if A–A be equidistant from B–B and C–C, and the pen in position + be drawn from A to A with under edge touching that line, the stroke resulting will be at the requisite visible centre. In the case of B P and R the point at which the lobes touch the stem should be at the centre of this line (so also K). The result will be that B's lower lobe will be slightly larger than the upper if both are semicircles : an effect always observed in classic inscriptions.

Fig. 217.

One may pause to inquire why our eyes prefer this centre to the geometric one. Our satisfaction is probably not due to sense of greater stability owing to the lower half's greater mass, for we rather appreciate the strength of vitality as of natural growth. The preference seems due more to a sort of ocular habit of observing men's faces rather than their boots, the ridge of the mountains, the horizon of the sea ; our ocular instinct pleasantly more upwards than downwards. The result is that we read the tops of letters rather than their bases. And most of us have tested this fact by covering first a good bottom half of a line of capitals and then the top half. In the former case we read them easily, in the latter only with difficulty.

It might be supposed that this is due to their having their difference of detail rather in their heads than their feet. But as a matter of fact the reverse is the case. And if the alphabet be examined, and divided into groups according to similar head-detail, we find that these are some eight or nine. For A is unlike any other in this respect, except possibly M and N; B D P and R are similar; C G O Q and S; E and F; H I J L and U; K; T and Z possibly; and V W X Y.

Dividing again into groups according to similarity of foot-detail, we find some twelve. A and X are similar; B and D; C and O; E and L with possibly Z; F H I P T and Y; G and U; K and R; M V and W; while J and N and Q and S are like no others.

So that theoretically we should read a line of letters more easily whose tops were covered. The fact is not so. Which would seem to prove that our habit of looking at the tops has resulted in a practised recognition of sufficient difference there, and a comparative neglect of their lower halves. And this habit may have tended further to reduction of the top half and consequent enlargement of the lower; and this in spite of the appreciation of the spreading of the top half sometimes to satisfy conformity to natural growth noted above. For it will be found to

HUNBM X

Fig. 218. Fig. 219.

beautify an H U or N if they be given the expansion, without exaggeration, however; for Figs. 218 and 219 would be intolerable. So that even in these subtle preferences we are not entirely consistent. But the Trajan V is wider than A, no doubt for the reason suggested, and

one may attempt to rationalise the conventions observed
without discovering a system. The visible centre, how-
ever, is not peculiar to this craft. The bookbinder knows
it well ; one might add, the architect.

The proportions of breadth to height in the Trajan
inscription are as follows (measurement is difficult, but
I hope I am not inaccurate, and I ignore projection of
serif) :

A's base is four-fifths of its height wide.

B's lower lobe is one-half its height wide.

C's width, eleven-thirteenths height.

D's, eleven-thirteenths.

E's, three-eighths and two-fifths.

F's also.

G's, just over four-fifths.

L's, just less than one-half.

M not equal to height at centre, but spread at base
equals height.

N's width just over four-fifths.

O's, eleven-twelfths.

P's, less than one-half.

Q's, twelve-thirteenths.

R's, more than one-half.

S's, less than half.

T's, three-quarters height.

V's, eleven-thirteenths.

X's, rather more than three-fifths.

A B C D E F G

H I J K L M N

O P Q R S T U

V W X Y Z

Fig. 220.

Compound Roman Capitals. Renaissance Manner.

These capitals, decorated with line work, are used for the initials to chapters of this book.

THE cap of A has been made variously (Fig. 221). The last but one is purely a chisel form, the second a pen modification of this, while the first is that the pen makes most easily. This cap occurs in the pen forms of M and N also, while the chisel forms of these are like that of the chisel-formed A in this detail.

Fig. 221.

If one or three be adopted it should be employed similarly for the three letters. Of these alternatives the first seems as suitable for brush-work as for penmanship. The presence of the serif, too, helps to fill up the space to the left, and in some hands is increased to a flag for this purpose, and not disagreeably (Fig. 222). But the form is too gay, perhaps, except for initial or isolated letters.

The lower serifs should conform to the general construction throughout the alphabet. And always a slight prolongation may be made outside the letter, while those inside the letter should be moderated. And care should be taken with them, for the powerful effect of exaggeration may be gauged from observation of the following (Fig. 223), where the first gives a ridiculous suggestion of Charlie Chaplin and the second of Tenniel's Hatter in prison.

Fig. 222.

Fig. 223.

The width of the letter has been given as four-fifths of its height, ignoring the serifs. The cross-bar should be placed, as noted above, when speaking of the medial line, the pen's breadth above the geometrical centre, A being one of the letters called upon to sacrifice something for the general evenness of the inscription. Certainly the height, as I place it, is apt to reduce the triangle of space enclosed, but this will still be sufficient if the two limbs are properly constructed together. These should be drawn as shown in Fig. 224, not as in Figs. 225 or 226 ; that is, the single stroke should be pivoted between

Fig. 224. Fig. 225. Fig. 226. Fig. 227. Fig. 228.

the double strokes at the constructional centre point. The same method should be observed with the similar caps of M and N that they may be well fitted there.

Again, care should be taken not to round the shoulders of A as is often carelessly done, but to give them the slight hollow of the faintly curved composing stroke ; not the form shown in Fig. 227, but that in Fig. 228.

B introduces several considerations applying to other letters as well. The first of these is alignment, as to which printers are perhaps unnecessarily strict. Their lines are rigidly and mechanically accurate. But we may copy them in this that they provide that the curves of such letters as B C D G O P Q R and S should very slightly break the lines above and below. And this, because as the letters carry such little weight there they hardly appear

to reach these lines unless they slightly break them. By
how much they should, therefore, break them to look as
if they truly align can only be determined by practice.
But one may say that the stems of B D P
and R should be exactly the height of the
I of the alphabet, which, of course, in any
alphabet sets the standard of height as O
does for curvature.

In Fig. 229 the distance apart of c and
D is about two-fifths the height of the
letter. The point E is just above the
geometric centre, and the lobes are nearly
semicircular, the outside of the
upper lobe and the inside of the
lower touching D D. The first of
these B's is drawn by the aid of compasses, the
second (Fig. 230) without. If the B be wider,
an unpleasant negative sort of straight
line results at the centre, technically
inconsistent (Fig. 231).

Fig. 229.

Fig. 230.

In all careful Roman alphabets
another general feature is to be noted—that
arms are projected from stems angularly, but
feet curvilinearly.

Fig. 231.

So the upper lobe of B starts from the stem
at an angle, the lower lobe rejoins it with a
curve, while both meet it angularly at the
centre. Similar treatment is given to D E F
H L P R and T. In making a bold B with
the pen the lines may well be drawn as shown in Fig. 232.

Fig. 232.

Fig. 232. Fig. 234.

And the serif at the top, as indeed in all cases, may be slightly longer than that at the base, as in Fig. 233, never as Fig. 234, plainly evidencing the 'feeling' for natural growth above mentioned.

C is one of the round or widest letters, eleven - thirteenths its height. It is not, however, a circle with a bite out, though often represented so (Fig. 235). But classically the two projections are bent, the upper upwards, the lower downwards (Fig. 236). Similarly with the projections of G and S. These limbs need to be carefully made lest they become snouts. The classic form is shown in Fig. 237, not as in Figs.

Fig. 235

Fig. 236.

Fig. 237.

Fig. 238.

Fig. 239.

238 or 239; A A in fact should (if produced) cut the curves (if produced), not be a tangent to them.

D is one of the most beautiful letters of the alphabet, eleven-thirteenths of its height wide. In the Trajan column the two D's in the words AD DECLAR are magnificent. It should appear like C reversed with a stem

added, the parts of the lobe near this being flattened as with C's projections, but still curving slightly, the upper joining the stem at an angle, the lower with a curve.

E in this inscription has all three limbs practically equal, its width being three-eighths or two-fifths of its height. In later times the lowest has been lengthened (Fig. 241), and its serif slanted slightly, as if leading upwards to the next letter in the line, and not disagreeably. A wide E is always vulgar, especially when the top and bottom limbs are made to bite over the middle (Fig. 242).

The 'visible' centre should be accurately preserved ;

E E E

Fig. 240. Fig. 241. Fig. 242.

for E, being such a common letter, is most apt to upset the tranquillity of the line if not attended to (Figs. 240 and 241).

F is like E minus the lowest limb, and is one of the few instances where the inner serif may be prolonged with advantage (of stability) (Fig. 243) where this feature is shown rather exaggerated.

F

Fig. 243.

G resembles C in all but the short stem on the right, and I think this should observe that 'visible' centre. Some lengthen it, some shorten it. The Trajan inscription gives somewhat of an angle at the point A (Fig. 244). It is perhaps more methodical to make a curve instead as at the base of other stems (as of D reversed).

Fig. 244. Fig. 245. Fig. 246.

The upper limb's point should always be perpendicularly over the outside of the stem below. If within, the letter becomes weak; if without, aggressive or forbidding (Figs. 245 and 246).

H's symmetry renders it one of the less pleasant letters. It may be made four-fifths of its height wide or perhaps five-sixths, and given that flower-like expanse of the top already mentioned, the upper and outer serifs rather prolonged, and the central line at the 'visible' centre carefully. This has sometimes been represented, as shown in Fig. 247, as if to modify the stark symmetry of the letter.

Fig. 247.

I There is little to be noted. It sets the standard of height and breadth of stem for the whole alphabet. Its rigidity may be modified by prolonging the top left-hand serif.

J Our modern letter is again one of the unsatisfactory letters. The penman and sign-writer are not, however, precluded from projecting the tail below the line, as the printer fears both for his type's and paper's sake. The tail, however, seems to demand a knob of some sort, and a knob occurs nowhere else in the alphabet. William Morris sometimes used a knob brought up again to the line as if grasping it (Fig. 248). This may serve for an initial, but in a line of letters an R or A immediately preceding renders it awkward.

A more convenient method is that suggested in my plate (p. 141). But it is somewhat insignificant. The printer's

Fig. 248.

form, JO, is both ugly and unstable, needing the next letter to support it. In Latin the I is the inscriptional form, but in English inscriptions this seems affected, since our language has the two letters, and not merely the majuscule and minuscule forms of one.

K needs care at the point where the diagonals meet the stem. The point should be at the ' visible ' centre and the diagonals should touch the stem firmly, but not imbed the angle in it, neither Figs. 249 nor 250. The last may be advisable in chisel-work for the same reason as with the cutting of R's tail (of which more presently), but it confuses the ' visible ' centre.

Fig. 249.

The letter may be half its height wide, with the lower limb perhaps projecting slightly beyond this. The pitfall in drawing lies in commencing the upper limb too far away from the stem.

Fig. 250.

L 's limb in the Trajan inscription is not one-half the length of the stem. It may be thought that this limb, being characteristic, should be allowed a greater display, but against this may be set the frequency with which L is followed by A, when a large gap is formed.

M in classic inscriptions usually has the legs splayed somewhat, no doubt to assist the cutting of the angles, where too fine a junction might tend to accident. With the pen or brush no such reason arises. Yet to preserve the tradition seems unobjectionable, but for the possible disturbance of the perpendicular's parallelism. The splaying also justifies the comparative thinness of the left leg, since its direction passes from E. of N. to W. of S., and drawn with a canted pen would naturally, therefore, be thinner than the other leg ; or the desire for contrast, as with N, may alone sufficiently explain this. The cap should be well fitted and in this alphabet the V always descends to the line. It should be drawn within the square, the lines of the square passing theoretically as shown in the much-splayed illustration (Fig. 251). In a well-drawn letter two curious obtuse angles will be found at A and B (Fig. 251). These should not be smoothed out. The drawing best proceeds with the strokes as in the order marked. This assures the proper stance for the V portion. The letter is one of those which, when drawn to a

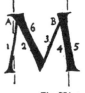

Fig. 251.

large size as in sign-writing, may well show a difference in the thickness of the thick diagonal and the right leg (as proposed on p. 131).

N's width should be just over four-fifths of its height. The diagonal should end with a clean point, not as in Fig. 252, as may be sometimes seen.

A good plan to effect this with the pen is to make the strokes in the numbered order, treating the making of the cap as 1 (Fig. 253) and turning the pen into the position at right angles to its previous pose for 4 and 5. And this proceeding also assures the correct breadth for the letter. If the diagonal be drawn before the right limb the breadth is endangered and the point hard to define.

Fig. 252.

Fig. 253.

O's width in the Trajan is about eleven-twelfths of its height. As with all lobes the inside strokes should be drawn first and slightly straightened as they descend, for the additional strokes outside will do the rounding. A refinement is advisable by placing the maximum width at the 'visible' centre; and with large letters the thinnest part of the curve, top and bottom, should be slightly increased. So also with Q. It should only be canted where the alphabet cants the rest of the lobes.

P is one of the letters which may be called upon to sacrifice somewhat of their individuality for the greater evenness of an inscription, by observing the 'visible' centre, and necessarily reducing the size of the lobe from that often seen **P**. The

P lobe tends to assume a jug-handle shape if not carefully made (Fig. 254). So also B and R. The inscriptional P often leaves the lobe's end free, as shown in (Fig. 255), which doubtless eases chisel-cutting, but seems affected in penmanship, which is not so eased.

Fig. 254.

P

Fig. 255.

Q is formed like O, and in Fig. 220, p. 141, is drawn narrower, to show admissible finessing with proportion, if occasion calls for a slight narrowing of all the forms from the Trajan standard. The form shown in Fig. 256 is late, evidencing playful penmanship, and is hardly advisable except perhaps with italics. The length of the tail may be a matter of taste and occasion. And as the letter is followed by U the direction of the tail needs to allow sufficient space between itself and the curve of the U. It seems better to attach it boldly like a handle

Q

Fig. 256.

Fig. 257.

Fig. 258.

Fig. 259.

(Fig. 257) than to attempt the weaker smoothness of a tangent to the curve (Fig. 258).

And one side of it, preferably the upper, should be straight, for strength, up to the tip (Fig. 259). Its direction should never be less than 45° from the perpendicular, or an absurd tadpole look is given the letter (Fig. 260).

With us it is rare. In Latin it was common ; and therefore, for convenience, the tail was sometimes reversed

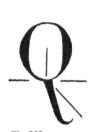

UARE FREMU=
ERUNT GENTES,
et populi meditati
sunt inania? &c.

Fig. 260. Fig. 261.

without any disfigurement. I have seen a Psalter in which all the initial Q's were treated as shown in Fig. 261.

R is shaped like **P** with a tail, either like K's, which seems preferable when the letter occurs in an inscription, or like Q's, rather modified, when it is a final or an initial. It is better to make the junction at the stem like K's also than to add the tail to the right of the lobe (Fig. 262), as is done for ease in chisel-cutting. For the chisel finds the junction of these V sections of differing depth (owing to the differing breadth of stroke) difficult to manipulate neatly. But this applies neither to pen nor brush.

Fig. 262.

The chisel form also often tends to present a piece of straight line at the junction of lobe and tail, undesirably (as with B, noted above). An enlarged lobe with an insignificant or frivolous tail is too often to be seen, violating the ' visible ' centre and introducing a sudden inconsistent gaiety (Fig. 263).

Fig. 263.

S in the Trajan inscription is less than half its height wide, about seven-sixteenths. Yet even drawn half its height wide it may seem too insignificantly narrow for modern use. And it is a difficult letter to draw without serpentine coiling or blowsiness, and without misfitting the gradations from thin to thick. The centre should be just above the geometric centre (as with O) and consequently (as with B) the upper coil smaller than the lower, though without exaggeration. The upper hook should be perpendicularly over the lower curve, the lower one project slightly beyond the upper curve, to give force (as of a swan swimming) to the letter, and to avoid the too downright symmetry.

The serifs may be slightly prolonged provided their direction is fairly perpendicular. Fig. 264 is awkward.

Great care should be given not to increase the breadth at A and B. The safest method of pen-drawing the letter is in the following order (Fig. 265):

Fig. 264.

This safeguards the continuity of the interior of each curve. The diagonal is best kept to about 45°. More curvature brings too great breadth and gaiety (Fig. 266a). The ends should avoid the tendency to become snouts (Fig. 266b).

Fig. 265.

Fig. 266a. Fig. 266b.

T is one of the few letters whose breadth seems slightly variable, without disfigurement, to suit occasion. The Trajan is about four-fifths or three-quarters of its height wide. The chisel and pen forms, for convenience of making, have usually given the cross-bar diagonal ends (Fig. 267),

and this may well be done now. Yet perhaps our printer's convention of perpendiculars here may well guide us in careful drawings, or a slight slope outwards in opposite directions (Fig. 267). A subtle liveliness may also be given this cross-bar (and Z's also) by very slightly curving it upwards towards each end (Fig. 268).

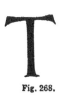

Fig. 268.

For our capital of this letter we have two forms of equal authority (Figs. 269 and 270). I prefer the latter as importing no fresh detail of construction into the alphabet. It has then the same detail as the G or the D reversed. If the former form be adopted care should be taken to give no serif to the heel of the stem. The form shown in Fig. 271 seems undesirable, as lacking

Fig. 269. Fig. 270. Fig. 271.

stability, and also importing a thin vertical unnecessarily into the alphabet.

is best formed by strokes in the order given in Fig. 272, the angles then made with the horizontal will have greater probability of equality. The Trajan's is eleven-thirteenths of its height wide. But four-fifths (as with A) is also suitable.

Fig. 272.

 is perhaps best made of two V's inter-
laced. If they are set side by side
the latter becomes too wide. And if we
narrow the V's a fresh diagonal is intro-
duced into the alphabet disturbingly.
It certainly has a look of affectation thus, like those
interlaced OO we meet unnecessarily. And various
devices have been resorted to, to avoid the interlacement,
such as shortening the interior. This
gives a point inconsistently at the centre,
unless we treat it to a cap (Fig. 273),
but the interlacement is now so common
that it seems the best way out of the
difficulty. Care needs to be taken to
avoid reducing the area at A (Fig. 274)

Fig. 273.

too much, and this is best done by drawing the letter
with strokes as numbered in Fig. 274, bisecting the
distance between 1 and 2 by 3 at the top. This will
provide for the space properly. If this order be not

Fig. 274.

Fig. 275.

observed the result is likely to be that shown in Fig.
275, or worse. The letter should be drawn within a
square, as shown in Fig. 274.

X is commonly drawn too wide. The
Trajan is three-fifths of height wide.
It is best drawn with strokes in
the following order (Fig. 276), 2
cutting 1 at the geometric centre.
Then 3 raises this centre to the visible one.

Fig. 276.

Y's top should conform to X's and can be made in the order of stroke shown in Fig. 277, and care should be given that the obtuse angles at the centre are in the same horizontal. Otherwise the letter looks defective (Fig. 278 or 279).

Fig. 277. Fig. 278. Fig. 279.

Z is so handsome a letter that one could wish it commoner in English, and this in spite of the thickness of the diagonal, which for contrast in the letter itself needs to be thus in spite of inconsistency with all other N.E.-S.W. strokes in the alphabet.

Like S's, the top horn should be vertically over the toe, but the lower horn may be produced slightly beyond the top, the whole letter being made about four-fifths of its height wide. The upper point should be perpendicular, like E's reversed, the lower one may point forward similarly (Fig. 280).

Fig. 280.

To this alphabet may be added two amperzands made consistently. This contraction or symbol is among the few modern use recognises, and is valuable for spacing purposes. It is often used, however, in inscriptions where no necessity calls, appearing also to have been gathered from another 'fount'; the minuscule form occurring

amongst capitals, and an italic form regardlessly, as *&*.
The soberer form in Fig. 281*b* is best confined to use with minuscules, and the form in Fig. 281*a* used with capitals. This certainly imports a foreign tongue into the work, the word *et* very plainly, and the minuscule form hides this better. But the objection is perhaps not too great. Another symbol has been used (Fig. 282), itself also originally a contraction of *et*. But this is too much like our 7 for nowadays.

Fig. 281a.

Fig. 281b.

Fig. 282.

In describing the construction of these letters I have avoided finesse so far as might be, having regard to the various elements which give the individuals shape and refinement. There remains the fact, however, that as no originality of form is admissible, refinement (which is almost finesse) is all that the scribe can bring to their presentation, of proportion or technique, with whatever modification of this latter his particular tool may suggest or demand. For instance, the sign-writer will find his brush leading him almost irresistibly into curly prolongation of serifs (see example on p. 213), an exaggeration easily allowable within bounds. The embroideress will do well to blunt these, the engraver to remember that it is absurd to cut the V sections in metal that the chisel makes so gloriously in stone, but that he must represent his stems with a system of parallel grooves, while the inscriber on brass can fill *his* incisions with coloured wax into the appearance of penmanship exquisitely written thereon as with some metal pen. See examples on pp. 197, 199.

CHAPTER SIXTEEN

ARRANGEMENT (GENERAL)

HESE six alphabets—formal and cursive minuscules, formal and cursive single-stroke or simple majuscules, and Gothic and Roman compound or spliced capitals—are all that are necessary for general practice. And of these no more than three are available for any particular work —the Gothic and Roman capitals not being used in company—though the cursive or italics may be needed also for differentiating parts of the text, as by notes, rubric or commentary. The Gothic capitals are, however, then unsuitable, their dates of origin seeming to separate them too far from italics. And whether the italics are desirable for the scribe in company with upright minuscules may be doubted. For the printer they no doubt serve well, and avoid the expense of two printings, but the scribe can differentiate as easily by using red for the rubrics ; and italics intermixed with his upright work have often the look of shaky distraction. Again, for the printer red for italics, as is sometimes used, is superfluous.

In general the arrangements which make for agreeable legibility are those to which we are accustomed. Novelties in this matter may indeed ' catch the eye,' but puzzle, dismay, and delay. We do not realise how conventional we are in reading. No one talks contrariwise to be heard merely, but to excite remark. Similarly, no one writes our language from right to left or perpendicularly ; though some have latterly taken to curves and slants. There are but few classic examples of curves, though the

Mosaic inscriptions over some Byzantine arches may be mentioned; and of slants none until the chemists took to making them across their windows and the milliners over their shops.

It will be convenient to speak of the spacing and arrangement of the capitals first; and first, again, of that between the letters themselves.

There will be noted three regular spaces amongst them : (1) that occurring between two lobes as OO, DO, OG; (2) that occurring between a lobe and a stem, as OD, HO; (3) That occurring between two stems as HE, IB.

Plainly, throughout an inscription the similar occasions of these should receive similar treatment. And then, also, the spaces between the three classes should be made to look similar in area. And if compactness be considered, as is advisable, two lobes may well be set almost touching (Fig. 283), which leaves the darkened area to be matched by a similar amount between O and D (Fig. 284); and this needs that D be set a little farther off than another O, to produce it. Again, similarly between H and E (Fig. 285). If this be attempted throughout an inscription a great deal will have been assured for evenness, though one can never be quite sure how much the eye recognises of the open areas inside the O's, etc. And with regard to other combinations one can lay down no rule but that similar combinations should be treated similarly throughout, and always with an eye to making them correspond in appearance with the spacing adopted for these three

Fig. 284.

Fig. 283.

Fig. 285.

main ones. Between E and S for instance, between TO, we can only gauge roughly how much the vacancies between the limbs of E and the hollow of S tell, and between the hollow below the limb of T and the O. While there are some combinations, as the notorious case of LA, which cannot be rendered evenly with others. But, where the inscription is close set with such combinations as AT FA LV, where the limb of a following letter begins perpendicularly over or under the preceding, these may be adjusted well by allowing serifs to overlap, but no part of the weight of the limb, as Fig. 286. If in

Fig. 286.

an inscription several narrow letters come together, as BER, the spacing will be apt to look crowded there, and the reverse where several broad letters occur, as GOOD. But this is of the nature of the case, and only eyes appreciative of mechanical regularity will resent it. To others these slight unevennesses will but provide a pleasant elasticity and vitality, or ebb and flow in the inscription.

Between words one breadth should be preserved; but how great this should be depends often on such matters as the length of the inscription, or the size of letters used. Similar precautions, as between the letters mentioned, are necessary between words, that they may 'look' even. Some have laid down that the breadth of an N is needed, others of O, but only common sense can direct the

matter. The space between lines of capitals also depends on their length; and no rule can be set as invariably satisfactory. Thus in the Trajan the lines (which contain between twenty-seven and thirty letters) are about three-fifths of the letters' height apart. (The student will notice how beautifully the sizes of the letters in each line are adjusted to their different height from the reader, those in the lower lines growing smaller.) In the Renaissance inscription on the monument of Jacopo Stefano Brivio (1484), the lines, which contain forty to forty-three letters, are about one-third of the letters' height apart, and look rather crowded. In the inscription on Albrecht Dürer's tomb, where the lines differ in length, the three chief ones containing twenty-eight, twenty-four, and twenty-four letters respectively, the space apart is equal, and just under the height of the letters, and looks rather wide.

The Della Robbia memorial tablet [1] to Simonetto di Chorso dall' Arena has a space equal to three-tenths of the height of the letters, which number eleven, ten, and eleven in its short three lines ; and that amount seems ample.

By comparison of many examples one deduces the general rule that for ordinary pleasant use the space between the lines should *never* be greater than the height of the letters, and should be less and less in proportion to the fewness of the letters from, say, fifty to ten. Otherwise they may straggle and fall apart.

Of modern examples a most beautiful one of well-spaced Roman capitals is that of Sir E. Burne-Jones in his panel of Perseus and the Graiæ (shown in Mr. Day's book on Lettering in Ornament, p. 11).

And for the ready calculation of the lateral extent of an inscription in Roman capitals I have found the following rule of service. With ordinary words an inscription usually occupies as many inches laterally as the inscription holds letters of an inch high, and so on in proportion. So

[1] All these to be seen at the Victoria and Albert Museum.

that a line of them two inches high and numbering forty will take some eighty inches ; or one-half inch high will take some twenty. This allows for their differing breadths and spaces between letters and words fairly and conventionally. But for the spacing between the lines of minuscules the same rules do not hold. With capitals used inscriptionally their purpose has suggested their being used as large as conveniently possible. With minuscules this is not so. And they are frequently used to tell decoratively as patches or lines, and are massed or drawn into strings accordingly. And they can never be set closer than the height of their bodies apart—however short their ascenders and descenders, and even so there will be tangling of these, with confusion and discomfort for reading, requiring special justification. In manuscript they have been set most usually on lines three times the height of the bodies (that is the height of o) apart (Fig. 287). But four times is also common, and five times not rare, and even six times. And with these wider spaces a beautiful effect has been produced by lengthening ascenders or descenders, or both, as if to account for the space, and give some extra clarity or decorative advantage. And the heads of these long strokes bud and break (Fig. 288). If the letter bodies are at the same time closely packed and thick in stroke a fine contrast is produced, and an appearance of room and dignity and individuality of line, very different from the

Fig. 287.

In the beginning God created the Heaven and the Earth: and the Earth

Fig. 288.

collectively forceful and brickwork solidity of the massed method (Fig. 289).

In the beginning God created the Heaven and the Earth: & the Earth was without form and void, and darkness was upon the face of the deep.

Fig. 289.

They immediately suggest the difference between poetry and prose ; and if this be kept in mind the use of either were not hard to determine—or the varying degrees between—for any particular purpose. The choice is more restricted for printers, who cannot so readily lengthen ascenders and descenders, and fear the openness of ' leading.'

Italics usually require the wider spacing. They are not often successful when massed. Their construction, which has been mostly of the lighter kind, and their age, which is too young to have served the characteristic massing of ' black letter,' seem to have settled their applicability to the comparatively wider spacing. They are freely made letters, of cursive quality, and require room and ease, resenting cramping. This explains the poor appearance of many inscriptions written with consideration only of condensing much matter into restricted area. They have then a shrivelled, stunted meagreness, as of birds in small cages, or of writers economising paper.

As a general rule, letters for signs and inscriptions should be of but few sizes. Two or at most three will often be sufficient. And of minuscules only one size should be

used, unless a second needs employment for some comparatively unimportant reference. In that case the difference should be marked and contrasted, not slightly reduced from the former. The modern habit of using many 'Founts' has come, not perhaps so much of a perverted (though inconsiderate) taste, as of the desire of the printer, with a large stock, to square up his matter into some reasonable shape, or silhouette,—and the unintelligent imitation of cheap job-work. The method also of the printers of centring, coupled with the use of many founts, is to be decried. It does not help the look of an inscription to make a line of smaller or larger sized letters fill up an equal length of space. The recurring expansion and contraction of letters has a dazzling effect more inconvenient than an incomplete line containing the overplus of words of the same size ; and blocks of similar sized letters are always preferable, especially where different colours are used for the several blocks. Compare :

LIVERPOOL TO BOMBAY & KARACHI

Steamers & dates of sailings on application

Excellent Passenger accommodation on Bridge Deck.
Special low Fares

with

LIVERPOOL to BOMBAY & Karachi (via Bombay)

STEAMERS &

Dates on application

SPECIAL LOW FARES

or even

LIVERPOOL
TO BOMBAY AND
KARACHI

steamers & dates
of sailings on ap-
plication

Excellent Passenger
accommodation on
Bridge Deck

Special low Fares

with

LIVERPOOL
TO
BOMBAY
AND
KARACHI
STEAMERS
AND
DATES
on application
Excellent
Passenger accommodation
on Bridge Deck
Special low Fares

Centring is in danger of becoming, in consequence of
the readiness with which in printing it can be mathe-
matically effected, a convention which our eyes do not
require for ease of reading, however they assent to the
symmetry of a general shape produced. And this general
symmetry has, in fact, become a fetish which the sign-
writer or scribe, who cannot so readily readjust his
operation, is in danger of reverencing too greatly, when
he might well turn rather to the beautiful headings and
introductory paragraphs of old MSS. for guidance, where
happier effects are produced with greater freedom.

The margins of his ground, and the isolation of his
inscription thereby, form also another problem, for which
it is impossible to provide set precedent. An inscription
on a house or on such an object as a tombstone calls for
differing treatment. For in the one case the wall of the
house, the house itself, forms the margins to his work ;
and where this is on a panel in the wall he may well fill

the whole of this. In the other case the eye needs a certain space all about the inscription itself, lest it ' fall off ' at the end of the lines or be puzzled at the start of them, owing to the involuntary action of ' accommodation ' of focus ; just as in books margins are necessary for comfort of reading. Anyone may test this by cutting a newspaper paragraph close to the edge and holding it up before him. At the end of each line his eyes will be inconvenienced to maintain their focus, and will tend to stray, or make effort not to stray, to the background of the room beyond. Accordingly, more margin is needed at either side than at the top. And at the bottom another reason seems to be added, our feeling for need of support, as of plinths to columns, which a large margin provides. This is usually made wider than all therefore. Roughly, between themselves margins may be proportioned successfully as 1 (top) : 1½ (side) : 2 or 2½ (bottom) (Figs. 290 and 291). But between them and the text the ratio depends on the situation, etc., of the matter.

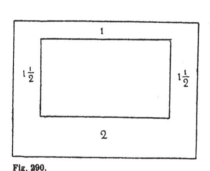

Fig. 290.

Fig. 291.

In the case of books the width of the text would be comfortably about five or six. (But for the adaptation of arrangement of books see next chapter.) Again, all

manner of shapes are available, according to occasion, oblongs (both broad and high), triangles, circles, ovals, etc. Or on a rectangular panel a shape other than rectangular

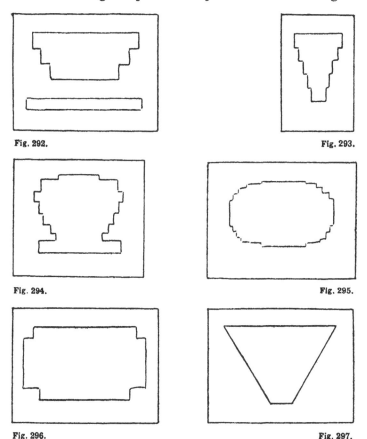

Fig. 292.

Fig. 293.

Fig. 294.

Fig. 295.

Fig. 296.

Fig. 297.

can be given an inscription, according to the suggestion of its matter or the length of certain words, etc. The arrangements shown in Figs. 292-298 have been drawn from observation. Fig. 297, however, should not be used the other way up.

Fig. 298.

But always horizontal lines should be employed, and the shape adopted with some reference to the matter; and for mural work rectangles wider than high seem classically to have been preferred, contrary to our own normal poster shape. For all short inscriptions, as signs of names, etc., commonly are, need width rather than height for convenience of arrangement of the comparatively large letters composing them.

Punctuation should, with such, be as sparingly employed as possible. An inscription, being a deliberate thing, should punctuate itself by care in wording and arrangement. The 'explanation' which punctuation supplies, in long or involved sentences, seems here as out of place as such matter itself. The legal method of exactly chosen words and well-considered order may well apply.

In our language, moreover, we have many little words, such as the two articles and the prepositions, which hamper and render ridiculous much of our printed and inscriptional work. It seems absurd to isolate and so give prominence to these little words by centring them, and then endeavour to counteract the prominence by making them small. Our use seems to have arisen from an attempt to imitate the terse clarity of Latin inscriptions where such words are rare.

Cf.

CARMINA	with	POEMS	IN MEMORY
Q. H. FLACCI		BY	of
		F. THOMPSON	JOHN JONES

We might well have looked at the precedent of the older Greek inscriptions, abounding in similar little words,

where they are given no such prominence ; such as

Η ΒΟΥΛΗ ΚΑΙ Ο ΔΗΜΟΣ ΕΤΕΙΜΗΣΑΝ κ.τ.λ.

which we should tend to render into

Η		*Η ΒΟΥΛΗ*
ΒΟΥΛΗ		*και*
ΚΑΙ	or	*Ο ΔΗΜΟΣ*
Ο		*ΕΤΕΙΜΗΣΑΝ*
ΔΗΜΟΣ		
ΕΤΕΙΜΗΣΑΝ		or somehow similarly.

I may here also note that constant desire of sign-writers to detach their letters from their ground ; though I would discuss this more particularly later, in connection with the theory of letters. It arises from some conception of letters as solids, which *can* be detached, made to ' stand out ' and cast shadows. We have all heard of him who prided himself on his ability to make his letters look ' as if they were falling off.' And I have seen an inscription in a West Country town where the letters seen from below on the wall of a house were displayed so as to look as if they were projected in a semicircle into the street, and throw the corresponding shadows (also painted) below them, somewhat like Fig. 299.

Fig. 299.

Unfortunately the realist had neglected to observe that the sun does not shine continuously (even in N. Devon) —at least not from the N.E.

And this desire for detachment shows itself also in the use of scrolls, etc., just ' happening ' with part of the wording set upon them, a sign upon a sign. No doubt this has come from the ' motto ' in Heraldry and adaptation of its pleasantness there to uses where it is foolish. Possibly also from its use in pictures to give the name to the portrait or the painter, where it is of reasonable and decorative advantage.

Arrangement in general should endeavour to be at ease with the matter provided, not elaborating method or refusing the natural display of it on account of some comparatively insignificant difficulty, as of dividing words syllabically at the ends of lines, though this is no doubt to be avoided where fairly possible. It is better to divide words then than to space the letters of one line differently from others, by condensing or spreading the letters or misproportioning them, so that the general evenness is affected. Mr. Voysey has even ventured to divide words otherwise than syllabically, and there seems no reason except convention against it. Legibility in the short matter of an inscription is not affected, and the gain of ease and fine performance is great.

Then also the habit of printers of ' justifying ' the ends of their lines by a rigid perpendicular is not so necessary for the sign-writer or inscription cutter. No particular reward attends the execution of his work so. Indeed he endangers the smoothness of his work through the lines by the endeavour, besides risking a mechanical finish inappropriately.

CHAPTER SEVENTEEN

ARRANGEMENT (OF BOOKS)

SINCE the invention of printing the title-page has become an important feature in the commencement of books. Of old this was not so, but the opening words of the text were enlarged (and decorated), and the actual title, as *evangelium secundum Lucam*, packed away, almost insignificantly above or beside them. And indeed this treatment was very preferable in most cases. The title for the first book of a Bible, for instance, is ' The first book of Moses, called Genesis.' The opening words are ' In the beginning God created the heaven and the earth '; words at once calling for greater attention than the former, which are little other than the label on the portmanteau. So that the scribe has reason and abundant precedent for following the ancient rather than the modern convention, and can make his actual title-page a plain statement (preferably in capitals) of fact and reserve his decorative treatment for the actual commencement.

Moreover, for him the modern convention has this practical inconvenience that the title-page contains the name of the publisher, the place of publication, and often the year, while he is his own publisher, and such other details are more properly inserted in his colophon at the end of his book. So that he is left with little but the name of the work and that of the author for his title; an amount of matter rather small for elaboration of ornament. His title-page is therefore usually more appropriately rendered if it follows the precedent of the printer's

half-title on the recto previous to the full title. The printer's standard form for this full title is usually somewhat of the shape of a champagne glass, thus :

TRAVELS ⎫ *Possibly red.*
WITH A DONKEY ⎭

BY ⟶ *Omissible.*

R. L. STEVENSON ⟶ *Black.*

⟶ *Some heraldic or
publisher's mark.*

London ⟶ *Black—sometimes placed
below publisher's name.*

Jones, Robinson & Co.

(1930) ⟶ *Omissible, and possibly in
red if the title is so.*

This would be the simplest possible. But there are endless adaptations where more particulars are introduced, such as the other works' names by the author, the name of a series to which the book belongs, etc. But these details shown in the illustration are the essentials, except that the small piece of heraldic or other decoration is omissible. And usually all the matter is arranged with careful centring, like those eulogistic memorial panels or tombstones of the eighteenth century.

But for the scribe still remains the method, more or less elaborated, shown above. And he can render

this the more imposing by setting a miniature on the verso opposite, and framing both that and his text on the recto with a border of decoration. The Kelmscott books show this method of treatment admirably, save that with them the title is displayed decoratively on the verso (in place of a miniature). And the precedent for this double-page method of commencing may be seen in many twelfth-century Psalters, where the verso is occupied with a large design of the opening words, 'Beatus vir,' the B sometimes enlarged to the height of the text on the recto. In most other centuries, and now modernly, the book begins on the first recto. And the scribe is well advised in following this convention, despite the verso's greater left-hand margin tempting him to set his initial letter there.

The margins for the book are but an adaptation of those already given for inscriptional panels with the top less than the outer side ones, and the bottom greatest of all. But actual proportions are still a matter of taste. The following I have found generally useful, and easy to remember (Fig. 300): Where the unit I for the margin at the fold is increased by $\frac{1}{2}$ for the top, another $\frac{1}{2}$ for the side, and yet another $\frac{1}{2}$ for the bottom, and the text is 5 or 6 times this unit wide and 7 or 8 high.

Fig. 300.

Books are now almost invariably formed of pages higher than wide, and are ever to be considered as diptychs, the two pages complements of each other to make one whole, divided by a margin equal to the outside margins or thereabouts, this margin being halved by the fold. And where books are thick and some foreshortening consequently occurs at the fold owing to the curvature,

allowance of a little more must be given, that the space
at the fold may still be about equal to the outside margins.

And for scribes the gatherings or sections of MSS. best
consist of two sheets, one inside the other, the outer
containing pages 1, 2, 7, and 8, the inner 3, 4, 5, and 6.
The binder can manipulate these comfortably. But in
case of thick books these may well be increased to three
or four sheets and paged accordingly.

Where the material used is parchment, care should be
taken that these sections be arranged and the parchment

folded so that the smoother sides
of the skin come opposite one
another and consequently the
rough ones also. This was
always done of old, and p. 1
is usually smooth in the MSS.
So that in the Fig. 301,
pp. 1, 4, 5, and 8 would be

Fig. 301.

smooth, 2, 3, 6, and 7 rough.

The pages need be ruled. And in the MSS. this ruling
was a lead line or sometimes ink and sometimes the
indentation of a style. This, however, gives a groove
one side and a ridge the other, and is awkward to write
upon. Never was the ruling considered a disfigurement,
but rather a support technically and even decoratively.
Of course, it must be done neatly and not too heavily or
conspicuously. And it must ever be done back to back
on the pages, and rectangularly. Nothing mars a MS.
worse than slovenly ruling.

To ensure its well-doing the sheets of the right size
should be cut to a straight edge and folded into two
along this edge carefully. Then as many as half a dozen
of these folded sheets can be set exactly one above another,
and pricked through with a fine steel big-headed pin at
the points shown in Fig. 302. In this the perpendicular
line of dots shows the distance of the coming lines of

writing apart (here fifteen. But, of course, any other number decided upon could be pricked similarly). Then take each folded sheet separately, unfold it, and rule the vertical marginal lines, from top to bottom of the page, by the pricks. And then, between these verticals, rule the writing lines similarly, taking care to jump the fold margins between them (Fig. 303). Then turn the page over and rule the other side. It will be observed that the one set of pricks does for both pages by this proceeding and all will be rectangular and exactly back to back.

Fig. 302.

If the paper has a deckle edge, this should be at the

Area : text = 35, margins = 53, = 88 sq. Page, 8 × 11 linear.

Fig. 303.

bottom, not at the top to catch the dust when the finished book is set in a bookcase.

The rulings may be made with a hard lead-pencil (or on pounced parchment with a silver point) or with a ruling-pen and diluted ink. And, as observed, if made with lead-pencil, should not be rubbed out. For not only is their support then lost, but the rubber spoils the gloss on the ink and dulls the writing.

At the same time, eyes accustomed now to print unsupported thus are apt to resent this ruling. If so, and if parchment be used (which is slightly transparent) or a thinnish paper, a well-ruled model opening may be made on strong paper and set under each sheet as it is written, held there by paper clips, and the writing done by the aid of this showing through. No objection seems to lie against the method (which also saves the trouble of ruling more than the one model for each book) except the loss of support to the finished writing. There is no pretence, as of doing without lines ; for every purchaser of the stationer's blocks of paper knows the trick. Of old the slight transparency of good creamy parchment seems to have been valued for this rich lucent quality, as of clear complexions. Our modern call for dead-white opacity did not prevail.

The proportions given above for margins and text are perhaps more generous of blank paper than printers can usually allow ; but at least the total area of the margins should be as great as that of the text. And among themselves other successful proportions have been : $1\frac{1}{2}$ (fold) ; 2 (top); 3 (side); 4 (bottom). And William Morris, I believe, used also 1, 2, 3, 4.

The text space has nearly always been higher than broad, since reading is eased by the arrangement which gives fairly short lines and yet a number of them on the page. We all know that long lines make for difficulty in recovery of position at the commencement of each. So

that where the text space is broad, as in large books, a double column is substituted, so that lines may yet be short. The double column, however—and a large page—seems only justified by extra length of the book's contents. The greater height of the text compared with its breadth is also, no doubt, due to a dislike of the insistent regularity of the square, and perhaps of two squares, one on top of the other. The rectangle of six wide by eight to ten high is usually preferred.

The size of the writing is less definite. For in some centuries, as the thirteenth, densely packed minute writing is set on comparatively large (still small, however) pages, even fifteen or sixteen lines to the inch; while in another, the fifteenth, comparatively large writing is often seen in small Books of Hours—as if for service in dim chapels. So that a wide choice is available.

But large writing on small pages is for the scribe undesirable for the reason that if he cannot get some twenty-five letters to his line he will have great difficulty, with our language, in which syllables often require five to seven letters, in avoiding a wildly uneven length of line and consequently a very pronounced serration down his right-hand margin. Most students desire at once to write small, and to make a *little* book that may be precious if only by reason of its size. This is a mistake; for though a reader may be charmed at first by the daintiness of the thing, his eyes soon cease to acknowledge any pleasure in the actual size, but will certainly detect inequalities and defects of details of small writing just as easily as with larger writing. And since such defects are more likely in small writing, the size itself enhancing difficulty in rendering detail and tending to slur and makeshift, the writer only increases his task without pleasing the reader. Let him rather write at a size which he can render comfortably and with due performance of all requisite detail, confident that the reader will acknowledge these and will,

after a page or two, be indifferent to the actual size, even unaware of it, provided of course that the book is still small enough to be held conveniently. One-sixth or one-eighth of an inch is an easily manageable size for the student's letter-body (minuscule o); one-ninth or one-tenth later. But seldom is writing successful less in size of body than one-twelfth of an inch.

Through the book the writing must be kept uniform in stroke as well as otherwise even, which means that the pen for the new page must be cut accurately as for the last written. Our eyes are less sensitive to change of size than change of proportion. Thus on recutting the pen, if by mishap one cuts it broader or narrower than before, the new page will almost certainly be written in a larger or smaller size accordingly, but the proportions of stroke in the letters themselves preserved ; and the discrepancy in size may escape observation until too late. One needs take precautions therefore. A good plan, after deciding with satisfaction on the breadth of pen to be used for the whole, is to make a dozen strokes like a railing with its full breadth on a piece of the same paper or parchment as the book to be written, and to preserve this carefully as standard. Then, on recutting, the recut pen should also make a similar railing at the edge of a scrap of paper, and this should be brought up against the standard. Any, even slight, discrepancy will be at once apparent and can be corrected—far more certainly than by doing a bit of writing with the new pen and comparing that with the previous page.

The student usually wishes to write out poetry. And this increases his difficulty about size. Our ordinary English metres with their five or six-foot line take some breadth, if written one-eighth of an inch for body. Only at one-twelfth or one-tenth can such lines be rendered without breaking in a smallish book. He must, therefore, either be content with a quarto book or break the poet's

lines—to alter the form of the poet's stanzas. To make
them into prose-like paragraphs would be the maximum
atrocity for his own ease. Yet if he decide to break the
lines it is better to bring all ' carry-overs ' to an inner
marginal line rather than set them under the ends of the
lines they exceed ; that the page may look centrally
balanced, and not have its weight too much at the right
side, thus Fig. 304 is to be preferred to Fig. 305.

Fig. 304. Fig. 305.

The arrangement of sonnets is particularly awkward,
owing to their tendency to the square shape, unless much
' leaded.' They need to be written with lines some
five o bodies apart if they are to form the ordinary upright
oblong, with fairly long ascenders and descenders. For
owing to their literary form and condensed significance,
they need a page each to themselves. Some of them,
indeed, lend themselves to breaking into twice as many
lines, such as Wordsworth's ' The world is too much with
us : late and soon,' where each line goes happily broken
into two. But this is exceptional, and, after all, gives an

upright oblong too high for its breadth, even if the lines be set close together.

A fair way is to leave a blank line between octet and sextet, and to give the beginning an initial of, say, two (or three) lines high, and the sextet's initial a one (or two) line importance correspondingly.

With rhymed lines the usual indentation of the second and fourth lines—or the setting of rhymed lines to the same margin—needs to be observed ; and in general the form the poet has given his verse, for its arrangement is already part of its art. And to take liberties with this is to presume.

Yet I am not sure that printers and scribes are not too scrupulous. For on an occasion when this matter of the ' carry-over ' was being discussed, a well-known poet assured me that poets do not ' see ' their poems in black and white on a page with its technical difficulties of arrangement—but ' hear ' them ; and so perhaps may be less particular over the methods of transcribers of their songs than the transcribers themselves.

With prose a noticeable alteration from the MSS. is the printer's habit of commencing his chapters some way down the page. There seems no good reason for this. The older, the natural way is to begin at the top. With paragraphs, too, the printer needs to ' indent ' : the scribe is free to put his initial into the margin, or as he chooses.

Where headlines are decided upon, the top margin may be slightly increased, and the headline set conveniently on what would be the second line above the ruling for the page, supposing that ruling continued upwards. Headlines are usually in capitals. The size of those used with the text is sufficient. Larger capitals tend to overweight the tops of the pages and to seem disproportionate.

Pagination implies the need for an index, not often applicable to MS. books. Where it is given, however, it

may conveniently be added at the foot of each page on the next line, or on the next but one, below the text, and at a distance inwards equal to the space between the lines, to the left on the verso, and to the right on the recto, giving rather the appearance of castors to a piece of furniture, and not disagreeably.

At the end of his MS., though its indulgence in a title-page is perhaps inconsistent with it, the scribe should add his colophon, which is little more than his signature to his work. This strange word is said to be taken from that town in Asia Minor which had such a reputation for its cavalry that their charge was always supposed to be decisive in a battle, and so conclusive. Hence the finishing touch, added on the completion of a book. The words used may, in English, be ' written out by A. B. at C. D. (and finished, or completed on) the blank day of blank 19— A.D. Note ' written out ' (Latin, *exscriptum*), not now written, which implies ' authorship.'

The scribe should arrange his time so that he may write out a whole opening of his book, or at least one whole page, at a sitting. For any interval will inevitably reveal the spot at which he recommences if he leaves off in the middle. For the pen will have become harder again in that interval, even if he himself writes as before. As it is, the softening of the pen down the page will be observable to careful scrutiny and comparison of top and bottom. But this, occurring on both pages of an opening equally (with the pen recut for each and well matched), is no drawback. Only a discontinuance, as mentioned, or the recutting of the pen in the course of the page is of consequence.

If for unpreventable cause a page must be discontinued when incomplete, it is best to leave off in the middle of a line, and in the middle of a word, even with a half-formed letter. The writer will find it easier thus to recover the evenness of his flow than with a fresh paragraph ; and

he may also soften his pen to its previous degree by writing a few words with it first on another piece.

Taking these precautions he will still need to assure himself, by the means recommended for matching his mended pen, that his next page keeps the proportions in all details of the previous ones ; trusting that the fact of turning over will minimise any slight discrepancy for the reader.

As to this important matter, it would be most interesting to know how the monastic scribes maintained the perfect evenness of their pages. In the case of later work, such as that of the humanistic scripts of the Renaissance one may, very occasionally, detect a ' join ' or ' fresh start ' ; but with the older work, never. And this is the more remarkable when one considers what were the conditions under which it was done. Professor J. Henry Middleton in his book on *Illuminated Manuscripts*, remarks on p. 210 : ' There is yet another of the conditions under which the monastic scribe worked which was not without important effect on the unvarying excellence of his work, and that was that he could never remain long enough at work, at any one time, for his hand or eye to get wearied. Owing to the constantly recurring choir services, the *Seven Hours*, which he had to attend, the monastic scribe could probably never continue labouring at his illumination for more than about two hours at a time.'

With regard to ' illumination,' certainly this fact can well account for the ' firmness of line,' and unrelaxing ' delicate crisp touch,' with the ' joy in his manual dexterity,' to which Professor Middleton calls our attention. But with actual writing interruption would bring an oppositely disturbing and constant anxiety over the completion of a given column or page within the given time, or else the inevitably visible break. And this is exactly what is never observable. There remains the miracle of monastic performance.

HE 'presentation address' is one of the commonest occasions calling for the scribe's service. It is usually accompanied by a list of subscribers, either to be written by the scribe or signed by the individuals. But the latter method, where there are many, is so inconvenient that it may be dismissed as impracticable. Either the address has to be sent or handed about, or the signatures have to be collected on separate sheets, difficult to arrange and fit together ; or on separate slips and pasted in—a deplorable expedient.

If the scribe writes them the wording needs avoid their description as 'undersigned,' for they are not ; and immediately the rather stiff phrase, 'whose names are written below,' or 'hereafter,' needs to be used instead. The scribe should call attention to this difficulty, and if he may, also venture to 'edit' the matter somewhat on technical grounds. For instance, the address usually begins : 'We, the undersigned subscribers,' or as the case may be. The word 'We' is very undesirable. For the W is the initial letter, and the scribe will need, technically, to emphasise and, if he employs ornament, to decorate this also. It immediately magnifies the importance of the donors, when rather the donee's name is that which calls for the emphasis. It is better, therefore, to commence with a less discriminating announcement, such as : 'On the occasion of your,' 'Now that you are leaving us.'

The date, which the addressers usually forget to insert, needs also to be added (usually at the end of the address) even if it be but the month and year.

The words 'Presented to' sometimes occur at the beginning, but 'to' is sufficient. And a form such as given in Fig. 306 is a safe one to adopt, the donee's name being set in simple or compound capitals in gold or colour at the head.

In the figure shown (306) the donee's name is in simple capitals, gold or black; the words 'vicar of, etc.' supposedly in red, the big initial O in gold. And the lines sketched in show the stem lines which might support any flowered ornament desired, the limits of this being suggested by the rectangular boundaries. Note the margins of the page and the regular ruling adopted throughout, which ruling would also be that for p. 2 at the back of this recto page, to follow.

This assumes that a book-form will be chosen for such an address; and indeed it is the most convenient and lasting. A panel precludes a large number of names being added below, and is perhaps more ostentatious than the recipient, and more difficult than the performer cares to accept or can design satisfactorily. A book decently bound or even only cased in vellum is more modest, convenient and generally manageable.

The names can be added in single or double column after the address as the size of the book suggests and their several lengths allow. They are usually set in alphabetical order by reference to surname. And if this be so there is no reason against setting the Christian names or initials in front, where they properly belong. The alphabetical order is not thereby falsified, and the list becomes less of the sort of index which is designed for rapidity of reference, here uncalled for. Almost inevitably on such occasions certain names arrive to be added after completion. These may form a separate short alphabet.

To THE REVEREND
JOHN ROBINSON, M.A.
Vicar of St.Paul's, Bigbury.

ON THE OCCASION
of your retirement,
after forty years' minis=
try in this Parish, We,
your parishioners and
many other friends de=
sire to &c.

THE COMMENCEMENT OF A PRESENTATION ADDRESS.

Fig. 306.

For as addresses usually have to be done against time it is unwise to delay general proceedings until all the names are ascertained. And in this respect the book form is also convenient, since the scribe is not delayed from starting upon his work.

The memorial books of those fallen in the war, now lying in so many of our cathedrals and parish churches and chapels, have also latterly given opportunity to the modern scribe and illuminator. In the Chapter House, Westminster, at Canterbury, Eton, Harrow, and Winchester, to name a few only, can be seen examples of the application of the craft, which the student may easily study for assistance in his work.

But the beginner is rather restricted for opportunity. There are too few occasions other than the tradesman's window-tickets or advertisements upon which he can exercise himself. And even Christmas cards need to be done for reproduction, so that the doing of a few is all he can hope for. Yet with them there is scope for individuality and certainly improvement. For most people still send them about and feel that they are right in sending them. Our difficulty is to find something fit to send. Latterly we have had fine reproductions of old masterpieces, without, however, much reference in these to the season. For even the reduced portrait of a saint is not wholly appropriate. And the verses on others are rarely worth copying, except the well-worn carols. The problem is rather literary than technical. But plainly a Christmas card needs reference to the birth of Christ; and the Christmas Gospel, the second chapter of St. Luke 1–20, the second chapter of St. Matthew 1–12, have not been overdone, nor yet the various references to the occasion in the Old Testament. And for some of these the booklet form immediately suggests itself as entirely suitable.

And then—the little almanacs, which now mostly

consist of a picture with a bunch of day pages below it to tear off, the whole thing hopelessly untidy from its very start in January. Or they may have twelve sets of compressed columns of numbers against abbreviations of the days of the week on glazed cards for a frame, and are serviceable enough—and no more.

But though their difficulty be thus acknowledged, few people think of attempting solution by reference to the exquisite calendars in the MSS. before the fifteenth century, which are always models of apt and beautiful arrangement. Our method of calculation is different, no doubt, and we need to use the Arabic figures in place of those Roman X's which beautify the columns of those Books of Hours and Psalters. And we cannot be bothered with Sunday letters and golden numbers, and a system which enabled the calendar to be a permanent instead of an annual reference-table. But the endeavour to render ours more permanent would lift the matter above the makeshift treatment it at present receives, and make some study of possible and agreeable arrangement more worth while.

Such a calendar should have a page to every month, as of old, or even a whole opening as of a book. The month's name should appear at the top and the days of the month perpendicularly below the initial letter. And beside each of these the names of the saints, as of old, or the more secular information desired. Each of these monthly pages could be placed below a mount (and the whole framed), the mount carrying the letters for the days of the week so that they came against the days of the month. There would need to be five weeks of these letters and two days. The mount would be permanently set in the frame. And the pages of the months, made the same breadth as the outside measurements of the mount, would be shorter top and bottom, so that they could be shifted on setting for the particular year to make

the days of the month come opposite the days of the week. The letters of the weekdays might be set on both margins of the mount, and so form a ribbon down each side, which could be decoratively treated by enlarging the Sundays or otherwise (see Fig. 307).

The so-called 'mount' is here set singly; but three of them to form a quarter of the year could be set side by side, and the whole framed to make one 'design.'

Another field, as yet almost untried, lies open in the making of covers for songs and other music, which at present are surely improvable. A certain amount of conventional matter is provided in such cases, as with the title-pages of books, upon which careful arrangement might well be given for reproduction. In the case of songs there is the complication of the little piece of stave given when the song is published in several keys. But if this were found too awkward, the key could be given in words, and the range likewise in letters, as 'A to F sharp,' or 'C to G'; for it is well understood that the lower note is given first. Latterly, floral adornment or decorative line-work seems to have been passing from the conventions affecting them—which simplifies and dignifies the matter, though if this were aptly supplied by the sober illuminator there seems no great reason against it.

Book-plates also call for fair writing, and with these some sort of heraldic or symbolic design is usually adopted. But a simpler and, to many, more acceptable method would be the writing of the name only. This should be in waterproof ink, and might be done on paper already gummed on the back—and by the hundred—the paper being cut up afterwards. It would be rapid, and excellent practice for the scribe.

With all work intended for reproduction by photographic process he needs to inform himself of the necessary though slight modifications the various processes will

Sight line of frame.

Height of month's page.

Inner edge of mount.

		OCTOBER		
S				S
M				M
Tu				Tu
W	1 ST.			W
Th	2			Th
F	3			F
S	4			S
S	5			S
M	6			M
Tu	7			Tu
W	8			W
Th	9			Th
F	10			F
S	11			S
S	12			S
M	13			M
Tu	14			Tu
W	15			W
Th	16			Th
F	17			F
S	18			S
S	19			S
M	20			M
Tu	21			Tu
W	22			W
Th	23			Th
F	24			F
S	25			S
S	26			S
M	27			M
Tu	28			Tu
W	29			W
Th	30			Th
F	31			F
S				S
S				S
M				M

Inner edge of mount.

Base of month's page.

Sight line of frame.

Fig. 307.

import. But he need not do his original so large as is generally done—twice the size of the reproduction. At most the reduction to be allowed for, sufficiently to tighten and clarify his performance, need be but as six to five ' linear,' or at most five to four. That is, let his writing be six inches (say) wide for a five-inch wide reproduction. For he must remember that a photographic block will, in printing, thicken his fine strokes more in proportion than his thick strokes—and he will not be able to gauge his ultimate effects so well if he makes his original larger than here proposed. Of all processes, other than the most expensive (as collotype and photogravure), lithography gives the nearest approach to the original writing. And this, of course, will be of the same size if done by aid of a writing on transfer paper. This but needs a little practice with the special ink and paper. But it has the disadvantage of rendering all dead flat. There is no ' impression,' as with a block, or the delicate groovings in the surface of vellum of the original writing.

The few instances mentioned above of the application of writing for purposes other than bookwork may serve to show how derivative are the arrangements which we find pleasant or convenient. The precedent is ever the book, the suggestion that suitable for a ' page.' And if the agreeable readableness of the matter be the primary consideration, as it usually needs to be, this precedent or this suggestion is safely conventional. The safety, the need for conventionality will appear more evidently in the chapter (Chapter XXI *et seq.*) on legibility. Here it may be enough to note that arrangement of matter of any sort, apart from its regard for the precedents of ' pages,' should avoid worry or variety, using few sorts, few sizes, few differing lengths or spacings. For with most work the reader wishes to read, not to admire or sympathise or be excited. And arrangement that regards the ordinary, like speech, looks after itself more than we incline to admit.

And even if the ordinary be unwarranted by reason, we may appear only self-conscious in disregarding it. The common method of writing a letter on paper with an address set at the right-hand top corner, and telephone and telegraph addresses slanted across the left-hand top corner, beginning with ' Dear So-and-so ' on the left, with the rest of that line blank, and ending with ' Yours truly ' in a line to itself towards the right—is all so ordinary that there are few purists in arrangement who would think to better matters with hypercritical ' improvements.'

In fact, it is easy to over-arrange, especially by the employment of different sizes to correspond with the relative importance supposed necessary to guide the reader in reference to the various items displayed. And many commercial houses use letter headings more like an oculist's test-tables than assistance (or encouragement) to deal with them.

It may be of very practical aid to examine the method of the makers of MSS. of old, and realise how easily, almost casually, they ' arranged ' a page intended to be somewhat important. Fig. 308 is a fair sample of this method, which at once shows how the scribe relied for assistance on the ruling of the page, the ruling being already there, as of any other of the pages of the book he was making. It is from a Psalter of the tenth century in the British Museum (Add. MS. 37517), and this page is reproduced in Series III of the reproductions of illuminated manuscripts issued by the Museum.

Here there were twenty-five ruled lines, the distance apart of the smaller coloured capitals on the page. And it was plainly intended to have an imposing Q to start with. The O of this Q is eleven of the spaces high ; the VID are four of the spaces high, the GLO three ; the rest of the word, RIARIS two ; and then come four lines of the smaller capitals, each the height of the space

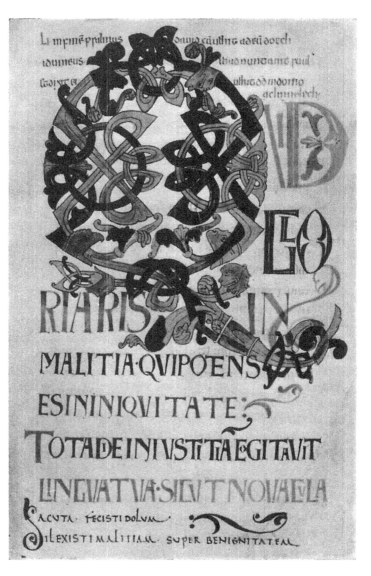

Fig. 308.

PSALTER, ENGLISH TENTH CENTURY, BRITISH MUSEUM
(ADD. MS. 37517), REDUCED.

Example of straightforward method of arranging by reference
to the lines already ruled on the page.

between two ruled lines, one such space high. Towards the end of the inscription the rubricator finds he has not enough room for all the wording originally intended to fill this page, and left to do so by the scribe, who had no doubt gone on with the black writing on the next page before these proceedings ; and accordingly has recourse to some trick of packing to get all the matter set out. Even so he over-packs, and the last two lines become rather empty. The great Q, no doubt, originally sketched in was then completed, and regardless of our modern finesse, runs over the RIARIS in one or two places without apparently any of the self-conscious diffidence we should feel over the appearance of misfit. Throughout the performance the ruling of the page has been relied upon for suggestion as to proceeding and the various proportions.

In the next chapter the use of writing used primarily as decoration is considered, where the matter of 'design' is involved, and the letters are intended to embody or assist some scheme, to which their legibility is subordinated. But this matter goes beyond the scope of this book and is only shortly dealt with ; the few examples referred to being purposely chosen from among many accessible at South Kensington, where the reader who cares to study the matter attentively may find endless suggestion and assistance.

CHAPTER NINETEEN

DECORATIVE ARRANGEMENT

ETTERS are so decorative and can be applied decoratively to such a multiplicity of objects that the use of them is almost inevitable in many kinds of work. I would refer again to the noble gesso panel of Burne-Jones of Perseus and the Graiæ, where eight lines of hexameters occupy the upper part of the panel like a system of ribboned clouds, as a fine example of the decorative use of quite strictly formed letters. Another I would cite is a tapestry at South Kensington representing the three Fates, where the placing of the Gothic lettering of their names is magnificently effective. And yet another is the lovely Latin inscription embossed in silver gilt on the shrine of St. Simeon at Zara in Dalmatia, also in the Victoria and Albert Museum. In this the words hardly matter—it is the beautiful richness of bossy surface which Francesco di Antonio, of Sesto, gave them in 1380 that counts ; leaving one, however, wondering what he thought about that long blank in the last line, which he either ' designed ' or accepted without ' minding a bit.'

These three examples well represent the power and delight of letters as decoration, and decorative artists have always felt this charm and confessed it in their work. Some have even invented mock writing to fill spaces, while others have recognised a beauty in words, even of other languages than their own ; as J. F. Millet is said to have liked the look of WEYMOUTH written in capitals. While, as a means of merely giving texture or variety to surface they are very valuable.

But while one recalls fine examples and feels that, in spite of them, with our printed matter before us continually, and our consequently rather cut-and-dried notions of legibility, we may have acquired too strict a standard and too narrow a judgment; surrounded as we also are with the advertisers' clamour and abuse; we are timid lest any playfulness of our own should but echo his. We fear to admit that letters can be beautiful or allowable which are not primarily legible, lest we fall into some of the pitfalls awaiting laxity; and cling to our safeguards of everyday attire. We cannot trust ourselves.

In times past our difficulty seems not to have existed. Lettering was used with the happiest effect in every imaginable connection. On painted mummy cases in Egypt, in carved reliefs in Nineveh, ivories in Byzantium, on coins of all nations, on Persian tiles and lustred pottery, on Gothic glass and tapestry and embroidery, on furniture, on leather bindings, in locksmiths' and goldsmiths' work, on seals and signet rings, lettering has played an important and decorative part with all people. But in later times it has not been turned to much account, even by such as Morris (except in his printed work). It has been ruined by commercial use. We are almost sick of it, everywhere recommending us to buy, and be fed and clothed, and housed and healed. We suspect it when we meet it, lest, like that insidious paragraph in the newspaper, it lure us to some soap or embrocation presently.

In ornament, however, we know that meaning plays an essential part, and may be desirable in addition to the beauty, which is its prime purpose; and the artist with ideas always desires to do something more than solve a decorative problem. Some turn to symbolism; but the possibilities of symbolism are restricted. It is either so familiar as to be hackneyed and commonplace or the interpretation makes demands upon recognition and sympathy to which only a few may be ready to respond.

It has often been found necessary to explain symbols by lettering, which in itself would have sufficed without the symbol. And symbols are more difficult to fit and manage than lettering. For this is equally ready to fill the most conspicuous place, or retire discreetly. And some of the alphabets, no longer now of conventional legibility, are easily admissible, as the ' black letter ' which, owing to its thickness of stroke and great regularity of form and manner, is useful as well as sumptuous. It has, however, the drawback of being a minuscule alphabet only, lacking consistent capitals. In the MSS. coloured compound uncials usually accompanied it, and our use of these together would now seem perhaps too imitatively dated. Numberless mediaeval brasses, however, exhibit the beauty of these minuscules, either blacked against the brass ground or themselves raised and the ground cut away and blacked.

And the study of these suggests at least the use of a minuscule alphabet, which can be thickened and densely packed, in place of the Roman capitals usually employed, which can only be disproportionately coarsened if so treated, that the beauty of inscription on brass, a matter of nice calculation of the distribution of black and shining metal, may be the better preserved. Moreover, the very curvatures of minuscules are better suited for the graver's operations than the chisel forms of the classic Roman capitals, and I have found craftsmen more than ready to entertain the doing of ' brasses ' thus.

The illustrations engraved on brass by my friend, Mr. G. T. Friend, may perhaps serve as examples of this alternative, and to me preferable method. In them is seen a certain character of ' inscribed ' rather than ' stamped ' metal ; and the graver's sympathy with penmanship, as more appropriately applicable to the medium than chisel-work, is very readily appreciable.

Again, the use of the horizontal—the rule for book-

1826 1834
WH LHH
1894 1917

In gratitude to God
for the happy life
and dear memory of
William Hudleston
of Hutton John, and
Laura Henrietta
his wife, this tablet
is set up by their
sons and daughters
in the Church where
they loved to pray.

May they rest in peace.

Fig. 309.

MEMORIAL BRASS.

Engraved by Mr. G. T. Friend from writing by the author. Reduced.
The character of 'writing' is here preserved.

work and inscription primarily meant to be read—hardly applies to much use of decorative lettering. For though this has usually adopted the horizontal line, one may often suspect that it has been used because a horizontal line was wanted, and lettering gave the excuse for it. Thus the upright figure of the saint has the contrast of his name horizontally across the background. And equally well he may have it round the nimbus about his head or curling in a scroll about his figure. In stained glass the divisions of panels have been most easily effected by bars of lettering, or again by scrolls of it filling empty spaces or helping the lines of the design otherwise. Bands of it are used on the doors of the Cathedral at Le Puy to divide up the little panels of figures, while the upright between the doors has the lettering perpendicularly. Book-covers have had inscriptions running round the four edges ; for they, like coins, are handled and turned about without difficulty. Even round a recumbent brass you can walk to read. In the case of doors, however, the inscription must needs run in the directions as ↑ ↓ ; while a book may run continuously, as in the lower arrow's direction.

In all cases the eye is supposed to read from the centre of the object, the bases of the letters being inwards, the heads outwards (except in the case of the bottom line of a door).

In the case of circular vessels a belt of inscription is valuable decorative help. In the Greek vases it occupies a position of honour in the scheme, and seems never to have been dragged in merely to fill up.

As a border it gives formality and steadiness, as with grave-slabs, medals, seals, and coins. With circular objects our use is nearly always circular also, but of old it has been set in squares of double lines of lettering (with

These

Of the Parishes of Elsted and Treyford cum Didling gave their lives serving the King in the years of our Lord 1914-1919.

Charles Ayling
Royal Fusiliers

William Henry Hall
Roy. Sussex R.

Fred Ceit Harris
Bedfordshire R.

Norman Harvey Noel
Canadian Forces

Alfred Urry
Norfolk Regt.

George Waller
Hampshire Reg

James Young
Royal Sussex Regiment

BRASS IN TREYFORD CHURCH, SUSSEX.

Fig. 310.

Engraved by Mr. G. T. Friend from writing by the author, also showing the character of 'writing' preserved. Reduced.

the Greeks) or as perpendicular bars, as a background pattern with the words split up as need prompted. In the Renaissance medals we have both uses, often in combination and contrast, and mostly with large-sized letters. Our own coinage usually has it insignificantly small.

And so far is legibility from being an essential of ornamental lettering that sometimes letters may be so used as to mystify purposely, or hide a meaning from all but those whom it may concern, or those who have the key. Others are given its decoration only. Indeed, many instances occur in which the meaning of the words should not be obvious. A certain mystery about the wording of a sentiment may be of the essence of its tenderness. If upon the marriage-chest a carver of old intertwined the names of bride and groom, if upon the bridesmaid's locket the goldsmith enamelled the initials of the pair, or a pious wish, or little prayer, he did not do so that the thing might be plain in a moment to the eye of the casual.

A simple way of preventing words staring is to break continuity with different colours. And this was even done in MSS. With embroidery different parts of a large letter might also be coloured differently, a thing also done with the large initials in MSS., giving them a harlequin appearance.

The degree of *illegibility* must depend on the purpose. Even where the 'secret' is an open one there may be charm in the mystery in which it is wrapped. In a printer's or a merchant's mark lettering may be tangled to form a recognisable and attractive sign. And we all know the attraction of some Icelandic, Chinese, or Arabic inscription which we cannot read, but yet enjoy as a piece of ornament. In the India Museum is a Persian mirror with a beautiful piece of lettering on the back in low relief, and gold and colour. The inscription is not to be read at once even by an Oriental, it is just beautiful tracery of bars and bends and curving stems. But the

beauty is greatly enhanced by the discovery that these lines can be deciphered to mean, in tribute to its fair possessor, ' O thou satisfier of wants.'

All Arab art is rich in inscription. Prohibited from picturing God's creatures the followers of the Prophet naturally turned to this alternative for their decoration, and had the luck not to be hampered by prejudice against the free use of an elastic alphabet. In lustred tiles, enamelled glass, fretted brass, plasterwork, wood-carving, embroidery, or silk-weaving, as well as in illumination of the Koran one may study it. And for those, like myself, who cannot read, to tell how legible or illegible these inscriptions are, there remains the greater sense of the decorativeness of handwriting.

As the joining together of letters may be done for mystery's sake, it may be done for convenience of spacing. In many cases in which it is clear from the first word or two what is to follow, as in the Lord's Prayer, Credo, or Ave, joining letters is not confusing. Such combinations are carried to excess on those doors of Le Puy, in order to fit rather clumsy letters to the spaces required ; yet the compounds add interest, and it is a pity that our print allows us so few. We have there but only the amperzand and a diphthong or two. The scribe is certainly free to combine others reasonably for his purposes.

The only occasions on which we usually allow ourselves this freedom are with monograms and ciphers, monograms being combined letters, combinations in one sign of two or more letters no longer separate. So Fig. 311 is a monogram (of XP), and so is &, and so might be Fig. 312 or Fig. 313; the point being that the one sign signifies the several letters composing it, there being present no letter which does not form part of another.

Fig. 311.

Fig. 312.

Fig. 313.

Fig. 314.

But Fig. 314 is not a monogram, it is a cipher; for the individual letters are there, though interwoven and tangled.

In making either, Roman capitals are more difficult to manipulate than the rounded forms, like uncials. And though symmetry is not essential, there must be balance. The natural sequence of the letters should also be apparent, a thing too often disregarded. The letters need not be all of one size, but there should not be an appearance of differing scale or weight.

Such letters as P and F are contained monogrammatically in B and R, and E, but in neither case will the one letter do for the two, if they are both to be read. Sometimes they may be reversed, as in Fig. 315, for Henri Deux et Diane on the ceiling at

Fig. 315.

Fontainebleau. And Fig. 316, for London County Council, is a very natural device. Capitals are usually preferable to minuscules, though for some ciphers the flowing lines of cursive minuscules are convenient enough.

Fig. 316.

Yet again the very unlikeness of plain letters to flowing ornament makes them useful in design by way of foil or contrast. They give pause and point to a pattern. It is common in design to need intervals of rest, too important to be treated on background, yet not calling for enrichment; where indeed the decoration, though it must not attract, shall not be insignificant. Lettering exactly fills such a space. And in numberless applications of lettering in design one may guess that it was set there, if not as an afterthought at least as so happy a thought as to be inspiration, by the hand of a craftsman experienced with the use of it as an implement of design for his need, in ages which had not lost the free use of letter forms,

unfettered by print, unvulgarised by commercial extravagance.

Among the common instances of our reluctance to employ it are the plates, on which we rarely see lettering, except on the bread-platter with its trite proverb. Little aphorisms are seen, too, on the Devon pottery, which would have been delightful if done by a letter-craftsman. Of old, inscription was usually alternated with panels of ornament round the edge of platters, with an effect agreeably preferable to continuous bands of either lettering or other ornament.

And on the whole the reluctance of modern designers seems to come of a fear of the obvious, in an age when lettering is overdone, as well as stereotyped. To wrap writing up in ornament is too great a liberty ; to be outspoken with it, stale and commonplace directly. That word ' ink ' on the ink-pot, ' blotter ' on the cover of the blotting-book, disgusts us.

Yet this fear of the obvious comes of poverty of expression, of having nothing to say no less than the fear of saying something. The bread-platter, with its association with the Lord's Prayer, has given us no inspiration all these years of years !

It may be perverse in a book on writing to ascribe a merit to writing which is intentionally illegible. But one may perhaps justify a plea for occasional freedom by long practice of strict rule. And as we know there can be in lettering a legibility which is not beauty (as with block letters on the whole), we may allow sometimes a beauty therein which shall not be that of legibility. Here the craftsman may assert an aim once and again at the other end of the scale from the advertiser, and wrap his meaning away from the casual, to grant it to him who cares to stay and look into it—as a confidence.

CHAPTER TWENTY

THEORY OF LETTERS

LETTERS may be defined technically as marks upon a surface, and if this definition were adhered to our general comfort in reading them would be greatly increased. An inscription on stone was at first only a systematic and glorified scratching of it, to be visible and permanent by regular incision, and the lights and shadows the method produced. And no doubt the Roman method of painting their inscriptions conveniently obviated the necessity of cutting them very deeply. There are, broadly speaking, no examples of raised lettering in classical (imperial Roman) inscriptions. The *litteræ prominentes* are of a later (Christian) date, and may have arisen from observation of the natural method of their use in coins (where the mould is incised) or, later still, from the introduction of such letters by the Moors, with their moulded clay forms, in Spain, when the material suggested its own different method. The readiness with which bronze or other thin metal may be beaten from behind, and finished in front, would also suggest similar treatment of the forms, as would all ' casting.'

But the raised inscription began as a luxury, even so, and was rare until a certain ease and decorativeness in performing ' black letter ' by such means rendered it common in the Middle Ages. The Renaissance inscriptions, however, return in most cases to the severer and simpler method, which was, of course, also the more economical, and in a way the more craftsmanlike. It is easier and quicker to cut letters than to cut away the background from them.

Moreover, the raised letter introduces many complica-

tions. It becomes a solid, casting a shadow, and the shadow is perceived rather than the letter. For if a simple form of letter is cut with a vertical section, and

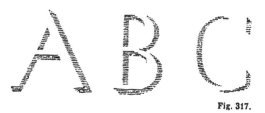

Fig. 317.

this lit from the side and above, nothing would be visible but this shadow, the letter remaining the same colour as the background (Fig. 317).

This is not carving letters but rather drawing shadows, confusing and comparatively illegible. The regularity and angularity of the forms in black letter, as well as their thickness of stroke, and the great richness of surface given in actual practice, however, in dense lines or masses, certainly commend it in their case. And this richness has recommended it in our luxurious age in connection with another standard of form, to which it is less applicable, and has led more than aught else to the vulgar degradation of our display lettering of all kinds. The appearance of projecting from the surface by reason of the shadow has been assisted by also colouring the latter, so that nowadays the letter is conceived of as a thing fashioned and stuck on in relief, almost invariably ; and no sign-writer is deemed to know his job who cannot make his letters ' catch the eye ' or ' stand well out ' by such devices.

The means assist the aims of the advertiser and all our modern efforts at intrusion and self-importance, and have led to various inconsistencies as well as much ridiculous excess. For instance, I have seen a notice-board beneath a shop-window, the name incised with a V section, which was gilded (contrary to all right use of

gilding, as presently to be noted), and the maker was so beset with the notion that a letter, even when incised, must still 'stand out,' that he had painted imaginary shadows to the letters on the surface—shadows cast, by a section into the surface, upon it! The imaginary thicknesses of the letters are also always painted in impossible isometric perspective. There yet remains the realism to be achieved by enterprise of painting them in true perspective, so that the spectator may stand at the centre of the inscription and view the letters casting their shadows indeed all one way, but showing their thicknesses of pretence solidity in true perspective—varying as they would to such a spectator, those on his left showing him their right side, those on the right their left, and those in the middle none at all. The effect would be prodigious, and at all events give us the pleasure of imagining a possible 'vanishing point' for the whole; a relief denied altogether, and possibly intentionally, by the isometric device! This sham thickness and its sham shadow are the results of the raised inscription, and the effect of solids and richly textured surfaces upon careless luxury; and seem, if only on account of all the falsity and vulgarity they have brought in their train, much better avoided. Avoiding them does not involve our refusing an outline to our letters, where such an outline may well be required to give strength and clearness to our forms upon certain surfaces or colours. In such cases the outline should be evenly drawn all about the letter that it may not appear to be for any pretence of solidity or shadow.

Here are shown two inscriptions, the first a rare example of the use of raised letters in marble at the Renaissance, the second incised with a V section in Roman stone by H. Fincham for the Church of St. Hugh, Letchworth, after the more usual Renaissance manner. And comparison, I think, shows at once which is the

FRANCIS̃
PTOLEMAEVS
AEDITVVS
HOCPVLPITVM
INSTAVRAVIT
EXORNAVIT
ETAVXIT
AN·D·M·D·
XLIII

Fig. 318.

EXAMPLE OF 'RAISED' INSCRIPTION IN MARBLE. ITALIAN RENAISSANCE.

Fig. 319.

INSCRIBED INSCRIPTION IN ROMAN STONE.

By Mr. H. Fincham, to the memory of Father Adrian Fortescue, at St. Hugh's Church, Letchworth. After the manner of Italian Renaissance 'incised' inscription cutting.

handsomer treatment of the inscriptional standard letters. In any exposed situation the use of serifs with the raised forms seems at once inappropriate, since if finely executed they will soon be damaged; if bluntly done they will be self-contradictory; for fine serifs are needed for the true beauty of inscriptional letters. One can hardly imagine beauty in block-cut marble letters or sausage-ended stems; yet these would, in a raised inscription, be the workmanlike letters intended for out-of-doors in our climate.

The folly of attaching raised metal letters to stone may be adequately viewed by any Londoner now regarding the entrance from Trafalgar Square to the Mall.

One may safely say that our standard inscriptional alphabet can only be advantageously used—incised; and the incision should be a V of an angle less (certainly not greater) than 60° to show well in the light of our climate.

In the manuscripts the use of solidity in letters is comparatively late, and sparingly or most carefully employed. The thickness is even then but slight, and no letters ever cast shadows; and the practice connects itself with the use of 'raised' gilding. This in itself arose, one may suppose, not from any desire of raising the letter into prominence so much as of providing a ground smooth enough to receive burnishing, which the parchment or vellum, owing to its texture, could never sufficiently do. On the introduction of gilding, the gold is applied with little or no ground, perhaps a mere gum, and not very successfully burnished. Later the gum or size contains plaster of Paris or whiting for smoothness. But this adds some necessary solidity, which became exaggerated at times, until we find this effect rejected once more by the fifteenth century, when many French and Italian MSS. show the gold exceedingly brightly burnished and yet set upon a gesso so improved that it hardly raises the

NDVLGENTIAM PRO ANIMA DILECTA

A · FORTI · SCVTO · S · T · D

E PRIMI RECTORIS · NATVS DIE XIV~

LXXIV POST STVDIA IONDINII ROMAE

CITER PERACTA CHRISTI SACERDOTIO

ES ORIENTALES PERLVSTRAVIT VT SACRA

A PENITVS COGNOSCERET QVA DE RE

ES FVIT SEDIS APOSTOLICAE · TANDEM

C DEMVM COMMORARI STATVIT VBI

IFICATA IPSE FORMA FACTVS GREGIS

DOMINO ERIGERET ATQVE ORNARET

Fig. 320.

A PORTION OF THE LAST INSCRIPTION BY MR. H. FINCHAM.

For comparison with the following, of the Italian Renaissance.

PHILIPPVS DECIVS SIVE DE DEXIO
RISCONSVLTVS CELEBRI FAMA NOT
LOCVM STVDII IN IVRE CANONIC
ISSET PISIS SENIS FLORENTIE PAD
VLTRA MŌTES IN CALLIA REVOC
EXCELSA FLORENTINOR REPVBLIC
STIPENDIVM MILLE QNGENTOR
PRO LECTVRA CONSECVTVS FVIS

Fig. 321.

PORTION OF ITALIAN RENAISSANCE INSCRIPTION.

letter at all. In fact, the theory of raising gold letters in books does not imply a consequent solidity, but a wish that they should be really gold, with its metallic quality, and not gilded parchment. And this quality of gold always needs a slight ' bossiness ' to be successful. Gilded planes are not successful. And yet the commonest mistake in fascia-painting is to write thereon flat gold letters, giving thus the richness supposed to be inseparable from ' gold ' with one hand, and with the other, as it were, taking it away by painting it on the flat surface, with the falsity of imaginary thickness and a shadow to obviate the technical defect.

Far better is the refusal of gold, where it cannot be thoroughly well used, and the contentment of using a colour on another well-contrasted colour, where there may be no necessity even for the strength of an added outline. And if the letter forms be well rendered they will need no trick or device to gain significance or impressiveness, no enrichment of unwarranted solidity or support to give them stability or dignity.

If decoration be desired, further than our standard alphabets are in their stately simplicity calculated to provide, it is safer to add it from outside than to deform the letters by excrescences and swellings and cleavages and mouldings and groovings and patternings into producing it by themselves. The historical development of the illuminated letter from its plainer ancestor may be urged to the contrary ; and if this were thoroughly studied and sympathetically followed by the sign-writer he would no doubt do most excellent work. But the study would need to be long, and the pitfalls awaiting the mere explorer for ' dodges ' so numerous that it is safer to say that the letters should be left alone and the decoration added by reference to their lines of growth indeed, but extraneously.

This letting of the letters alone means that we need

JOHN·PARSONS·HASTINGS·CHARITY

1907

A sum of £300. the interest whereof is to be distributed annually at the discretion of the Rector and Churchwardens, in fuel or other articles of household consumption among the deserving poor of the parish of Martley was given by the REVᴰ. JAMES FRANCIS HASTINGS, CHARLES PAGET HASTINGS Eꜱꞯ & Mᴿꜱ ELEANOR ELIZABETH LLOYD, in memory of their Father, the REVᴰ. JOHN PARSONS HASTINGS, Rector of this Parish 1875 to 1907

Fig. 322.

PAINTED PANEL BY L. MacDONALD GILL.

Showing the lively and characteristic adaptation by the brush of standard letters.

to return to the primitive consideration of them as marks upon a surface, having only two dimensions. And yet this cannot be quite so. For while we deny them thickness, we still require of them stability—which implies at least an attenuated substance. We conceive of them as ' standing ' upon a line with a certain vigorous stiffness, not flapping thinly or hanging limply from a line. And one of the dangers we have to guard against in consequence is the tendency of some ill-made letters to roll, and of others to totter and fall if unsupported or ill-balanced.

If this theory of but two dimensions be accepted, the writer's endeavour will be more simply concentrated on good form, fair proportion, and the right use of his tools—which is enough for any man. He is a painter of the surface, not a carver nor an engraver ; and his expression lies, apart from form and proportion, with the ' quality ' of his effectual painting. Let him be reconciled to the simplicity of the mere surface and the pattern of appropriately contrasted colour his well-painted letters make upon it. Too often is the writer inclined to think that not enough can be made of them without introducing the appearance of something else ; that his dexterity or imagination may be applauded, and the reader read not with comfort so much as admiration. But the consideration of the purpose of lettering should incline him to regard it continually from the point of view of the reader, who is not interested in and would indeed be hindered by novelties of original distortion or intricacies of imaginary material. A painted wooden panel is not a sunset, nor are letters blocks or drain-pipes that can be made to catch the glow. The panel is just paint, and so are the letters upon it. But they can be made to convey their message very agreeably all the same ; as the refinement of style in a speaker is consistent with self-denial in the matter of rhetoric, and words of the simplest use.

Fig. 323.　　Example of Incised Minuscules, in the Renaissance Manner.　By Percy J. Smith.

It is the arrangement of them and their natural delivery that matter.

Yet in spite of what has been said, letters have something more than the substance necessary for their stability; they should have vitality. Their stems spring from the ground; they have, when well drawn, a vigour as of growing things, not the strength of posts and rails. They can never, therefore, be satisfactorily drawn with compass and set-square, but need the free hand to give them this expression, an expression our ubiquitous printing is robbing us of the power to appreciate. The sign-writer can always introduce it, and should never disregard it. In Chapter XI, where I have spoken of the construction of the capitals, I have already alluded to this, in respect of the stems, and the very natural analogy which finds pleasure in the slight spreading of the top rather than the base and the delicate tapering of the waist between.

Fig. 324.

But the analogy goes further, where either the letter is made to provide the root of ornament outgrowing from it, or is the boundary or frame for ornament set within it. Letters have, in fact, lines of growth, and the ornament should acknowledge this. Thus C grows towards the points, not away from them, and ornament should not ignore it, as Fig. 324, however well such ornament might fill the space.

E's growth is outwards along its limbs, not as shown in Fig. 325, nor downwards from its stem. But with A, ornament springs naturally in the direction shown; B and N similarly (Fig. 326). And, in general, the very drawing of the letter will tend to show the writer the direction in which the ornament should spring from it, or

Fig. 325.

pass when accompanying any letter. Only the very symmetric letters, as H I O T, convey puzzling suggestions of several alternatives.

PRINTERS' INITIALS. II
AN ALPHABET OF ROMAN CAPITALS DRAWN
IN OUTLINE WITH ORNAMENT SET UPON
A BLACK BACKGROUND; DESIGNED BY
THE AUTHOR AND MISS I. D. HENSTOCK

This alphabet is also adapted for 'illumination,'
the letters being gilded, the ornament
toned delicately with raw sienna (like
ivory) and the background filled in with
blue, red and green, blue predominating.

This natural analogy precludes us (as indeed the technical authority of penmanship does yet more strongly) from imagining letters with thin stems and thick limbs or branches. Our instincts would instantly reject the HE or T, shown in Fig. 327, however well drawn and beautifully proportioned otherwise.

Fig. 326.

We feel they are unnatural, because of this attribution

Fig. 327.

of vitality to our forms; and endeavour to make our inventions conform to the observed order of nature's pleasant environment.

This analogy of growth, however, relates far less to the minuscules, where the pen with its single downstroke of regular width has standardised a more mechanical expression. Yet even here there has been the

Fig. 328.

feeling for the budding and playfulness of flower and leaf, as is evidenced by the tops of the ascenders of many centuries (Fig. 328) or such spontaneous ornament as the constant trefoil of the Book of Kells (Fig. 329), or the tips shown in Fig. 330 in innumerable instances.

Fig. 329.

Fig. 330.

The want of success of much modern decoration comes of disregard for this vitality of letters with their consequent lines of growth. The decoration, apart from other

inconsistencies, ignores the suggested direction or acts contrary, and is inharmonious at once, the reader feels, whether he recognises the cause or not. Even in the fifteenth century we have initial letters set upon a little square of background, with a spray of some sort coming out of one corner or as may be ; and the letter may be an I or an O, an H or an S indifferently. The sprays behave with no regard to them. And often, indeed, the backgrounds are but as little mats upon which a letter, usually far too small, is dropped ; so that they have no necessary connection. The older illuminators never did so, but treated their letters much more organically always. The construction of his ornament should, therefore, to be consistent and harmonious, always proceed from or acknowledge the lines of growth of the writer's letters, recognising that letters, to be satisfactory, should have this spirit or vitality we connect with growth and vigour, and prefer to lifeless geometry or mechanical perfections. The initial letters to the chapters of this book have been decorated in accordance with these general principles.

CHAPTER TWENTY-ONE

OF LEGIBILITY

ONSIDERATION of legibility is apt to take too small account of the variety of service to which modern life applies the alphabet, to assume that some general standard is compatible, if scientifically ascertainable. It is usually devoted to the legibility of ' print ' without reference to the many influences which go to modify our judgment of this ; for as soon as these influences are admitted, the problem appears altogether too complex or indefinite. Yet these influences persist ; and the judgment, which discriminates between the legibility proper to a sky-sign or a danger-signal at one extreme and that of a cipher or monogram at the other, is affected when it comes to consider a book or newspaper in ways which may not be easily apprised scientifically, but yet cannot be disregarded in practice. For everything we read exercises our capacity and develops habit. Legibility is the result of habit in the main, and of habit hardly stable in the individual, but subject to slight modification in its exercise ; and different in different individuals. Mr. Weller senior's was derived from the Way Bills.

The individual also applies different standards of legibility to the words he meets, designed as they are for various purposes. The sort needed for warning of a river's weir or at a level-crossing is not the sort we look for in a book, but it is an important and increasing sort. Its intent is to command instant, unhesitating recognition, in a flash, at a blow. It is comparable with the intent of

the voice of the drill-sergeant, of whom Stephen Graham writes : [1] 'The characteristic word of command was not merely enforced by firmness, by peremptoriness, by loudness. The vital thing in it must be menace ; it must be an intimidating bawl, and must not only be heard, but must act on the nerves.'

Similarly the graphic bawl has its uses, legibility at its maximum. But this is not what we mean by legibility, wherein we imply rather the word of civil intercourse than that which who runs (or motor-cycles) may recognise as by explosion ; while the command needs only be concerned with a clarity indisputable. So in some American public gardens the board on the grass is reported to bear the legend : **KEEP OFF. THIS MEANS YOU.** The consistent alphabet need not bother about civility. Or the clarity may be designed in express consideration for us and yet require naught else, as in the frequent warning : **TARRING IN PROGRESS. CYCLISTS ARE ADVISED TO WALK.**

For all such purposes the block letter seems proper enough. There is no doubt of its legibility when reasonably proportioned and used as large as circumstances will allow. And the proof of this is afforded by the general use the advertiser makes of it, without considering what right he has to adopt the drill-sergeant's method towards everybody. Roman capitals have been declared by a prominent advertising agent to be ' no good for advertising.' They do not hit you in the eye.

The advertiser with a sense of humour has also recognised a commercial advantage in slapping us on the back. He often imports a facetious clumsiness or playful distortion into his forms, developing a sort of legibility of caricature. Mr. John Hassall, in his picture of the vacuum-cleaner, has written the one word 'ELP as well as it could be done for the purpose. In an American

[1] *A Private in the Guards*, p. 213.

hat store, at the entrance to the juvenile department, the invitation LIDS FOR KIDS needed rather more lively treatment than blunt block capitals, on the one hand, or the gentlemanly Trajan column, on the other, could afford. Indeed the Trajan column is a new peril, and I have seen in a tailor's shop-window the ticket, IDEAL CHRIST- MAS PRESENT rendered with all the taste and distinction of the style—which is the latest stunt of puffery. The greater the revulsion then when the refinement was recognised as connecting Bethlehem with a trouser stretcher.

Legibility can even be effected by the determined negation of conventional method. In the neighbourhood of Camberwell Green used to appear the words ƎЯOTƧ YDNAƆ over a shop window. One read them at once—and remembered. All this business of ' catching our eyes ' is necessarily having its effect upon them. The classic forms of the Roman capitals are becoming too slender, too elegant. Size or exaggerated isolation is also disconcerting traditional arrangement. And, in general, our standards are being attacked and degraded by the uses to which our commercial activities are putting the louder sorts of legibility. They have intruded extensively into the Press. The newspaper is an uproar of headline and advertisement ; the magazine page is alternated with advertisement, and scatters others over you as you open it ; the ' weekly ' or ' monthly ' can no longer be bound into volumes with any decency.[1] And in all these riot the sorts of alphabets that are legible with the legibility of the business man who knows what he is doing—getting his stuff read.

One needs constantly to remember that the history of the hoarding has been quite different from that of the book designed solely for ease and beauty. Its track lies back to the mural inscription and the

[1] Let me at once except *Punch*—with thanksgiving.—G. H.

development of this from dignified proclamation into competitive uproar.

In another direction tradition is also assailed. The typewriter is so common, and its output so general, that its necessary method of interspacing letters has ceased to annoy. It is now taken for granted. Type-founts have even been created in imitation. There can be little doubt that our standard is being insensibly modified in this regard, and our sense of rhythm blunted.

The traditions with books, however, still prevail ; but if they are to be preserved, scientific analysis, in its consideration of the legibility appropriate, needs to take cognisance of all these latter-day influences which tend to tamper with it, and in particular to determine how far the clarity of loudness is detrimental to the comfort of sustained reading. At present there is nothing but custom, continually being attacked by these noisy methods, which hinders the introduction of types that shall adopt somewhat similar tones, under the impression that their legibility, established as it appears to be by the hoarding, is strictly applicable to bookwork and only hampered for the time being by what are depreciatingly called ' æsthetic ' or old-fashioned considerations. To most persistent readers the virtues of good type would seem to be chiefly negative. Not to be asked for admiration, not to be hindered by offence, are equally desirable—to listen, as it were, to the flow of a well-modulated voice, neither monotonous, nor emphatic, nor spasmodic—this is comfort in legibility for long spells. Even speed of reading, combined with accuracy, does not suffice to recommend if the reading tires or strains. We need ease, and the negative pleasure of absence of any particular effort. For such purposes the considerate printer studies convention, the prevalent habit of ordinary folk ; but without enough assistance so far from the physiologists and ophthalmologists as to the admission of the innovations with

which modern life is continually assailing or modifying convention.

The scientists have hardly been ' popular ' enough over the matter, and in especial have underrated the great influence which the apparently ungaugeable ' æsthetic ' consideration imports, the peculiar inheritance in the craft of printing from the Italian Renaissance. Yet such an inheritance from so gifted a people is a fact very relevant. It is part of our ' system,' in our blood. It is one of those too few cases in which good taste is natural to us—and therefore within the purview of science ; the beauty and utility vitally merging for our good. The scientists have already established one or two instances in this connection —as that ' tests of numerous readers of print of various founts of type have shown that the vast majority prefer thick and thin strokes for the sake of legibility ' ; though this proves little but that people prefer what they are accustomed to. But who doubts that ? This is to dis-cover the obvious. And in this matter it is not to be forgotten that there can be no independent witnesses. Every one who reads has formed a habit, and the illiterate cannot testify to legibility.

The other instance is the advantage of serifs to counter-act irradiation ; the fact as to this last being that they were put on for that simple æsthetic purpose, common tidiness, and have served the scientific one to boot.

It has been said that the conventional is unrelated to practical needs, but the truth is rather that the practical needs are now those which convention has established. It may be well, then, to regard the whole matter from the point of view of convention, in order to realise why legibility has come to accompany the methods we employ ; and to start from what may seem the wrong end, the making of letters instead of the reading of them—this very business of the scribe (always remembering, how-ever, the problem of the priority of the hen and the egg)

—since the necessities and conveniences of construction have plainly a very important bearing upon the beautiful utility of the thing constructed and the subsequent conventions resultant. For legibility, though variable and contemporary, is dependent on the customs that have prevailed and persist ; and the customs have been based on the scribe's convenient methods of construction with the tools and materials found suitable. It is the scribe who created the legibility we inherit.

And here our printers have been rather unsusceptive of very available assistance. They have indeed acknowledged the derivation of our established founts from the calligraphic scripts or book hands of the Italian Renaissance, but have been content to photograph or copy without sympathy or practical inquiry into the reasons for the thing as they found it and adopted it for mechanical reproduction. They have accepted the traditions and maintained them, but now find themselves somewhat at a loss to justify their conventional method, when it is assaulted or called in question by the ignorant or the innovator. They have overlooked the thousand years of evolution of technique by the hand, the ages of practice by which the scribe achieved the legibility they are imitating, and the fact in particular that the rules of the game were all settled before ever they arrived.

And since that time it is a cause for thankfulness rather than reproach that through its five hundred years of practice the printing press has observed the traditions so loyally that it may be said to have invented or originated nothing of itself, except the title-page. The format of books is the same as of old, with the marginal proportions retained, save where parsimony has begrudged them ; though the folio and the double column are certainly less frequent, not suiting modern requirements of size and ease. The headline is still with us. The position of headings, the commencement as by steps down from a

large capital, through smaller capitals, to the lower-case
(evidenced in any prayer-book) remains as established by
the eleventh century. The practice of indenting the
start of the paragraphs instead of extending the initial,
wholly or in part, into the margin is certainly a variant,
but only so for the technical alternative reason. The
indenting still acknowledges the propriety of commencing
the paragraph with a fresh line. The unit of the book is
still the full opening (although our books and MSS. alike
begin on a recto) ; and the discomfort of departure from
this custom is well instanced in such a decoratively inten-
tioned example as the *Omar* illustrated by E. Dulac,
where the recto throughout the book is quite swamped
by the blankness of the verso.

And with the text itself perhaps a more detailed
examination may be admitted, which can best be presented
by some remarks on legibility from the point of view of
the scribe, endeavouring to apply appropriate labour to
the task of writing that may be fit for the occasion. For
with the scribe the question of speed comes into account.
The legibility of the printed types is unaffected by such
a consideration.

There were, at any time, various degrees of polish and
pace between the set formal or book-hand of a period
and the cursive of everyday use—with consequential
degrees of legibility. And throughout the development
and practice of the Roman alphabet the cursive has con-
tinually tended to modify the formal, substituting simpler
form as well as speedier manner. So that between the
two ends of the scale was ever a sort of compromise
which may be called semi-formal or semi-cursive. Our
present lower-case letters are due to this tendency of
the scribe to modify for speed's sake, when the Roman
cursive developed the half-uncial from its forerunner.
We have, fortunately, in the British Museum an example
of the method of one Marcus Vicentinus, showing how

a scribe, of later times, indeed, but still illustrative enough,
varied his hand for the sake of speed (for his formal
method is also extant), in a funeral oration written, as he
remarks, *calamo volanti*, no doubt against time for the
particular occasion (see illustrations at p. 61). We have
also a whole Cæsar's *Commentaries* (B.M., Add. MS.
16982) written in one of these semi-formal hands in the
space of little over a month, and many more.

But while the need of apportioning appropriate labour
to particular purpose rendered his work more or less fit
to be read easily, we find the scribe applying certain general
principles to his performance, which render the perform-
ance good and fit; and that these principles are connected
with certain primary human instincts. There is the
instinct for regularity or uniformity. Irregular writing
has always been bad writing. We ever recognise the value
of order. Order is natural; and though writing may be
said not to be natural, since it has no counterpart in what
we usually mean by nature, yet we find ourselves by very
natural analogy applying the demand for order to our
writing if it is to satisfy this instinct.

Then also we observe in nature as natural a tendency
to *disorder*, or that variety by which evolution proceeds.
And in this matter of writing the want of sufficient variety
becomes monotony, and the writing, as we say, mechanical,
recognising indeed that the personality of the individual,
as compared with machine production, is generally assur-
ance against this defect ; but requiring also that the letter
forms themselves shall differ sufficiently no less than that
they be sufficiently uniform. For we recognise that such
writing as Ogam inscription, or indeed some fifteenth-
century ' black-letter ' is deficient in this respect. To be
satisfactory and legible in the superior sense, writing must
display the quality of variety modifying order, with a due
proportion of both.

Another deep human instinct is for power or control,

which in this connection is the desire and display of ease in performance, the slick doing of the work, a facility which shall acknowledge counterbalancing demands duly considered in respect of labour for the particular occasion, but shall assert its claim on every occasion.

With these instincts within him the scribe applies certain elements in good writing, which seem to group themselves under the three heads of clearness, speed, and beauty. And though one must needs be set first and another last, it were safer to regard them as a sort of triangle of forces, the sides varying in length, according to occasion, but ever preserving equilibrium. So that now the purpose may demand more speed than clearness or beauty, as in the funeral oration above-mentioned ; now more beauty than clearness or speed, as in the device of some monogram or the decorative employment of some inscription ; now more clearness than beauty or speed, as in some public notice or proclamation. Always, however, even in the beautiful formal hands of mediaeval MSS. is observed a certain respect for speed, no superfine exquisiteness of detail being allowed to prolong unduly the doing of the work. Similarly, in a good cursive hand beauty will be very apparent, the beauty of swift, clean workmanship inseparable from the mastery of an appropriate tool. Or yet again, as in sign-writing, the writer, whatever his beauty or clarity, must be so reasonably speedy over it as to render it of practical service. These matters are ever cases for compromise. There was never any dodge discoverable for writing a lightning hand as clear and beautiful as the Lindisfarne Gospels. It had needs to be clear *enough*, rapid *enough*, beautiful *enough*. And what is enough of each depends upon purpose, the demand of the particular occasion.

The elements which go to form these groups making for clarity, speed, and beauty are set out in the next three chapters.

CHAPTER TWENTY-TWO

LEGIBILITY. CLEARNESS

THE elements making for clarity would seem to be :

A. Sufficient difference between the tones of the ground and the ink or colour used. This is perhaps too obvious to mention. But the love of staring white paper is common. Buff or pale yellow is reported to be preferable. The ancients' vellum or the unbleached linen paper gave their work at once an agreeable introduction.

B. Convention in forms and arrangements. This is perhaps more important than any other element for clearness' sake. The desire for ' effect ' or ' originality ' is continually attacking it, no less than the carelessness of the ignorant. As well might one hope to be intelligible by coining new words or mispronouncing the usual ones as legible with unaccustomed letter-forms. The determined revival of classic usage at the Renaissance was as positive a change as writing seems ever to have undergone, previous change having been rather by gradual evolution, slight modification, never sudden creation. Our custom is inherited therefrom, our convention that of the round Italian forms. And these forms are superior in legibility to us for this reason, though not entirely. Unconventionality may be either of form or manner, with equal illegibility.

In Fig. 331, for instance, the presence of the archaic *t* is sufficient to obscure it, though the manner of the writing is one to which we are accustomed. In Fig. 332 the forms are ordinary, only the manner is angular and

invariable. The one, however, would have been perfectly
legible to a reader in the eighth century,
and the other in the fifteenth.

Fig. 331.

And as regards arrangements, we
hardly appreciate how entirely conven-
tional they are, and that it is but
custom which rules that our writing (and printing) proceeds
from left to right, instead of from right to left, as with
some other nations ; or perpendicularly,
as in the Far East. There seems no
optical advantage in our own conven-
tion. Our very alphabet was once
written from right to left, with the
forms of the letters reversed, and later has known a
stage when the lines read from right to left and from
left to right alternately, with the letters facing alternately
also.

Fig. 332.

The upright oblong of our pages has rather more than
conventionality to recommend it. The horizontal oblong
would certainly tend to muddle our eyes at the end of its
longer line in recovering position. The short line is
always favoured. But if it were
not that convention has established
the double page as the unit of our
books,[1] one might easily imagine,
in an age of ever thinner paper,
and a custom affirmed of printing
upon one side only, that books
might cease to be rectangular, and

Fig. 333.

a form adopted to assist recovery of position by the eye
on a page shaped as in Fig. 333.

C. The letters, besides being conventional, must be
uniform or regular in various respects, as in height,

[1] A convention, alas ! already being attacked, by some insidious process of
the printers' compositors' convenience in dealing with MS., as also that of the
typewriter.

breadth, method of construction, direction, alignment. They must be all of one family, or rather of one regiment; and they must follow one another without any sort of unevenness. The stems must be equal in thickness, the gradations even and evenly placed : a matter the pen assures. The serifs, a detail generally, should also be regular, for only then is the reader allowed tranquillity to read. Playful or variable serifs are, in particular, a hindrance and distraction. And of this order of hindrances are the unnecessary diagonals given in fancy founts and by some writers to the second downstroke of *h* or *n* and the third of *m*. At the same time, orderliness can be carried to excess, and, in the word ' immunity,' instanced above, the exaggeration of this quality, and the adding of narrowness thereto, until its expression to us is as of a row of park-palings, becomes mechanical and unpleasant, and the manner of the fifteenth-century ' black letter ' demonstrably unsound.

By our natural analogy we recognise the importance of the next element of clearness.

D. Variety, that is, sufficient difference in shape as important as sufficient uniformity. There needs to be enough difference between the forms of letters to render discrimination easy and reading unlaboured.

The habit of reading renders us content with very little. It is well known that we do not read so much by regarding the individual forms as by the prompt recognition of the shapes of the bunches of letters which compose the words. As anyone can attest who remembers occasions on which, reading rapidly, he has *mis*read, solely in consequence of this habit, such similarly shaped words as ease for case, daisy for dairy, poison for prison. Such misreading, no doubt, evidences the occasional failure of our letters to be different enough. The general evidence, however, does not seem to call for change.

With regard to the capitals, hardly any combination

tends to obscurity, save perhaps the case of IVI, mistakable for M, and vice versa. And with the minuscules there are only the instances of *b* too like *h* (especially some italic *h*'s), *i*, *u*, *m*, and *n* confusable, and possibly *cl* and *d*, that occur to the mind readily. We may congratulate ourselves, on reading Canon Isaac Taylor's remarks on certain Arabic letters : ' These forms are so undistinguishable that it has been found necessary to invent a whole apparatus of diacritical points to enable the reader to recognise and identify them, and they are now written in the following troublesome fashion * * * *. Thus the action of the law of least effort has had the curious result of increasing instead of diminishing the labour of the scribe.'[1] Our *i* and *j* are the only two letters in which we have need of these objectionable diacritical points.

E. Compactness. This, perhaps, it were needless to notice if it were not that some teachers of handwriting have advocated a system of widely separating letters of words with a length of connecting stroke, entirely disregarding that method of reading by bunches mentioned above. Letters need to be well set together ; and any straggling tends to delay and illegibility—as we all experience when we read those thin columns of spread-out letters set beside ill-fitting illustrations in the pages of some magazines.

F. Simplicity. This obvious essential is one the seeker after some positive beauty in script or type is apt to lose sight of in his constructive efforts. Here beauty no less than clarity comes of self-denial, that ' absence of many things,' which nowadays can only be achieved by the ' rejection of many things ' ; conscious trial, that is, and refusal. Our letters need consist of but few elements and little detail, this little most carefully selected. A thick stroke, the contrast of a thin stroke, the gradation from one to the other in a curve, and all this as short and

[1] *The Alphabet,* Vol. I., p. 162.

compact as may be, but tidied up at the ends so as not to be blunt or rough—these are all the details necessary for clearness, as indeed for beauty, when appropriately ordered and diversified. Superfluity or excess of any kind immediately tends to obscure.

LEGIBILITY. SPEED

A s simplicity is desirable for clarity's sake, so is it obviously helpful towards speed. So that in the group of elements affecting legibility under the head of speed one may again assert simplicity, but here rather from the point of view of:

A. Economy of means to ends, the end being here ease of expression. This means that the forms and necessary differences and details must be easily expressible or comparatively so, and that all writing done with excess of effort and expenditure distracts the reader with wonder or sympathy over the performance ; and so hinders the proper business of reading what is there to be read. A formal hand may be overloaded with detail until it becomes as burdensome to the reader as to the writer. At the other end of the scale some cursive may easily omit too much— until it becomes a personal shorthand or substitute for handwriting.

B. Uniformity of method. The method of using the pen needs be uniform and regular for speed's sake, as uniformity of result is necessary for clarity's sake. The action for the various letters should be similar in similar detail and direction, with no shifting or twisting of the pen for exceptional treatment. Smooth work must have proceeded smoothly and evenly to impart that sort of ease and confidence to the reader which the hearer of a fine player enjoys for what is to come. And notice may here be taken of our capital M and N, the Renaissance forms copied from inscriptional prototypes. These are not pen

forms so much as chisel forms, and can only be rendered
rather coarsely by the pen unless it applies an amount
of special treatment which is not workmanlike in its
disproportionate labour.

C. With penmanship downstrokes should do most
in the construction of form. The fewer and less im-
portant the upstrokes the easier and speedier the writing.
This applies to formal and cursive alike. Indeed, with
formal work precision of execution depends chiefly on
the downstrokes for effectiveness, the downstrokes being
joined together to form the letters carefully, which in
cursive are rendered more dashingly, with a continuous
and, of course, still swifter though less trustworthy line.
The *o* in formal is made with two downstrokes, in cursive
with a down and an upstroke. The reason for the more
confident ease of downstrokes is plain ; in contracting the
necessary muscles we retain more control than in extending
them. For us these pull-strokes are easier than push-
strokes. Yet one must not forget that the superb pen-
men of the East, writing from right to left, push rather
than pull their pens for many of the strokes (all the
horizontal ones), which for us are pulls.

And the matter of speed involves some consideration
(and choice) of general method in rendering the letters
for cursive without too much deformation. Many literary
men (certainly before the coming of the typewriter) have
been known to use little but
downstroke, proceeding by
a series of dabs or pecks
(Fig. 334). In the Victoria
and Albert Museum the
change in Dickens' hand from the time of *Oliver
Twist* to that of *Edwin Drood* shows that much
writing had greatly reduced the upstrokes. Others
have adopted a streaming line, until their *m*'s and *n*'s
and *i*'s and *u*'s are represented by a slightly un-

Fig. 334.

dulating horizontal, and even the words are inter-
connected (Fig. 335).

In Chapter V notice was made of the preference by
some for an ' overhand,' and by others for an ' underhand '

Fig. 335.

action, in obviating the hindrance caused by the necessary
change of direction in expressing the different letters.
Consideration of speed needs some amplification now of
this matter. For it is the break in continuity of action
which tends to hinder.

If anyone will examine the following pen actions

Fig. 336.

he will find that No. 1 is the easiest of all to perform,
and that though direction is reversed for down and
upstrokes, there is little delay or hindrance, simply
because the brain is not called upon for more than one
general instruction. Similarly with Nos. 2 and 3, which
are almost as easy ; 2 being slightly easier than 3 on
account of the pull stroke downwards predominating, as

is evidenced by the greater number of writers using this
action rather than 3. In 3 the upward curve pre-
dominates with more push in it. In No. 4 the double
curve is yet not difficult, because again the brain is not
called upon for more than one general instruction, which
indeed alternates the action, but no more than in walking.
But in Nos. 5 or 6 the brain has to redirect the action into
the straight after each curve, and though the downstroke
of 5 makes this easier than the upstroke of 6, they are
both more exacting than the previous actions. No. 6 has
been used for some Renaissance cursives, so that *in*
becomes indistinguishable from *m*, etc. No. 5 so much
obscures the *m* and *n* that it has never been adopted
save in some modern careless hands — and rather
frequently.

The action of No. 7 is what our conventional alphabet
demands for careful writing, even cursive ; and the
amount of control and redirection by the brain at once
explains its necessary slowness, as if in walking one
should need repeatedly, yet irregularly, to be changing
step. No wonder, then, that many writers have from the
Renaissance onwards adopted the easiest method of all,
No. 1, and this in spite of the equal malformation of
the *m*'s and the *u*'s ; with a general detraction from
clearness thus exercised for the sake of the speed, which
the saving of brain control permits (see Ascham's hand,
Fig. 19, p. 52).

In all, the continuity of stroke, the pen not leaving
the surface, is relied upon to ease the performance. But
this, as observed above, with many hands becomes super-
seded in time by the pecking or dabbing spoken of. This
dabbing action somewhat assists the change of direction
in the *m*'s and *u*'s, which with the pen continuing on the
paper tends so easily to malformations, such as *am* almost
mistakable for *arn*, or *ne*, *we*, etc., already noted in
Chapter V, Figs. 54–57, p. 66. Moreover, it eliminates

the loops, with which every one becomes sooner or later disgusted, as superfluous and disfiguring.

The continuance of the pen on the paper is the only reason, apparently, why loops ever came into being. And where that action is negligible by the individual for speed's sake, writing is certainly better without them. And that this continuity of line is not necessary for speed is very evident from the fact, above all, that no shorthand adopts it.

D. Comfort in writing. All matters relating to his pens, ink, paper, desk, seat, and lighting need be considered by the scribe ; though the sign-writer or carver rather need, wherever possible, to work *in situ* and take counterbalancing advantages of fitting performance to override such personal considerations. Of pens, ink, paper and vellum I will make mention in Chapter XXV, of materials.

The desks of schools are necessarily adapted to general use in class. Yet for writing, if they could be adjustable to a slope of 45°, they would be better. And if a flatter slope be unavoidable, it were almost better if the whole desk were generally lower, that the writer, bending over, might bend at the waist, instead of humping himself up to reach enough above it.

And his work (his writing lines) need not be horizontal in front of him. I think this is a matter in which the individual may be left to adopt the position most comfortable to himself in this respect. Certainly a ' flat ' hand can be written more easily with these lines tending from S.W. to N.E., provided the eyes can be relied upon for the perpendiculars ; for rigidly horizontal lines tend to force the right elbow crampedly into the side, despite the pen's obliquely cut edge.

The paper at a desk adjusted to an angle of 45° or so can be best kept from slipping by tying a piece of broadish tape tightly round the whole desk-top. The paper slid

under this will be held in position efficiently. And under-
neath the paper should always be kept a clean sheet or
two of blotting-paper, otherwise the grain of the wood
will obstruct the writing. Above the paper also, between
it and the hand, it is always advisable to keep another
piece of blotting-paper or a piece of flannel to protect
the surface.

As regards lighting, for ordinary black and white there
may be too strong a light. The strong contrast of white
and black is inadvisable. The light in an ordinary room,
not necessarily close to a window, is ample. But it should
come generally from what I may call the N.W. of the
paper (supposing it a map) and not from the W., or (worse)
from the N. And, of course, E. or S. are out of the
question.

As regards seating also the writer's position should be
easy, not too high or low. I myself have always worked
on an ordinary flat-seated chair, but one with a slight
tilt forward is preferred by some. I have found myself,
too, often resting also on my toes, as if in a Sam Weller's
anxiety about the performance, though I restrain my
tongue ; but am sure that the soles of the feet should be
set firmly and flatly on the floor.

Cold fingers are a trouble in winter-time and need
more consideration of loose sleeves than women, and
even men, are apt to give. Such matters as one's circula-
tion, like one's eyesight, become important in the long
run. I have always endeavoured to keep students' eyes
at least a foot away from their paper. But not even
oculists can do this. Every consideration that promotes
comfort and ease assists speed.

Another small detail is the conduct of the left hand.
This, with all careful work, should be guarded from the
surface, like the right. It is, however, needed to keep the
parchment, and even paper, from the tendency to rise
between the pen-strokes, which interferes with calm

progress. The ancients seem to have safeguarded this with the penknife held in the left hand, as may be seen in any picture or miniature of scribes at work. But they always have the point of the knife downwards, which I have found dangerous. Using an ivory-handled scalpel for pen-cutting, I have reversed this for the present purpose. And its haft is like the thin paper-knives so unnecessarily sold for slitting envelopes. One of these or a bone penholder would, of course, serve admirably.

As to the actual position of the hand in writing there has been too much dogmatism concerning an action which seems to demand personal accommodation after all, as every person's physique slightly differs. In a general way the pen needs the thumb and first and second fingers for guidance, the others for ' purchase ' ; the thumb to thrust to the right, the first finger to pull downwards, the second to push to the left, so that this should not be resting on the pen parallel with the first, as sometimes advocated. As to the third and fourth, the farther they can be drawn backwards towards the wrist the longer downstroke is available for the writer, especially useful for drawing tall spliced letters. But most of us prefer them bunched fairly closely under the first two ; and most of us use the top joint of the little finger for a pivot, with the wrist also resting on the work for assurance. Certainly writing is finger action rather than whole-hand action, though I have seen a writer compelled by habit to work with the whole hand and forearm stiff from the elbow.

There are here three illustrations given, after drawings by Miss I. D. Henstock : the first of an ordinarily useful pose ; the second with the two last fingers drawn back, still serviceably supporting and steadying the action ; and the last is for a warning to those teachers who find children adopting it. This concave-upwards bending of the first finger hinders its contraction, and consequently

the most useful stroke, the downwards pull. It so stiffens
all proceedings that its adoption will certainly lead to a

Fig. 337.

Fig. 338.

cramped style, and rob the user of all liveliness and
freedom with his writing.

The hand should also never be allowed to roll over on to the lower joints or knuckle of the little finger. Another writer, who writes a most excellent formal hand, has

Fig. 339.

allowed this tendency to develop until the third finger is in danger of smudging the line of writing above that in process ; an example of excellent, if perilous, results with what Urbanus Wyss, in his book (Zurich, 1549), well designates as *Inepta calami comprehensio*.

LEGIBILITY. BEAUTY

N the group of elements which make for beauty one needs again to put first :

A. Simplicity. In this business of writing beauty comes of fitness, and all we associate with fitness. There is no ' line of beauty ' in writing other than those the tool is fitted to draw easily and shortly, and our minds recognise at once as fair help towards tranquil reading, our tranquillity being our permanent and indispensable demand upon it. The twirling spirals of expert *tours de force* are not ordinarily beautiful. They are not fit, because they are superfluous (see p. 94). Unfortunately, simplicity in these days is not a simple matter to come by. We are burdened with our inheritance of the styles of the centuries to discriminate and prefer amongst; we spend our lives in a constant state of choice, which implies refusal. We cannot set about the simplest job without deciding what we will *not* do.

A regard for speed and a determination to be uniformly methodical will, however, do much to secure simplicity, and so safeguard beauty of form. By good fortune our standard alphabets, this convention of the Italian round-hand, are in this respect most admirable. They are simple and simply executed. It is not to be wondered at, considering their origin, that the models incline to the expression of majesty and order, satisfying that instinct, rather than to the vivacity and variety which one associates with the craftsmanship of the Middle Ages. The English vernacular book-hand of Chaucer's time, which may be compared with the Italian contemporaries at pp. 44 and 46.

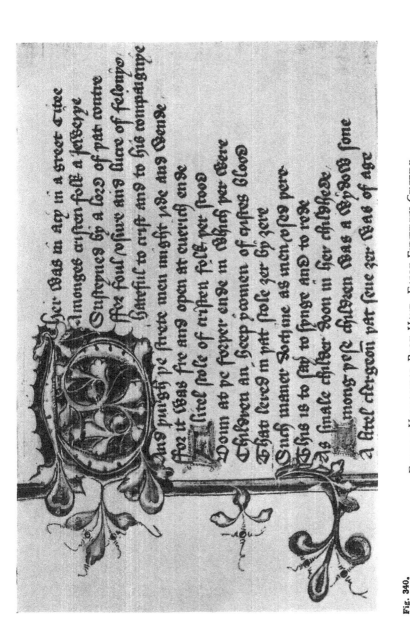

Fig. 340. English Vernacular Book Hand, Early Fifteenth Century.

Chaucer's *Canterbury Tales*. Brit. Mus. Harl. 7334. A vivacious hand compared with Italian Renaissance stateliness and sobriety. Actual size.

To kneel and bide her coming near:

So as she drew towards the door
His eyes were drooped upon the floor,
But his hands held the bowl aloft;
And sure her gaze was calm and soft
As now she stayed and understood
How he had guessed the thing she would
Then gently stooped her dainty chin,
And with her hand she dipped in
And laved her cheek and made it clean,
And lovelier than it ere had been
So done she drew a little air
To see him kneel and tremble there.
And then she smiled and touched his lips

With two angelic finger tips.
But not a word spake she,— nor he.
No riddle over less lacked key.
King Lucas read it doubtfully;
Distraught 'twixt man and king' to see
The glowing crimson flood the cheek
That had been pale and dimmed a week.
This was the end to his fine plan
To give his folk for king a man—
The women come to make a king
Of any metal that may ring
True to the touch of love and chance
And happy set of circumstance.—
So be it. "Is it so," he said?
"Even so," said she, and raised her head.

Fig. 341.

An adaptation by the author of the previous example, with some modification of some of the letter forms for legibility's sake. Actual size.

instances the difference admirably. And I have added
a couple of pages from a modern writing based on the
style (*cf.* Figs. 340 and 341).

B. And again, as it makes for clearness, so does
uniformity make for beauty. Simplicity and uniformity,
therefore, leave us little scope for 'originality.' And here
comparison with speech seems particularly apposite.
Beautiful speech is not original. Indeed one may not be
original with speech without becoming unintelligible,
except with the originality of refinement. Certain in-
dividualities of expression and style will yet be manifest
in every man's speech as in everything he does ; but these
are but personality expressing the conventions. His
speech, if he be wise, is not a jumble of languages, of
neologisms, of catchwords (even the latest), of slang ;
nor his manners a perpetual challenge to the habits of
others. And with writing one needs also to accept the
current standards. There is exercise enough left for
craftsmanship. But the objection is sometimes made
that if everybody wrote in the manner here advocated,
writing would become monotonously alike, and 'char-
acter' be lost. This objection, however, would lie equally
against any system or standard. Writings similar to *any*
copy-book's will be similar to each other. And the
criticism also ignores the impossibility of any two persons
doing the same thing entirely alike. We teach children
to pronounce and to make sentences by certain standards.
They do not speak monotonously by consequence. Every
child's individuality is displayed in everything he does, or
says—or writes.

But this 'character' in handwriting seems to be
imagined as something more than this inevitable individu-
ality, some art he may be taught or ingeniously acquire.
Yet no musician would set about teaching a child to play
the violin 'characteristically.' At most he could but
supply a mannerism, the affectation of somebody else's

individuality. The child who is taught to play well will, besides doing so, in time reveal his personality, his character, to all who know how to listen to violin-playing. He needs, indeed, to learn to play his instrument well before he can express this individuality otherwise than in terms of awkwardness and inefficiency. But what is well? A defensible system and capable craftsmanship. One may but teach these, and leave personality to adapt them to its use. Character will take care of itself. Nature allows no two alike. To affect a character, which will be but a mannerism, is to be content to be unprofessional.

C. Proportion. Much that makes for proportion in writing is safeguarded by the consideration of the elements already mentioned. Speed alone precludes exaggeration, method more. It is chiefly in detail that proportion needs study and care. Experience and occasion determine the length of ascenders and descenders ; for at one time the object may be a dense block, the printers' ' setting solid,' when they will be minimised ; or at another, as in poetry, where the line rather than the paragraph becomes the unit of arrangement, they may be lengthened for fineness and display. Condensed writing of thickish stroke with fairly long ascenders and descenders (*h* and *p* at least double the height of *o*) set the space of four or even five *o*'s between the lines (*on* which they are set) gives richness of appearance, while still preserving ' colour.'

The proportion of width of letters to their height is more settled. Our conventions prefer in general a form slightly higher than wide for the body. In no age does the reverse seem to have been preferred, although broad letters have been said to be more legible. It seems ever the style of the slovenly (Fig. 342). Lateral compression (Fig. 343) is indeed also objectionable, though the letters' cramped narrowness gives ever the less offence ; perhaps because it implies care and painstaking to make them so.

Of the actual breadth of the downstrokes in proportion
to height one may perhaps affirm no fast rule. Four
breadths high is thick, five breadths a medium. At one

objectionable objectionable

Fig. 342. Fig. 343.

time the massed effect may be aimed at, as in a thirteenth-
century Bible, at another the open elegance of much
Renaissance work. And to the fantastic disproportions
affected for commercial or ' fancy ' purposes one needs
allude, because of their insidious effects upon our eyes : R's
with little pug tails ; H's and E's with high waists ; K's
made of three sticks leaning together ; S's like eels, M's
with exaggerated straddle and no V to speak of ; O's
kicked into the air ; B's and D's in hooped skirts, and so
on, and all kinds of trick and twitch and spiral. Indeed
spiral is a sort of besetting sin to which children take,
otherwise unaccountably.

Even with the classic Roman capitals one is apt to
generalise and group for convenience of rapid calculations
and so to detract from their beauty of proportion and
character. I have already, for instance, alluded to the
Trajan o's subtle improvement on the circle.

D. But of all the elements of legibility which go to
satisfy the instincts of order and variety, and so of natural
beauty, contrast is the most important—the characteristic
contrast of thick and thin strokes—even more important
than the sufficient similarity and dissimilarity of the
letter-forms themselves. This contrast of thick and thin
is the special beauty of good writing, the quality which
the classic tool has been found so readily to produce,
and has by reaction of our appreciation tended to
accentuate ; the contrast of thick downstrokes and thin
level strokes, and the beautiful and uniform gradation

from one to the other, which it so easily and so evenly effects. If writing presents no other virtue in its execution than this, it is still respectable ; for it is founded on the craftsmanship which endeavours to observe the requirements of inherited method to express itself.

Contrast is the production of a particular tool and not an inevitable tool ; for some races use other tools ; but a tool adapted to our natural satisfaction, and without doubt on this account accepted and honoured by all heirs to the Roman alphabet. It is the broad-edged pen, whether reed or quill, and no other tool has had any comparable share in the evolution of our technique. The share it has had in the development of the so-called ' essential form ' were harder to determine. For this has seemed less dependent upon tools, the tools and materials employed but modifying these essential forms according to their own requirements in appropriate performance. We all recognise that our capitals (Fig. 344), for instance, have the essential characteristics : the first two of one stroke, the second two of three strokes, and the last two of four strokes, and roughly in these positions, quite independently of any technique of thick and thin or finish at the ends we may give them, as observed in Chapter I. We, however, do not think *solely* of these essential forms when we visualise these letters, but immediately and involuntarily, as Fig. 345 ; that is, as clothed with the technique of the classic pen. This has been its action for more than fifteen hundred years—to the time of the printing press. And I stress the matter by this repetition, that its importance may be recognised as the last as well as the first of considerations for penmanship. Historically,

I O A H M W

Fig. 344.

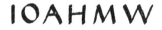

Fig. 345.

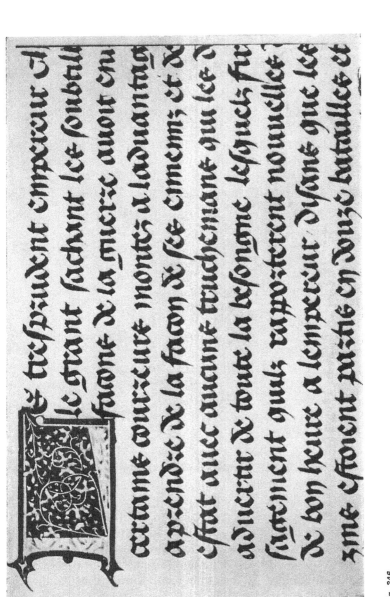

Fig. 346.

FLEMISH HAND. CONQUÊTES DE CHARLEMAGNE, A.D. 1458.

Written by Hubert, Librarian to Philip the Good, Duke of Burgundy, with a pliable pen, pressed upon for downstrokes.
Brussels. Bib. Roy. Actual Size.

because instinctively accepted ; conventionally at present because historical—this has been—and therefore *is*—the chief duty—and one may say safely on all these counts— the chief beauty of the pen.

Which necessarily excludes either block letter at one end or spider-pen letters at the other from the consideration of those who would use writing, like ordinary folk's speech, for agreeable and social intercourse.

E. And lastly, Beauty comes of the choice of materials. But of these in the next chapter. Here I may tabulate the elements of legibility, mentioned above, thus :—

CLEARNESS.	SPEED.	BEAUTY.
A. Contrast of colour and ground.	*A.* Ease of expression.	*A.* Simplicity.
B. Convention of form and arrangement.	*B.* Regular method.	*B.* Uniformity.
C. Similarity of form.	*C.* Downstrokes.	*C.* Proportion.
D. Difference of form.	*D.* Physical comfort of writer.	*D.* Contrast and gradation.
E. Compactness.		*E.* Of materials.
F. Simplicity.		

And before ending this chapter I would mention the hand that prevailed in Flanders during the fifteenth century, in which, contrary to the custom of most times and countries, a more pliable pen was used ; and this was pressed upon to swell the breadth of downstrokes and give a pointed finish to all strokes that do not return upwards. In its freedom it is allied to our English vernacular hand, but seems to me dangerous to imitate ; for though beautiful and decorative, it might too easily become loose or affected.

MATERIALS. PENS AND INK

N o one who has learned to cut a quill will ever again be content to use a steel pen for serious work ; and this although the quill needs to be recut for every page of a manuscript, and although pens are now made very serviceably of steel and other metals, and the size of stroke from page to page can be kept more exactly with them than with the quill, the recutting of which involves a very nice matching of the breadth of the nibs, if the uniformity of the MS. is to be preserved.

But the quill easily counterbalances all drawbacks with its fine qualities. Its pliability is tapered to the point like a good fishing-rod's, instead of disposed as by a hinge some way from the points, as all metal pens must be. Its texture is never too hard for the paper or parchment it works upon, while if the metal is cut cleanly enough to give a sharp definition down each edge of its stroke, it must tend to scratch the surface, and if cut thinly enough for crisp work, to cut it where working horizontally, and to spurt on upstrokes. Metal pens are, at best, but convenient makeshifts. And they differ further from quills or reeds in this also that their edges are cut from flat metal instead of from a barrel, as with the quill or reed. No doubt if cut from the barrel they would score or scratch the surface still more ; but the fact that it *is* cut from the barrel enables the quill or reed to score the surface slightly, and so give clean definition to both edges of downstrokes, while its own material is not strong enough to injure that on which it is working. With the metal

pen, cut as it is, the definitions of these downstrokes if examined through a lens will be seen to be too frequently serrated. And though the defect be small, it seems to be irremediable and its multiplication through a manuscript becomes a serious inferiority, as of engravings printed from worn plates.

No doubt the modern fountain pen with its iridium points has advantages to outweigh fastidious niceties for common service : constancy, readiness, general convenience. Yet the quill remains the tool of the craftsman, and its mastery indispensable to his standard. And not only for writing. The draughtsman can buy nothing out of the shop that he cannot better for his purpose with this ancient ally and a sharp knife. A delicacy and suppleness of line and subtlety of individual expression at once reward the little extra trouble involved.

The cutting is, however, certainly a stumbling-block to the beginner. But no more than need be, if he be at all neat fingered. It is the knife rather than the pen that needs attention too rarely given. No one can cut a pen with a blunt knife. This must be good and sharp—and (here is the crux) must be kept so. And this seems to lead away from his business so far as to be disregarded as an essential part of his job. The nuisance of using oil with a stone hinders some. But while paraffin and a good joiner's oil-stone are certainly best, it is more convenient and almost as good to use water. Carborundum, even fine, is inadvisable. It eats the steel away too fast. I have used a boy's hone I bought at a toy-shop and a razor strop for finish afterwards with satisfaction. There is no mystery, but constant attention *is* necessary. As for the knife—it should be of good steel set in a handle not too slim, but well suited to the individual's grasp, and with a blade $1\frac{1}{2}$ or 2 inches long, and not remarkable in any way. It will get better as time goes on and its section gradually passes from its originally hollow-ground

sort (Fig. 347) to one more adapted to shaping the pen (Fig. 348).

And with the knife should be kept a small magnifying glass : a pocket-lens with which to examine the newly cut pen. If a watchmaker's glass can be held by the eye this is better still. This saves incalculable time and experiment both as to size and fitness.

Also the scribe needs a piece of vulcanite or celluloid (such as a small set-square) to cut the edge-cut upon. Nothing is better. Glass or a worn coin blunt the knife too soon. With these three things, well kept, pen-cutting need not be a hindrance long.

Fig. 347. Fig. 348.

As to the shaping of the pens' nibs, I have found preferences differ considerably. Some prefer Fig. 349, others Fig. 350, with gradations between, and the slit longer or shorter, as also the back-cut farther or nearer, and deeper or slighter (Fig. 351).

Fig. 349. Fig. 350.

In these matters one may experiment and adopt a method found suitable to one's hand and nature. But none of the methods really prevent the nuisance which

Fig. 351.

afflicts all scribes alike, the parting of the two nibs, which sets in too early, however well cut. They may be pressed back from time to time, of course, and the shorter the back-cut the less the nuisance, but no dodge obviates it entirely. And one may not do without the slit, or even have this too short, or the pen will not mark, or only greyly. The slit is there that capillary attraction may keep the edge supplied with ink rather than for spreading the points for downstrokes ; and though experiments

have been made by scratching the inside of the pen to the edge instead of slitting it, they have not solved the difficulty, and have, of course, deprived the pen of its slight but necessary pliability. The length of the slit is not invariable, but should be accommodated to this pliability, a stiffer pen needing a longer slit for ease. Usually it should be about the length of the nib-cuts as shown in the figures.

Some writers prefer turkey quills, others the ordinary goose quills ; the substance of the turkey's being stiffer, thicker, and harder, though sooner worn down. Goose quills are suppler and thinner (not in barrel but) in substance, and their substance seems denser and wears longer. That is, of two tall pages the turkey-written one will go coarser towards the end than the goose-written one. The extra stiffness is the turkey's chief advantage, for those who prefer this.

Of the goose quills some prefer those of the left wing, others those from the right ; for the difference is very noticeable in the curve of the shaft of these and their ' lie ' in the hand. With the turkey's this matters much less, for the curve is similar though more marked. For myself I have always preferred the left wing of the goose, and as stiff as I can find. Though for all compound or spliced letters a rather pliable pen, with a longer slit than usual, is convenient. For very fine work a duck quill may be used. This is not too small to grasp, as a crow quill is. And if the barrel of either be found altogether too slim they may be ' whipped ' with suitable string to increase their girth, like a bowstring or a cricket-bat.

The cross-cut of the nibs, which gives the writing edge, needs the chief attention with all pens. This may be made with one downward cut a little out of the perpendicular, as in Fig. 352, or sometimes with two (Fig. 353). But, plainly, the edge must not be cut with but one flattish cut, as in Fig. 354, or it will turn up too soon and make

havoc of the fine strokes (Fig. 354). These cuts should always be made downwards with the nibs resting on the set-square at the edge of the table. For if done upwards

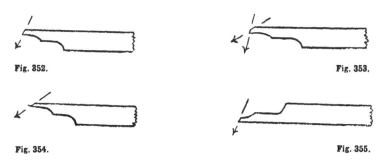

Fig. 352. **Fig. 353.**

Fig. 354. **Fig. 355.**

(by reversing the pen) the result will be almost certainly somewhat as shown in Fig. 355, which gives an obtuse instead of an acute-angled edge to write with—again with loss of fineness to all thin strokes.

Where, for delicate drawing, in some cases a continuously even line is needed, *i.e.* without the thin and thick which the standard pen-edge produces, the pen may be cut to a fine point and then one of the nib ends cut off close to the end. The capillary attraction will then still operate with the ink, but the mark be uniform in every direction (Fig. 356). This is useful for line-drawing.

Fig. 356.

Turkey quills can be had larger than any goose, and for larger work still swans' may be used, though they remain uncomfortably greasy compared with the others, and are not easy to obtain. But for all large work—and this up to sizes required for posters, etc., reeds or canes are employed, cut similarly to quills. There are reeds from Japan and India available as well as our own softer substitutes. But, indeed, any hollow cane of the requisite diameter and thin enough material for the particular purpose, makes a very serviceable pen. To these may

be fitted a strip of bent tin to hold enough ink and to hold it back (Fig. 357); as indeed with the quills also. With ordinary use, however, this tin is not absolutely necessary,

Fig. 357.

if the writing is done at so stiff a slope of desk that the shaft of the pen is nearly horizontal. In that case the ink will not tend to flood towards the pen's edge inconveniently. Of the difference of the cut of the pen's edge for 'flat' or 'canted' writing, I have already spoken in the chapters relating to those hands.

With all pens it is best to put the ink into them, instead of them into the ink. This is easily done with the ' filler ' supplied with the usual Indian ink bottles, or with an old quill rather than with a brush, which is apt to cause accidents ; the object being to wet the under side only, between the tin and the concavity of the pen, and thus to preserve a finer stroke for the thin lines than is possible with the pen wet above as well as below.

There are two sorts of inks, carbon and iron, the *atramentum* and *encaustum* of the ancients. The one is a black paint, the minute particles of which are attached to the surface by gum, and is of itself absolutely permanent. The other is rather of the nature of a stain or dye sinking into the surface ; and there seems, unfortunately, nowadays to be no maker who will guarantee the permanence of this article. For the manufacture of the sort which used to carry the guarantee of a Government analyst has ceased. And besides their want of permanence, most of these iron inks of to-day are of a hideous blue colour, for no reason apparently but a mistaken notion that people like them so. No writer of a manuscript, therefore, intended to be beautiful or permanent thinks of using them, despite their valuable fluidity.

Fortunately the carbon inks have received better atten-

tion, and there are now several makes of these available in liquid form—British, French, and American, and waterproof or non-waterproof. The latter are preferable for the finest penmanship, as being more fluid ; for writing has not to guard against subsequent washing with colour, and in books is not endangered except by damp-handling. The waterproof inks are made so with a varnish which renders them less fluid and convenient for clean writing— not impossibly so, however.

But for important work I have found it best to use the sticks of ' Indian ' ink, rubbed up with water freshly for the occasion. And there seems little difference in quality between those certainly imported from the East and those manufactured here, except that the former are sometimes of a slightly browner tint, to me preferable.

This rubbing-up is a drawback for those in a hurry, as it needs to be done carefully, and from day to day. Yesterday's, which has gone dry, is not good enough. The particles seem to have appreciably clotted.

The palette or ink slant needs to be washed and a fresh supply rubbed. And the ink needs to be rubbed to the same density always, a matter a little difficult to gauge. I have found that to put a measured number of drops of rain-water into the palette-slant and then to rub the ink, until the ink-stick smears a dry path in its action, gives an appropriate and similar density from day to day. And no more than is necessary for the day's work need be made. Some add a little gum-water and lampblack to it, but it seems to me unnecessarily.

One of the hindrances to the teaching of children the traditional use of the broad pen arises from the difficulty of ink. For the broad pen with young beginners is apt to be messy; *and the ink out of the stationer's shop iron-moulds.*

Absurd as it sounds, this trivial difficulty is certainly hindering the proper teaching of young children. They

are either given a fine (and futile) steel pen, wherewith
the ink as supplied will not be so dangerous, although
with it they can learn nothing but uncraftsmanlike make-
shift ; or they are given a carpenter's broad-leaded pencil,
sharpened indeed like a proper pen, but too imperma-
nently so to last for more than a line or two ; so that the
virtues of the clean-cut alphabets are rapidly lost sight of,
and a smudgy slovenliness substituted in their perform-
ance, to the discouragement of their efforts and the
muddling of their ideas.

And all because common ink iron-moulds and people
cannot but go to the stationer's ! Yet the whole difficulty
can be met by the purchase of a tube of water-colour
lampblack (or indeed sepia) and the provision of little
inkpots. For the ink for children's exercises need not
be very black, and with such a mixture, diluted to taste,
none of the possible disasters is to be considered against
the advantage of a defensible method of teaching. For
both carbon and cuttlefish wash easily out of clothes, and
there is nothing else here but a little gum.

For any who may be interested in preserving their
independence further of ordinary ink, and avoiding the
common blue-black varieties, I add the prescription
gathered from Edward Cocker's *The Pen's Transcendency* :
' Ink, a receipt for. Poure two gallons of Rain water into
an earthen stand or vessel that is well leaded or glazed
within ; and infuse in it 2 pounds of Gum Arabick,
2 pounds of Blew-Galls bruised, 1 Pound of Copperas,
and 2 ounces of Roch-Allum : stir it every Morning with
a stick, for 10 days, and then you may use it. You may
vary the quantity, observing the same proportions.'

This is easily made by oneself or the local chemist ;
and I have found it most beautifully black and serviceable
in every way—though the amount of gum arabic, which
is possibly reducible, renders it a little resentful of
blotting.

As to its permanence, one may not vouch, perhaps ; but no doubt it observes the method practised for many years even before Cocker, and the prescription may be well trusted as traditional. It has the beauty of fine black Indian ink.

MATERIALS. PAPER AND PARCHMENT

HIS book ought to make recommendation of good papers. Yet since the best modern paper is inferior to parchment, and since all my own experience has been with parchment, I can but refer to paper inadequately.

For practice any good smooth thinnish paper is sufficient (though even his practice may well begin upon the material the serious writer will find indispensable later—parchment). The thickness of the sheet depends upon whether a folio, quarto, or octavo page is contemplated. The papers with specially prepared surfaces are usually too thick for aught but folios. ' Bank ' papers, on the other hand, are too transparent, and also too ' tinny ' (vocal, like bank-notes), though delightfully thin. A soft pliability is the need, combined with smooth yet not glassy surface. This the hot-pressed papers supply fairly, though not usually thin or pliable enough. A book with stiff pages is most uncomfortable.

There is no particular superiority, for writing, in a hand-made over a machine-made paper. Indeed the best paper for the purpose I have known was one called J. W. N. (Double Elephant), a machine-made paper of the O.W. & A.S. This, as in the case of the guaranteed ink, is no longer made.

The test for all, for the writer's immediate purpose, after experiments made for comfort in performance, pliability, etc., is the examination of his downstrokes upon it with a strong lens. If the definition of the edges of these show but few or slight gaps or serrations, and his

fine strokes are really fine, the paper may be reckoned good for writing upon. Of old the paper was often burnished with an agate before being written upon, to render it smooth enough. Our needs, with the hot-pressed sort, are rather the other way, and even a very slight pouncing may be helpful, as for parchment.

As to the colour, a slight buffish or yellowish tinge is preferable to dead white. And if it be very slightly transparent this is, contrary to some opinion, no disadvantage. For its lasting qualities one needs to rely upon the maker.

Parchment is, however, incomparably preferable. In texture and tone and surface it is so agreeable that I have always marvelled that draughtsmen (especially those devoted to black and white) do not use it. For it immediately imparts a ' quality ' to every line drawn upon it, compared with which similar strokes on paper seem rough or enfeebled by the ' grain.' Parchment has no ' grain.' The disadvantage that it will not bear ' washing,' and will cockle when framed, if special precaution is not adopted, has no doubt hindered its use for pictorial purpose. But neither of these drawbacks affect book-making with it. For with books the method of painting upon it has ordinarily been by ' matt ' or body colour, like tempera—and no doubt on account of the tendency to cockle under a wash. Yet a very careful and dryish wash *can* be employed upon all but the extra thin sort; for the work in books is on a comparatively small scale, where the danger is the less.

Skins are either of sheep (and lamb) or goat (and kid) or calf. The last is the true vellum, as its name implies ; but it is so thick (nowadays) that except for panel pieces it is unserviceable.

Kid skins are delightful, but unfortunately available in this country in but very small quantities. They immediately recall the humanistic ' vellum ' of the Italian

Renaissance. There remain for general use the sheep and lamb skins, known loosely as ' vellum.' These vary with every maker's handling of them. They are split skins ; that is, of the three layers into which the actual skin is split, our parchment is the one next the animal's flesh and blood. It has a natural side, therefore (that next the flesh), which is the smoother side, and a manufactured side, slightly rougher. On the latter the scribe may, with care, make slight erasures, but on the smooth side none without disaster. For a film of a fine texture, somewhat like the skin of an egg, only finer yet, covers the surface, and a scratch upon this ' shows ' at once and irremediably. All work, however, is more beautiful, both writing, painting, and gilding, on this smooth side. But it is rather more difficult for the painter, and of course more perilous for the writer liable to clerical error ; who, if he has to do an ' address ' against time, is set a disconcerting problem as to which side he shall choose.

If the sheet cannot, by some misfortune, be recopied, or if the mistake be slight and at once discovered, a correction may be made by a very careful person, even on the smooth side—in this way. Suppose the words should be, ' Be thou my guardian and my guide,' and the writer omits the ' and,' writes ' my ' next guardian, and is at once aware of the mistake, he may, as soon as the ink is dry, convert the ' my ' into ' and,' as shown in Fig. 358, and go on. Then by the aid of a lens and a sharp,

Be thou my guardian and

Fig. 358.

pointed knife he may pick off the ink from the strokes not wanted, when all is quite dry. The erasure will show, of course, but will be almost insignificant. Similarly if ' trees green ' has been written, which should have been

'trees are green' (Fig. 359), the 'are' may be over-written and the unwanted strokes picked off. After the whole is again dry it may be burnished with the burnisher, a piece of grease-proof thin paper being held between the burnisher and the ink during the process.

trees greegreen

Fig. 359.

When erasures are made on the rough side, a piece of glass should be placed below the work and the knife-blade applied backwards and forwards at right angles to the surface. It should be very sharp (a blunt edge only smudges the ink into the surface) and, of course, no place should be scarred but what is absolutely necessary. When the ink is removed the blade may be then applied almost horizontally against the surface to remove the fluffiness as far as possible. But this requires great care and the blade should not be hollow ground or it will inevitably cut in. A blade worn to rather a rounded section but well sharpened is, however, fairly safe. When the fluff is well shaved off the place should be burnished.

Skins should be very pliable and soft to feel ('suent' as they say in Devon). And if one waft a sheet in the air it should not kink readily nor rattle with the 'tinny' sound mentioned above in reference to 'bank' papers. They should seem as natural, as little 'prepared' as may be, and not stiff or brittle with chemicals. Some makers try to make them excessively white. This was not wanted of old, nor is it wanted now, except by 'the trade'; who, unfortunately, have a habit of getting what they want, even without reason.

They are, moreover, not opaque enough for those accustomed to our untransparent papers. But opacity is another quality not demanded of old. Indeed a slight transparency, only slight, of course, gives the pages of

old MSS. the delightfulness of clear complexions as compared with muddy ones.

But there is one fault to which they are liable, though its frequency varies with the makers; and that is the fault called 'ink sinking,' a fault not unknown in the past. I have observed some of the pages in the beautiful Aristotle's *Ethics* (B.M., Add. MS. 21120) to be distinctly 'ink sinkers.' This means that on some portion of a skin it may happen that a pen-stroke on the smooth side will, without previous warning—after a column of writing perhaps on the same piece close by—flood into the texture of the skin below the film and spread about as if in blotting-paper. If this continues with similar strokes there is nothing to be done. The clean-cut look of the work is gone, and the page, and its fellow maybe behind it or beside it, must be scrapped. If, however, an endeavour to save the page *must* be made, it will be found that a careful dusting and rubbing with powdered sandarach of the portion of the page yet to be written upon will mitigate, if not abate, the nuisance. The sandarach, however, makes the writing uneasy in execution and curiously rough in appearance; for the pen 'speaks' with difficulty upon it when it is used sufficiently to counteract the ink-sinking. But it may save a situation. The skins liable to behave thus can sometimes (not always, even by the makers), though not reliably, be detected in advance by some unusual softness, even woolliness of texture, and rather looser substance, which may even look somewhat loofah-like beneath a strong lens, and is also apt to pucker or 'gather' like a surface of liquid vibrating. And though woolly, they seem extra dry. Small wonder one prefers the makers least addicted to this misfortune.

And here I would pay my tribute to the firm of Messrs. G. & A. Stallard of Havant, Hants, who for more than a quarter of a century have supplied my own wants with a most serviceable, beautiful, and trustworthy article,

prepared according to traditions handed down through generations of fine handicraft, and preserved scrupulously and valuably for our work to-day. I have naturally, if but for confirmation, experimented elsewhere, but have found no other make so fine, nor, what is of great importance also for continuity of work, so constant and invariable.

For framed panels, parchment, and even the stiff vellum, needs to be stretched, like a painter's canvas, on a wooden stretcher or it will cockle as time goes on and the dry and wet weather tighten and relax it. On the other hand, when stretched, skins assume a flatness oddly inconsistent with the character of skin. All skins seem to demand the freedom of ' pages,' all frames the flatness of glazed panels. So that framed parchment is ever somewhat an unhappy or inconsistent affair.

The skin needs to be kept from touching the glass by a hidden mount at least one-eighth of an inch deep. This may be a strip of wood and hidden behind the rebate of the frame. If allowed to touch the glass the skin shows the influence of change of weather still more readily.

On the whole, skins seem unsuitable for such purposes, even though vellum be too stiff for general book use, except perhaps for folios. And if vellum be left unframed and unstretched, but attached to rollers, like school maps, which certainly seems a more appropriate manner with it, it soon becomes disfigured and shabby in our climate, and has altogether too temporary and makeshift a look.

It is certainly inappropriate for use in framed panels in churches, where its apparent advantage over paper or cardboard, as regards permanence, so frequently and mistakenly recommends it. For our churches suffer from changes of temperature and dampness more than any buildings ; and the framed Rolls of Honour inscribed on

vellum therein are already rapidly decomposing in many
cases. One has known framed parchment to be set even
in church porches, its permanence under suitable con-
ditions having been taken as assurance. Kept dry, and
not too hot, it seems imperishable.

Writing is, however, often wanted on walls, decora-
tively or for other service, and often in a larger mass
than brushwork can conveniently cope with, directly upon
the wall. And as this cannot be written on with a pen,
owing to its perpendicularity, except with inappropriate
labour and awkwardness (the necessary slant of pen and
ink to the surface being extremely difficult to manage),
the use of vellum, framed or unframed, is convenient
temporarily.

But a more appropriate method may be adopted by
employing panels of gesso, which can be fixed to the wall
after being written upon in comfort, and can be framed
or not, and generally made to fit the occasion, even
architecturally considered, better than any panel of skin.
Upon gesso, appropriately sized, the pen can write as
well as upon skin, and after the writing the whole can
be varnished and so protected without glazing. For
wall writings, where painted letters are not suitable, owing
to quantity and size or otherwise, and indeed on some
occasions where painting *can* be used, this pen perform-
ance may well be employed. And the preparation of such
boards involves little more than a few experiments with
the mixing of a gesso (at least for the last two coats applied)
which shall take pen-strokes cleanly without blurring.
The varnish applied afterwards need not be shiny, but
just sufficiently so to give an ' egg-shell ' finish to the
panel. The ink used should be waterproof ink—though
I have known a varnisher so quick and skilful as to varnish
a non-waterproof ink without dragging or smudging it.

Again, plain panels of any whitish or lightish-coloured
wood, which can be planed smooth enough, can be similarly

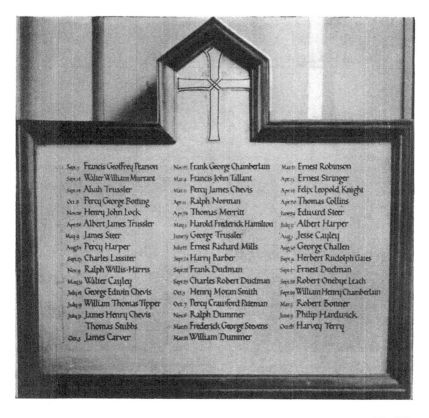

Fig. 360.

FRAMED GESSO MEMORIAL PANEL IN EASEBOURNE PARISH CHURCH, near MIDHURST, SUSSEX.
Written by the author and varnished, but not glazed. Much reduced of course.

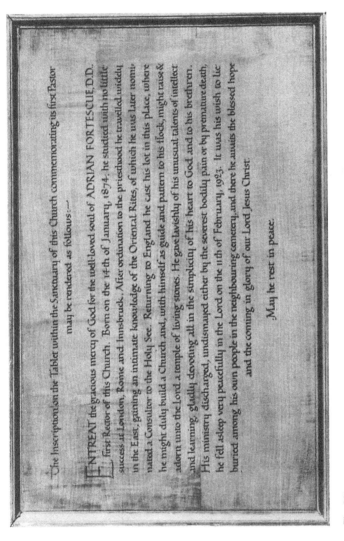

The Inscription on the Tablet within the Sanctuary of this Church commemorating its first Pastor may be rendered as follows:—

ENTREAT the gracious mercy of God for the well-loved soul of ADRIAN FORTESCUE, D.D. first Rector of this Church. Born on the 14th of January, 1874, he studied with no little success at London, Rome and Innsbruck. After ordination to the priesthood he travelled widely in the East, gaining an intimate knowledge of the Oriental Rites, of which he was later nominated a Consultor to the Holy See. Returning to England he cast his lot in this place, where he might duly build a Church and, with himself as guide and pattern to his flock, might raise & adorn unto the Lord a temple of living stones. He gave lavishly of his unusual talents of intellect and learning, gladly devoting all in the simplicity of his heart to God and to his brethren. His ministry discharged, undismayed either by the severest bodily pain or by premature death, he fell asleep very peacefully in the Lord on the 11th of February, 1923. It was his wish to lie buried among his own people in the neighbouring cemetery, and there he awaits the blessed hope and the coming in glory of our Lord Jesus Christ.

May he rest in peace.

Fig. 351.

ENGLISH TRANSLATION OF AN INSCRIPTION (p. 208) IN ST. HUGH'S CHURCH, LETCHWORTH.

Written by the author on a varnished wooden panel, and varnished afresh above the writing, and left unglazed. Reduced.

written upon, one coat of varnish being, of course, applied
before the writing, that the ink may not spread along the
grain, and another afterwards to fix the ink.

These gesso or plain wooden panels, so written on, have
a finely direct and unworried look for many purposes of
wall inscription, and should be more generally employed ;
as, for instance, the writing of the Creed, the Lord's
Prayer, the Ten Commandments, and tables of kindred, to
be set in churches.

MATERIALS. POUNCE, ETC., PIGMENTS

LTHOUGH carefully prepared, parchment always needs pouncing according to the individual's taste, before writing ; *i.e.* dusting and rubbing with a powder to render the pen-strokes clean and even upon it. The law stationers supply these powders, no doubt made by traditional recipes, and I have used several. But I have found as serviceable a one can be made for oneself by blending gilders' whiting, pumice powder, and a gum-resin called sandarach, in various proportions. I have never yet, however, found one equally serviceable upon all skins, or quite similar in action on the two sides of the same skin. Four of pumice, with two of whiting, and one of sandarach is most generally obliging. The sandarach should never exceed one-sixth of the whole; for while it helps the pen to crisp expression, it will, if in excess, prevent its marking the surface at all, or only allow it to do so spasmodically and unevenly. Nevertheless, on the smooth side only of a seemingly greasy skin a dusting and wiping over gently with sandarach will sometimes render an intractable surface pleasant enough for action. The smooth side of the skin is easily injured by rough rubbing. It is, therefore, better to apply this treatment than to go on rubbing the usual mixture in, in the hopes that more pouncing will improve it.

Pumice alone can be used, and for both sides, but it roughens the surface over-much and is specially dangerous on the smooth side. It has one great advantage. All ink tends to lie blacker where it has been used, either alone or in large proportion.

Whiting alone is not good. Its office is rather to moderate the others. I have, however, used it alone with sandarach in the proportion of five to one, with success sometimes. It, however, should be used alone, when the writing is done, upon any part of the work which is to be gilded. This overcomes the effects of the sandarach of the mixture applied before the writing, sandarach always tending to cause gold-leaf to adhere to the surface.

With pouncing generally not only must care be taken not to scar the smooth side, but with both sides not to overdo the business, and yet to do it evenly all over, and to knock (not wipe) the pounce well away before working. I have found the bare palm of the hand safest, whereby one retains feeling of the action of the powder on the surface, using a circular sweep and not too timidly. A couple of dozen such sweeps about the sheet should be enough. And during the action care must be given to prevent the sheet kinking or getting dog's-eared. It should next be turned upon its long edge, and this bowed slightly, and then the bent edge knocked on the table a few times (which is, of course, covered with a paper to receive the dust knocked out). This rids the skin sufficiently of all superfluity, and with care the edge will not be harmed. The hand should not be allowed to touch the surface afterwards. Ruling had therefore better be done before pouncing, which indeed helps to soften it and render it even.

Some writers leave too much pounce behind, others wipe too much away by using a cloth. Too much hinders the writing and clogs the pen at the time, and later spoils the gloss of the ink as it works about over the pages when the book is used. Certainly throughout it is better to use and do too little than too much. A page woolly or dirty with pouncing or scarred with rough usage is very uncomfortable. If the surface be found not quite pleasant to work upon after treatment as above suggested, it may

be improved by some slight further rubbing with a piece
of parchment, not screwed up into a ball in the hand
—for this would score the sheet with its inevitable
edges—but applied so that a smooth surface only touches
the sheet.

Besides the pounce mentioned I have also tried pow-
dered ' cuttlefish ' as well as French chalk, mixed with the
others and alone ; but have not found them of assistance.
Indeed, I suspect the cuttlefish of attracting damp. Damp
is the one danger to the life of parchment. An extra dry
room will cause an open parchment book to curl up
uncomfortably, but no harm is done to it, if it be carefully
closed (not pressed) and left to recover. But a damp cup-
board or bookcase will soon invite mildew and rot to a
substance which, in an ordinary climate, with ordinary
care, seems indestructible.

Of colours the scribe needs but three—red, blue, and
green, with gold for special occasions : and this ousted
yellow from all but very early MSS. These colours may
usually be considered equivalent to the heraldic gules,
azure and vert ; for the crimsons belong, with the purples,
to late Renaissance work, and for writing text or initials
no pale or indefinite colours seem ever to have been in
favour. They need to be pure and bright and of the best
quality. Dry cake pigments are most convenient, keeping
cleaner than pan colours, and their preparation does not
involve any substance to keep them moist, as with tube
colours. And since they need to be used thick and matt
this is of importance. I have known letters drawn with
tube colours refuse to dry for hours—most inconveniently.
The medium with the dry-cake colours as usually prepared
is sufficient for the scribe's purposes. But if he keeps,
say, vermilion in some quantity wet from day to day in a
palette he had better add a drop or two of gum from time
to time to replace that which is abstracted unequally,
owing to the whole not being kept stirred adequately

when in use. He should, however, make a point of keeping all colours well stirred.

For red, vermilion, representing the ancient cinnabar, stands first; and it needs to be chosen attentively. For all the makers make at least four vermilions : orange v., scarlet v., ordinary v., and Chinese v. ; so that we have in England at least two dozen vermilions to select from. Our choice may, however, be limited to the so-called Chinese vermilions (the name signifying but different process in manufacture) ; for these certainly resemble most closely the vermilion of the MSS. Beside them the other sorts seem hot and staring.

And this is also the best pigment to experiment with for the beginner. For it behaves in the pen most like his Indian ink, and is, indeed, very tractable and conveniently dense. It should be used thickly enough to avoid any appearance of cloudinesses in his letters or writing ; and this precludes his having a tin strip to hold it in his pen. He must, on the other hand, not safeguard himself from floodings by the steepness of his writing-table or board, or the colour will run down the stems of his letters, and leave the tops pale. He must experiment both with slope of board and density of colour until he can get it to work comfortably from the pen and lie flatly on his letters afterwards. To assist this it is well to wet the pen with colour at least an inch back from the nibs up the barrel, and not to keep only the nibs themselves moistened with it. An old brush, not too big, should lie in the colour the whole time—both to stir the paint and feed the pen— supported against, say, the handle of the cup of water used. Rain-water is said to be best.

Besides the vermilions one may wish that the red lead of the MSS. were again available, for the rather more orange tint one observes where it occurs in them is particularly beautiful. But modern chemistry seems unable to provide permanence for it in our atmospheres,

although that used in mediaeval times seems still resistant. And the orange vermilions do not supply the tint.

With the blues there is also a large choice, but in all cases a mixture is needed, as there is no one pigment presenting a pure, true, permanent blue. The ultramarines are too purplish, as are also the cobalts, and certainly the smalts; Prussian blue is too transparent and impermanent, ceruleum too greenish and hard, ultramarine ash (which also varies considerably in the hands of the makers) too grey. But this last has a very dignified quality, so that it may well be added to any mixture to give distinction. Real ultramarine, as modernly prepared, seems hardly worth the extra expense, being lacking in the scintillant quality one marks in the MSS., besides being too far towards the violet side of true blue. It is probably to-day too chemically pure and has lost some invaluable imperfection, like that prescription of Dr. Jekyll's which left him Hyde.

An ordinary French ultramarine, or cobalt, mixed with ceruleum to the required tone gives good results, the greener shade of the ceruleum being valuable as well as the great 'body' it imports, the ultramarine inclining to be too transparent unless used so thickly as to be too dark. Messrs. Newman, of Soho Square, have obligingly made up this mixture into dry cakes, ready for service. But some may prefer to add yet a little more ceruleum. The fault of which is to me a certain metallic hardness of quality, almost sourness.

Of old, from A.D. 1250 to about 1400, a most beautiful true blue appeared in the MSS., a native copper ore called azurite or chessylite, more beautiful than ultramarine. The angels in the Apocalypses of that one hundred and fifty years usually wear it. Not one of our manufacturers will make it to-day, and Professor Laurie has told me: 'We have cobalt instead!' And this although no artist can be indifferent to the tone and 'quality' of this

pigment, and although it occurs all over the world in a native state ready to hand, but too pale when ground finely enough by the experimenter. It is as if in that one hundred and fifty years some specially dark 'pocket' of it (possibly in Hungary) was used up.

Formerly I have used ultramarine ash enlivened with Prussian blue, but fearing the impermanence of the latter I discontinued it. The mixture gave a very beautiful and refined colour, and I observe that no change I can detect has affected letters drawn with it twenty-five years ago in certain books. Colours in books are normally well enough protected from light and even impure air, so that one may be unnecessarily anxious—and certainly not accept the standard asserted by that pottery painter, who told me that we should use no colours but such as were permanent enough to endure a kiln.

For green we again need a mixture, there being no one pigment supplying at once body and vividness of tone. And here the oxides of chromium are serviceable, the darker, solider sort mixed with lemon yellow, cadmium yellow, or aureolin; or the transparent sort (called viridian) mixed either with cadmium yellow or lemon yellow. The last mixture, although of comfortable body—it needs particularly constant stirring—is inclined to be sour; that with the cadmium yellow to be thin in body. Body may always be supplied by Chinese white; but white is rather a last resort. It seems invariably to dim, even to muddy, the colours it thickens.

I have also used with pleasure emerald green with viridian. The colour is certainly too blue, but the quality delightfully pure, and the body sufficient.

There are also the various blues to blend with these yellows, and ceruleum being already inclined to greenishness at once suggests itself as convenient. There is also cobalt green, though with this one can only get a dullish tone, not that bright apple-green which seems to suit

letters best. Cobalt green and aureolin, however, look well.

All the mixtures mentioned may be used without fear of chemical disagreement, except perhaps that of the emerald green and viridian. I have had no misfortune with this, but emerald green is chemically unsociable.

And as regards their use in MSS. (apart from added decoration, that is) for text, initials, and headings one observes that convention has dedicated vermilion to ' rubric,' and that no other colours may be said to be used for the text of books, except very occasionally, almost playfully. They are kept for the decoration of the important letters, initial, and paragraph, and sometimes for headings. And vermilion, besides serving for rubric notes, shoulder headings, etc., also shares with the others in decorative function. Alternating the colours of the verse-initials in Psalters and Bibles was one of the commonest methods of employing colours. And similar alternation can be seen in the headings of the pages of many Bibles, or in the opening sentences of important chapters ; and one may question the advisability of such close mixing. The colours used thus are inclined to blur into a dull intermediate tone, and to suggest that the decoration were better helped if they be separated somewhat from each other—to call for treatment in patches rather than by medley. In some ecclesiastical books, where rubric occasionally comes in alternate lines with black text this defect may be seen and compared with the cases where a patch of rubric precedes a prayer. In the latter case the decorative power of vermilion can be fully appreciated, in the other the page is apt to present a rusty ineffectiveness. And similarly this danger befalls the insertion of coloured capitals into the body of the black text. The honour intended fails, and an unpleasantness is created instead, unless the capitals are so heavy as to assert their colour pronouncedly. But in this case they break up the

block of the text into irregular masses. In either case the writer defeats his own aim.

Where alternately coloured letters are used, occasion may sometimes bring but one such letter to an opening. If its turn be blue the rubricator is better advised to use red. For a single blue initial to a whole opening of black text is poor in effect. Better to forgo the strict alternation than this. Indeed blue alone with black, even in some quantity, is meagre decoratively. Green is better in this respect.

But a single red letter on an opening has the effect of enabling a number of letters of the other colours to be used decoratively, if need be for them. And red and black alone combine perfectly. Red and gold, however, are not too happy, even with black text. For instance, if there be a large piece of rubric (red) before a prayer (black), and the initial to the prayer be set in gold, the page will look hot unless a blue initial occurs lower down or on the same opening. Gold in the neighbourhood of blue with some red in ' the offing,' as it were, is the happiest combination, and the one chiefly observable in the plainer mediaeval manuscripts. Gold and red alone together without the company of any black become uncomfortably ostentatious and ineffectual. Nevertheless some of the most beautiful pages of old are those containing church music, in which the staves are always red, the square notes and the words below them black, and the initial letters gold and blue and red. Here the red and black are so closely mingled that a rusty effect might be expected. But the pages are almost invariably brilliant and beautiful, even where a block of rubric tends here and there to swamp the black. The four stave lines are usually very thin, and their delicacy is no doubt of chief assistance in the refined splendour of such pages.

If paragraph marks be employed to mark the paragraphs (either with or without coloured initials), these may be

coloured after the same manner as proposed for initials.
If used with initials, they may be effectively made of a
different colour from the initial. They may be (Fig. 362)
quite pleasantly inserted in colour
into a printed book, and make
 competent decoration for a valued
copy of some plainly printed
author. To insert them, however,
unless the book be in sheets
unbound, is a tedious business, as the opening finished
must be dry before the page can be turned for the next.

Fig. 362.

ROFESSOR LAURIE questions the use of gold leaf on MSS. before the eleventh century; previous examples showing gold powder only, as in the magnificent books of the Early Winchester School, where the gilding is yet very fine. But from the eleventh to the fifteenth century gold leaf is employed laid on a 'ground,' until the backgrounds of the Flemish naturalistic borders and the little square mats of the later Italian initial letters reverted to the powder method. And in some hands this method, particularly where a ground is used beneath the powder, gives good results, with brilliancy of burnish. But I have always used the method of gold leaf on a ground as recommended by Cennino Cennini in Chapter CLVII of his book,[1] and can endorse his assurance that ' it is most excellent '—so excellent that after trial of various modern preparations, and ineffectual experiments with vague mediaeval recipes, I have latterly endeavoured rather to improve my practice with this one found serviceable than to explore further.

The first need is to understand and make the ' asiso ' for oneself. This consists of a slaked plaster of Paris, white lead, and sugar ground together with water. The property of the first is to raise the letter or ornament treated with it from the surface slightly and at the same time to give it texture and pliability.

And on examining it with a microscope one realises at

[1] *The Book of the Art of Cennino Cennini*—translated from the Italian by Chistiana J. Herringham.

once how this is effected. For the substance consists of
crystals about as long in proportion to their thickness as,
say, cricket stumps. These mat together, with air
entangled, instead of lying flat. Grinding breaks these
up, and can obviously be overdone. Indeed Mrs.
Herringham (p. 233) considers grinding a mistake
because of its reducing the crystals, and weakening the
texture they make. But on trying to use the plaster
unground I have ˙ found that it has too much of this
texture, gives an inordinate raising to the work, and is so
weakened with air cavities that it cannot be burnished.
For the burnisher crushes it together and cracks it to
pieces. It grinds it, in fact, after instead of before, and
is altogether disastrous. Cennino tells us to grind it
' very finely ' (*sottilisimamente*). This implies that sufficient
texture is still retained by the broken stumps. And one
is just left guessing at what point of grinding efficiency of
texture and adaptability for burnish meet. Over-ground
it may take a fine burnish and yet crack later for want of
texture. On the other hand, if under-ground, it may
yet crack on being burnished, owing to its texture being
too loose.

The office of the lead is to harden, to dry, and, as I
imagine, to fill up the interstices in the texture, and so to
ease the burnishing and minimise the dangers of that
process. It is amorphous. And its office may be sup-
posed similar to the effect of a proportion of cricket-balls
mixed into the broken cricket stumps, and the whole
rolled down in glue with a steam roller. Cennino warns
us against using too much of it, without saying why.
One is left to guess that it conduces later to such dry
hardness that cracking may come of it.

The sugar or candy is provided partly as glue and partly
to prevent this cracking. For being hydroscopic it helps
to keep the asiso horny when it might otherwise
become brittle. But we are again left uncertain as to

whether our sugar candy is similar in power to the candy
of Cennino's day, not long then known to the world,
imported only from the East Indies and sold like a drug
at the chemists'. Sugar has certainly ' evolved ' con-
siderably since his day. Then also since its usefulness
depends upon its hydroscopic capacity, the climate of
Florence or Padua needs to be considered in comparison
with ours. In summer Cennino speaks of such difficulty
in gilding as necessitated keeping the work in ' a cellar
at the foot of the casks ' just before operating (Chapter
CXXXVII). Our climate, with exceptions, does not
call for this, and the need for sugar is probably less with
us. The proportion advisable is therefore matter for
experience. Moreover, Cennino does not tell us exactly
how much was used, and leaves the amount rather ' to
taste ' with the proviso that it should be ' less ' than that
of the white lead. Some instinct has, however, prompted
me to adopt the most crystalline form I can obtain, as
probably nearest to his ' candy,' and as giving a result
less subject to sudden changes of weather. And that
which the grocers call ' centrifugal ' seems to me best
for the purpose. I distrust treacle entirely, and all the
' brown ' sorts, for I think Cennino cannot have known
them. Others, however, use them as providing stickiness
with smaller quantity. But the hardness of the crystalline
sort seems to me preferable, and the quantity not so im-
portant to consider.

Cennino tempered the whole with ' white of egg, well
beaten, as I have before directed you.' Again we are
uncertain, not only perhaps as to the powers of our hens
in comparison with his, for so domestic a bird has probably
undergone ungaugeable, however slight, chemical evolu-
tion since his day, but chiefly because he has given us
two directions as to this beating, and does not say to which
he is referring. In Chapter CLVI, so closely preceding,
that one must suppose he had it in his mind, he gives

directions for beating the white with no addition of water.
And though this is to be used as a sort of makeshift
method for varnishing a picture, and with no reference
to gilding, it is immediately followed by the chapter
containing the recipe for the asiso. It is in Chapter
CXXXI that he gives the other ' direction ' : ' Put the
white of an egg into a very clean glazed basin. Take a
broom of twigs[1] cut equal, and as if you beat spinach,
that is beating it very fine, so beat up the white of egg
with it till the basin is full of thick froth, which appears
like snow. Then take a common drinking-glass, not too
large, and not quite full of water ; pour it on the white of
egg into the basin. Let it stand from night till the
next morning to clarify itself.'

The ' common drinking-glass,' I have been assured,
was most probably about the size of our sherry glasses,
certainly not a ' tumbler,' and the quantity recommended,
therefore, some three or four tablespoonfuls of water.
At all events this provides a manageable ' temper.'

The unfortunate part of the business, apart from these
various uncertainties, is that an asiso so prepared is
not strong enough to take burnishing unless one so
overloads it with sugar as to render it liable to become
sticky, with entire loss of brilliancy at the onset of the
next cyclone, even if one can make a temporary brilliancy
at the time. I have therefore used fish-glue as well, or
instead, for strength ; and have considerably reduced the
sugar from the amount I have supposed he recommends ;
as I will detail presently.

The modern glues and seccotines are very many and
puzzling. One never quite knows what one is buying.
But fish-glue has a reliable history, and though Van Dyck
rejected it as a priming for pictures, my friend the late
Allan Vigers used it latterly as the sole ' medium ' for

[1] I have always assumed he would have no objection to our modern egg-whisks.

his colour in illuminations, which are still perfectly fresh
and bright. The best way is to buy it in a bottle. It is
put into tubes sometimes, but apparently weakened there
with something to keep it moist and squeezable—precisely
what is *not* wanted.

The first thing to be done is to slake some plaster of
Paris. For it is only sold unslaked, except by Messrs.
Newman, who, however, sell it in powder form, while
Cennino tells us to keep it in little cakes. I am told that
in powder it is apt to be affected by weather on keeping.
Cennino's directions for slaking are given in Chapter CXVI
of his book, and the following method is adapted to
our smaller quantities (using the plaster-caster's finest
plaster, though I am not sure that the ordinary surgical
plaster is not as serviceable):—Fill a bucket or housemaid's
pail two-thirds full of pure water and a breakfast-cup
two-thirds full of the plaster. Then dribble the plaster
into the water, stirring the while with a wooden spoon,
and occasionally putting the hand down to feel that no
nodules of plaster are setting at the bottom, the object
of the stirring being to keep it from setting. Continue
stirring for twenty minutes to half an hour. Again the
same day, some four to six hours later, stir it for another
twenty minutes, and again feel for and reduce any nodules
formed. Then once a day for a week stir it similarly ten
or fifteen minutes. At the end of the week, before stirring
pour off the water, as much as will come without the
plaster, which will be lying at the bottom. Refill, and
stir. Repeat the process for three more weeks, stirring
every day, and every week changing the water. Finally,
pour off the water as usual, and the plaster thereafter into
a clean handkerchief. Squeeze with this all the water
possible out of it. The plaster will be found to have
increased enormously in bulk. Cut the pudding up into
neat cakes, about the size of a child's toy bricks or large
dominoes, and lay them in rows on a piece of cardboard,

and let them dry away from dust and any artificial heat.
When quite dry in a few days store them like biscuits in
a tin box. And only when and as you need this now
gesso sottile scrape a brick into the powder you require
for making your asiso with a knife. The bricks seem
to ' keep ' indefinitely in a good tin.

And so to Cennino's recipe (Chapter CLVII) which
I give in the Italian ; for neither Mrs. Merrifield nor
Mrs. Herringham seem to have translated it quite
accurately.

'. . . Poi ti conviene d'avere d'un colore d'un gesso,
il quale si chiama asiso (i), e fassi per questo modo ;
cioè, abbi un poco di gesso sottile, e un poco di biacca,
men che per terza parte del gesso ; poi togli un poco di
zucchero di Candia, men che la biacca. Tria queste cose
con acqua chiara sottilisimamente. Poi 'l ricogli : lascialo
seccare senza sole. Quando ne vuoi adoperare per
mettere d'oro, tonne un poco, quello che per bisogno
ti fa ; e disperalo con chiara d'uovo bene sbattuta, come
di sopra t'hone insegnato. E tempera con essa questo
mescuglio. Lascialo seccare. Poi abbi il tuo oro : e con
l'alito, *e* senza alito, il puo mettere. E mettendo in su
l'oro, abbi il tuo dentello e pietra da brunire, e bruniscilo
immantinente ; e (ii) sotto la carta una tavoletta soda
di buono legname, e ben pulita : e quinci su brunesci.
E sappi, che di questo asiso puoi scrivere con penna
lettere, campi, e ciò che vuoi, ch'è perfettissimo. E mi-
ranzi che lo metta d'oro guarda s'è di bisogno con punta
di coltellino raderlo, o spianarlo, o nettarlo di niente : che
alcuna volta il tuo pennelletto pone piu un luogo che in
un altro. Di ciò ti guarda sempre.' Which Mrs. Herring-
ham translates thus :

'. . . Then you must have a paint that is a sort of
gesso, called asiso, and it is made in this manner : namely,
a little gesso sottile and a little biacca,[1] never more of this

[1] White lead.

than equals a third part of the gesso ; then take a little candy, less than the biacca ; grind these ingredients very finely with clear water, collect them together, and let them dry without sun. When you wish to use some to put on gold, cut off a piece as large as you have need of, and temper it with the white of an egg, well beaten, as I have taught you. Temper this mixture with it ; let it dry ; then take your gold, and either breathing on it or not, as you please, you can put it on ; and the gold being laid on, take the tooth or burnishing-stone and burnish it, but hold under the parchment a firm tablet of good wood, very smooth. And you must know that you may write letters with a pen and this asiso, or lay a ground of it, or whatever you please—it is most excellent. But before you lay the gold on it, see whether it is needful to scrape or level it with the point of a knife, or clean it in any way, for your brush sometimes puts more in one place than in another. Always beware of this.'

We can never be grateful enough to Mrs. Herringham for her book, which is indispensable to all who are interested in the methods of the Renaissance craftsman.

In the Italian the words in italics are translated by Mrs. Merrifield : [1] 'less than the third part is to be of gesso.' Which is plainly wrong. While Mrs. Herringham puts, 'never more of this than equals a third part of the gesso,' though Cennino says clearly, 'men che per terza parte,' that is, less than a third part. Which is not the same thing. In practice, however, I have found Mrs. Herringham incline to what seems, in this climate at any rate, to be a more serviceable proportion ; and I now boldly put more than a third part. Note that this third is a third of the gesso sottile, not of the whole asiso so far as one can see, since Cennino seems to call the whole the asiso and the gesso sottile the gesso. He has,

[1] *A Treatise on Painting* by C. Cennini, translated by Mrs. Merrifield. London, 1844.

however, at first called the whole ' gesso ' ; and it *may be*
that the amount of the white lead is to be less than a third
of the whole asiso. And this certainly brings it nearer
to the proportions I have found best, namely, eight
plaster of Paris to three of white lead. Note also that the
proportions are evidently by quantity, not weight. I have
found a saltspoon in which one can flatten powders and
so measure them equally with liquids, a convenient
measure for the quantities one needs to prepare from
time to time.

Both Mrs. Merrifield and Mrs. Herringham translate
the later *e* I have italicised ' or.' It may be that they give
the true sense by ' either breathing on it or not, as you
please.' But the direction given is so doubtful in practice
that it might have served no better to construe the sentence
for us word by word. Whether one breathes or not to us
makes all the difference between attaching the gold or not.
If the gold were attachable without breathing, one would
not be able to burnish, certainly not to give a metallic
lustre. The substance would be ever too sticky. It
may well be that he means breathe first ; and then
afterwards, as one often finds, on a part which one has
injured with the burnisher applied too soon, one may
attach the gold leaf renewed without further breathing.
Occasionally one finds on some damp days that one may
attach the gold leaf without breathing ; but this cannot
be relied upon, and is certainly not ' as one pleases.'

With eight powdered plaster of Paris and three of
white lead I take one of crystalline sugar and one of fish-
glue. I put them all on a ground glass slab, the glue last,
helping it out of the saltspoon by taking four of water
with it. No more water than this is usually required for
the grinding, but if during the process the asiso becomes
dryer than can conveniently be ground I add another
saltspoonful of water. I grind for at least half an hour
with another piece of ground glass. (If one were to

measure by teaspoons I imagine one would need to grind much longer to bring the stuff to the same condition. So that my recipe needs be followed exactly.) I then with a palette-knife scrape the whole together and set it evenly on the bottom of a small shallow tin box, such as the desiccated soups or ounces of tobacco are sold in. I do not shut down the lid but leave a crack open, and put it away in a drawer to dry slowly. It takes about a fortnight to do this and. is then fit for service, and so far as I can notice, remains so indefinitely.

At the time of grinding one may add a pinch of Armenian bole, just enough to colour the stuff a pale pink. This is of advantage for fine work, for by its aid one may see better what one is doing than with a substance the same colour as the ground. I never use more than a cayenne pepper spoon might take up. For the drying power of Armenian bole is so great and its property to me so obscure that I hesitate to use more, especially as in this recipe Cennino does not mention it, though elsewhere he is constantly recommending it.

The asiso will be a flat dry cake at the bottom of the tin box; and since the glue will have tended to dry to the sides and the lead probably to sink to the bottom, one needs to take care to cut the piece, for working, out slice-wise, as out of a jam sandwich, from the centre to the edge, and from top to bottom, that one may rely upon having the due proportion of the ingredients (Fig. 363). Put the cut piece into the well of a small china palette which shall be comparatively deep for its size and crush it to small pieces (Fig. 364). To these add a drop or two of

Fig. 363.

water, and leave it for half an hour or so. Then with the end of a bone pen-holder (or similar slender, hard

finger shape) render the asiso to the consistency of putty, no looser. A little experience will soon tell how much water will suffice to provide this in about half an hour with the amount used. Again add to this putty-like mass a few more drops of water (or the egg-water Cennino advises—though this is now not necessary as the glue serves instead) sufficient in another ten minutes to provide you with a cream-like asiso, such as you can use in a pen.

Fig. 364.

Stir it after the ten minutes, not too fast. And if you follow these rather tedious directions exactly you will avoid bubbles in your asiso, which are a great and common hindrance to success, owing to the disfigurement in the appearance of the work and the weakness generated by the air-spaces they impart. Those that do occur should be pricked with the knife-point, after touching the hair with it. The asiso should just flow from the pen, and can be easily too thick or too thin. If just right letters can be written with it as readily as with vermilion and with no more retouching ; though always the junctions of thick strokes with thin strokes should be watched, as they may need an extra touch with the pen, the stuff pulling away from them on drying. The density needs to be specially safeguarded for minuscule writing, as this cannot safely be retouched without unevenness of appearance when gilded. Equally important with such writing is the even supply of asiso in the pen and its extra smooth working, that all the strokes may be equally raised from the surface as well as equally wide. For if the stem-strokes are dense in one part and less dense in another (as may happen as the pen's supply gives out) when the burnisher comes to work upon them the denser will tend to spread under it wider than the other—and the writing be seriously disturbed.

It is often advisable in drawing letters on parchment

suspected of any greasiness to 'score,' as it were, their
outlines with the edge of the pen or one of its angles, that
the asiso may obtain a firmer grip ; and, where dots of
ornament or minute patches for gilding occur, to prick
the parchment slightly through the asiso with the point
of the knife, or a needle, for the same purpose.

Before the asiso is used, all places where it is to go
should be pounced with whiting or chalk, that the gold
leaf may not adhere to the parchment, and the whiting
wiped away carefully.

Cennino tells one to 'let it dry,' then gild. As if the
laying the ground and gilding were all in the same hour's
work. But some consideration is not out of place here of
the requirements for success. For this one needs that the
gold leaf be easily attached, and that the surface take a good
burnish—and finally that there be no cracking.

To attach the gold leaf easily the asiso needs to be cool
that the breath may condense upon it readily. It needs to
be hard below and just soft enough on the surface for the
burnisher to work smoothly. If one gilds too soon (or
later if the asiso is too soft from unsuitable proportions),
the asiso will not have set firmly enough for the burnisher
to work without actually kneading the surface with the
undulation of its passage to and fro. This is to weaken
it, and start the numerous little cracks which will show
worse as it dries thoroughly. Moreover, if it be not dry
all through, the breath will not condense very readily
and the gold leaf will not adhere ; so that one should at
least wait until the whole is quite dry. And it should be
cool. It is difficult to gild in a warm room, especially one
warmed by a radiator. It is also difficult to gild in a dry
east wind. But then also it is difficult to burnish in warm
moist weather. For in the first case the breath will not
condense easily, in the second the asiso remains too soft.

So that Cennino's 'let it dry' needs supplementing.
I have gilded easily in the afternoon after laying the size

in the morning, putting the sheets away into a cool room between whiles. But the best time for gilding is early next morning, when the asiso is cool, and has had more than twelve hours to dry out and set. And chiefly because the breath condenses without difficulty then, and even the workroom is not yet dried up with the day. But one is not pressed for time, for unless egg-water has been used (when drying becomes more permanent), the asiso remains susceptible to the breath and may be gilded days after. If to-day there is an east wind it is better to wait, even a week, for the south-west. But the most favourable condition of all is south-west to-day when one lays the asiso, veering in the night to north-west in the morning, when one gilds.

The susceptibility to breath, *i.e.* damp, is reduced by the burnishing and the gold leaf; for though, of course, the breath will condense upon the surface if the work is peered into, it will not readily penetrate below the surface and soften the asiso. Prolonged damp weather, however, will, and the protection egg-water provides is therefore worth considering. For when once dried white of egg becomes insoluble. The drawback is that it tends to crack. MSS. are often injured on binding or framing by the damping and pressing and folding processes of inexperienced binders or framers, who are apt to think that the thing bound or framed is of less importance than the perfection of the binding or framing.

If the asiso so gets redamped and the burnish lost, this may be renewed before the thing has become quite dry again, or the work may be regilded—with some difficulty ; but when once again dry, as well as dimmed, reburnishing will rub through the leaf and spoil the work further.

CHAPTER TWENTY-NINE

GILDING THE ASISO

ENNINO tells us to have a 'firm tablet of good wood' under our work when gilding. I find wood neither hard enough nor cold enough, and use a piece of japanned tin instead, which is harder and also helps the breath to condense with its chill. Some prefer a piece of glass, which is apt, however, to cause accidents with its edges under the stress of the gilder's operations. Cennino tells us also to scrape our asiso or level it with the point of a knife (why the point?), but a careful laying of the size renders this needless. And one only needs to scrape on the occasions when from some miscalculation the size has been too moist and a groove forms down the centre of letter stems, etc., as they dry. Even then it is not wise to scrape much, for the adhesive elements are at the surface, and scraping removes them and increases the difficulty of attaching the leaf. Unless the grooves are deep it is better to leave them and trust to burnishing them down. Usually, however, I burnish the work slightly before attempting to lay the leaf; but not for the sake of the smoothness so much as the readier condensation of the breath on the shiny surface.

Two burnishers are advisable, one a claw-shaped one, the other with a boss. And neither should be so small as are usually sold. A small burnisher imparts that undulation spoken of to the surface over which it passes, which makes for cracks later. But the claw should have point enough to define edges competently and deal with filigree. The main tool, however, is the bossed burnisher, either

of agate or (better still) hæmatite, and large enough to flatten the work as well as brighten it. They are not usually sold of quite serviceable shape, but may be ground so by a lapidary. I have found that given in Figs. 365, 6 (actual size) satisfactory. The boss has a flat plane, shown, and no angles anywhere, and all the burnishing is done with this plane. The claw is used for edges and tidying up. Both should be about six inches long altogether and have handles that can be gripped. These, if not thick enough, can be whipped with string. Gilding is not tickling. Real force is to be used. The claw, on purchase, needs to be examined through a lens for facets. The angles between these scratch. It should be all smoothly rounded. And burnishers seem to improve with use. Fig. 367.

The scribe and illuminator need no gilder's cushion, special knife, and tip ; but, besides the burnishers and japanned tin (or piece of glass), and, of course, the gold leaf, there are a few other requisites to provide : a piece of grease-proof and semi-transparent paper about six inches square, such as is used to protect the covers of books for sale, a piece of old (well-washed) flannel, folded double, a small soft stencil brush, a few paper stumps as used in chalk drawing, which should be rubbed a little fluffy for our purpose, and a very good pair of scissors about six inches long at least, which must be kept bright and frequently wiped with the flannel.

Fig. 365.

Fig. 366.

Also a crewel needle set in a stick or a fine steel
knitting-needle is useful for dotting patterns when wanted
on the burnished gold. The scribe's knife and lens and a
substantial paper-weight should be handy.

The gold leaf I have used has always been
'fine' gold, that is, as pure gold as the beaters
can beat it, and either of 'single' or 'double'
thickness. The former, with two layers, does
best for fine work, the latter for general use,
supplementing it with a layer of the single,
either first or last, to ensure good edges—and
mend flaws. But this is not always necessary.
The leaf should be in unrouged books. It is
thus certainly more liable to injury; but, if
rouged, the rouge is apt to make a pink fog
on the background, spread there by burnishing.
And this is the greater evil.

The operation is as follows :—The gilder
should have the light from the left front, as
usual, and the work before him on a flat board
or table, with the japanned tin immediately
under the work, and the paper-weight holding

Fig. 367.

it firmly, for both hands need to be free. And since it is
necessary, lest the gold leaf adhere to ink or colour present,
to screen off with pieces of blotting-paper all writing, etc.,
the paper-weight may usefully hold these in position at
the same time. Gold leaf stuck to the black writing
about a gilded letter is slovenly and unsightly.

The book of gold leaf should next be carefully opened,
and the bottom leaf resting on its paper leaf should be
let droop and nicked along its fore-edge three or four
times with the scissors and then the paper leaf with the
gold cut off close to the fold of the book, and the book
laid aside. The nicks will hold the leaf to the paper
sufficiently. Then boldly cut a piece, paper and all, leaf
upwards, the size required to cover the letter to be gilded.

The whole leaf may sometimes be needed ; but, especially at first, it is 'wiser to use but a fourth part of this (or less) at a time. The cuts will hold the leaf to the paper. But if the scissors be allowed to become rusty, or even if, kept bright, they be not frequently wiped on the flannel, the gold leaf will adhere to them and become unmanageable.

Now breathe on the letter with the open mouth an inch or two from it,[1] holding the little piece of paper leaf downwards in the right hand. Breathe about a dozen breaths, or less on a damp day, and immediately place the paper (and leaf) on the letter. Give a slight rub with the forefinger, flick the paper away, or remove it with the knife-point, and as quickly as possible set the doubled flannel upon the bare leaf ; and, holding this stretched taut upon the work with the forefinger and thumb of the left hand three or four inches apart, that it may not be disturbed at all, rub the finger-nails of the right across the letter upon the flannel, and not too timidly. This drives the gold leaf down to all edges and intricacies of the form or pattern, and allows one at the same time to feel what one is doing. It is not the least dangerous if the flannel be kept tense and the amount of breathing has not been too great. If it has, another leaf of gold may be at once set upon the first and the process repeated more gently. Any accident to the first may be detected on removing the flannel by shielding the letter from the direct light with the six-inch square of transparent paper. If, on the other hand, the gold leaf comes away with the flannel the breathing was not sufficient. And this last is the usual beginner's difficulty, who, however, will find success come the better, the faster he can perform the operation.

Supposing the leaf look fairly attached, set the transparent paper upon it, and with the boss give a general

[1] I never use a tube now. Too many accidents arise. Any spot of water on asiso or background attaches the gold leaf amiss, and on background it is difficult to remove afterwards.

burnish with a spiralled sweeping action (Fig. 368) through
the paper and also run round all edges with the claw.
This as quickly as may be. Then, holding the paper in
the left hand to shield the direct light
away, burnish the body and edges of the
work directly upon the leaf with a similar
action, and an up and down the stem
action also. Any mishap will immediately
be detected, as a scratch or speck upon
the surface, and may be remedied (mostly
and fortunately) with another piece of

Fig. 368.

single leaf burnished straight down upon the spot—
without rebreathing. But if not, the whole process needs
redoing, at least to the injured part. In such a case the
uninjured portions should be shielded from the rebreath-
ing with other pieces of blotting-paper.

In the usual course the brightness should appear the
moment the boss touches the bare leaf, and the burnishing
should be quite a rapid business. Success will not come
with straining. The asiso should feel neither hard nor
soft under the burnisher, but rather should give the
sensation of pliant, smooth submission. The burnishing
should be gentle at first, and then forceful. And to give
some idea of the pace at which the proceedings should go,
if success is attending, some twelve to fifteen separate
plain letters, Gothic or Roman, say one inch or three-
quarters of an inch in size, may be easily thus gilded in an
hour. Sometimes it is not necessary to use the flannel at
all, but the transparent paper may be placed over the letter
and burnished, directly the gold leaf's paper is removed ;
though the flannel is certainly safer. And I use flannel
instead of the dabbing down with cotton wool so often
recommended, because little hairs from this are apt to
attach themselves to the asiso and cause annoyance.

As regards the pace of performance—any observation of
illuminated MSS. declares at once that gilding was an easy

matter of old. So far from using it as by an effort, or for special occasions, the scriptoria of the Middle Ages have poured it forth over their books with as great lavishness as magnificence, and, apparently, consummate ease. And from unfinished examples of their work come down to us, as the Douce Apocalypse in the Bodleian Library at Oxford, MS. 180, or the Metz Pontifical now in the Fitzwilliam Museum at Cambridge, or the Winchester Bible in the Chapter House Library at Winchester, one learns—as one may also learn by convenience in experiences—that the gilding came after the writing and the drawing on a page, but before the painting. For the gold leaf will adhere to any paint that precedes it, and is, of course, hardly to be kept clear of this in an illuminated letter, etc.

For further investigation of this matter the student may refer in the British Museum to ' Regola della Compagnia di S. Maria della Plata, in Firenze,' a humanistic MS., Harl. 3547, where the book has been finished except for initials on ff. 12 and 20, where the letters have been drawn like the others and gilded, but uncoloured. And through the book as at f. 17 the gold dots have not been put in, and in other pages they have ; but the radiant black lines, added elsewhere, have not been given them ; showing that this extra was the last detail in the finish of the decoration.

In another MS., Add. MS. 30025, Tresor de Bonnet Latin, of the fourteenth century the asiso, which is of two colours in the book, a reddish pink and a greyish pink, has been laid in a number of pages, but left ungilded, though most of the book's decorated initials have been completed. And there are so many thus unfinished as to leave one to conclude that it was not some accident of a gilder's illness or absence that made default ; but that the asiso was put on ready for gilding ' soon ' or ' at convenience ' ; which rather upsets one's assumption that there is

need for any particular hurry over completion. And indeed I myself have found that the asiso prepared with fish glue remains sufficiently hydroscopic for whatever length of time I have been prevented from completion, on occasion. But I have never tested for maximum length of time.

The most instructive, however, of these uncompleted MSS. is B.M. 20 C. vii Roy. MS., 'Les Chroniques de Saint-Denis,' vol. ii. This is a small folio in double columns with a great number of square miniatures set in the text in thin gold frames. The text and the decorated initials (generally L's) and these frames throughout have been completed. The quires of the book seem then to have been handed out to different miniaturists, and some have finished their work, some have only half done it or put in their pale ink sketches ; and in some quires the blank squares are still quite vacant. In the unfinished ones the backgrounds of coloured diapers have sometimes been put in, but not the figures, and where these diapers have been occasionally of gold, a different coloured gesso may be seen from that of the frame already there ; and, moreover, this further gilding has done some considerable violence to that of the frame, leaving one to wonder whether this would have been repaired on finishing the miniature. For the ruled black lines of these frames have been left to be added on completion, evidently with the notion of a general final tidying up of all. The book is also interesting from a signature occurring at f. 134b, Richard Gloucester, supposed to have been afterwards our Richard III.

As soon as the letter is burnished the stencil brush should be dabbed perpendicularly and brushed over it to remove the superfluous gold from all surroundings. This is as rough treatment as the letter is likely to receive, and a test of the success of its gilding. After this a stump may be applied quite safely to rub away any gold still sticking

to the background, and especially along edges ; failing this the knife's point should be used to trim all, by the aid of the lens. Finally, the letter should be reburnished with a few strokes to restore any gloss lost by these cleanings-up. Gilding should be subsequently taken care of by inter-leaved tissue-paper till the book is bound, or the work permanently protected. The sheets of an unbound book are apt to rub and may injure the gilded letters projecting from the surface. As soon as bound they are safe, because mere pressure, unless the binder overdoes this, or mal-treats them by damping or otherwise, does not harm them.

Gold is the finest decoration for MSS., but needs, even with letters only, to be used with judgment. To make a MS. wholly in gold with the purpose of making it splendid can easily fail in effect ; for gilding on the ivory of parch-ment needs to be arranged with extra care that the massed writing may be rich. Straggling writing emphasises the limitation of such a restricted colour scheme ; also the literary matter needs to justify the method. I have seen some ' addresses ' so rendered, which by their awkward phrasing, lame sentiment, and occasionally want of grammar have almost ridiculously stultified their ostenta-tious treatment. Gilding on parchment stained or dyed purple, blue, or green fails to achieve the Byzantine manner ; and failing, imports a sense of affectation. The magnificence is somehow alien, even barbaric. The master who could restore this to us is yet to come.

The safe use of gold is for the initial letters of chapters, or their opening sentence at most ; and later, for especial paragraph initials rather than for all. For black writing with gold initials only has also rather a pompous or funereal air. Blended appropriately with the other colours it has its greatest success in enriching. For instance, a Psalter might have all the first letters of Psalms in gold, with a first line of gold capitals for the first Psalm and

certain others. Throughout the book the verse initials might be of alternate colours—red, blue ; red, blue ; or red, green ; red, green ; or red, blue ; red, green. Or, more sumptuously, the system might be gold, blue, red, green ; gold, blue, red, green ; and so on, with variants.

In the York Chapter Acts of 1346 an interesting deed of agreement with a scribe for writing and decorating a Psalter is preserved ; in which he undertakes to write a Psalter with a calendar, and ' will illuminate all the Psalms with the large letters of gold set in colours. . . . And all letters at beginning of verses shall be illuminated with good azure and vermilion, and those at the opening of each nocturn shall be great five-line uncials.[1] But *Beatus vir* and *Dixit Dominus* shall be six- or seven-line letters.' For this he was to receive five shillings and sixpence. Even if, as is probable, he was boarded and lodged the while, one would need to multiply his honorarium by considerably more than the allowed increase in the value of money since the fourteenth century for a modern to entertain such a commission. Money was not then two hundred times to-day's value. Comparisons are difficult, but a certain humility may be extracted as well as encouragement. And he had an allowance for colours and gold !

Gilded letters should look metallic as well as bright, and it is in this respect that powdered gold, even burnished, usually fails. It becomes just a substitute for yellow. The raised gilding in the mediaeval MSS. shows various excellence, the Flemish of the fourteenth century perhaps being the best, though English of the same period is first class also. The Italian of the fifteenth century is also very fine, though with more cracks now apparent. But in all cases it shows this metallic quality and is hardly

[1] Rather corroborative of the view that this strange word was originally ' initials,' or at least of the general use of it so, rather than descriptive of the sort of letters, even though in this case they were doubtless compound forms of derivatively ' uncial' character.

ever tinselly or brittle-looking. The grounds vary in colour from white to dark bole (even with some admixture —perhaps of ' black-lead,' as I have gathered from some recipes—to aid burnish) ; but always the colour and quality are beautiful, enhanced most usually in any letters, etc., of fair size with black outlines. I never can think this outline added to conceal defects of attachment of gold leaf at edges—our frequent fault—but intentionally to define form and splendour the better. It was certainly performed in most cases with a pen, and is one of the most difficult feats to attempt, owing to the glazed surface it has to set the ink upon. The ink must have been very viscous for such performance.

But sometimes, even in magnificent MSS., such as the Aristotle's *Ethics* (B.M., Add. MS. 21120) of the fifteenth century, a defect in quality is observable, such as too often afflicts our own preparations, a granulated or spongy appearance of the surface, although very bright, as of gilded jam rather than hard metal. And this I have found with our own always proceeds from excess of glue and sugar—although we use certainly less sugar than Cennino did.

Mechanically the quality comes of burnish of the asiso when too soft, that kneading I have spoken of, so that the texture is really disturbed from dense solidity even though the glue prevents more apparent accident. I have tested both the plaster of Paris and white lead by using them alone with the adhesives. But while they both can be made to work, the plaster is difficult to put on, tending to such flocculency in the pen that I have sometimes thought the white lead was added as a corrective, and breaks with burnishing ; and the white lead alone gives too little raising and sets very brittle and hard ; doubtless to crack later as the pages are bent in use. So that my experiments have not been very informative. But one must not forget that white lead is a cement itself, and

that if very scientifically applied with the plaster these may require little besides to set into a firm bed ; and that the sugar may be added only to keep this horny instead of brittle, and the egg-water merely to attach the gold leaf. Yet the moment one abandons the glue the difficulty of attaching the leaf is renewed, while if the glue is not diminished to the minimum that will yet secure this, the disagreeable jammy look will spoil the finished work.

Another defect in quality is observable if one adopts in our climate Cennino's proportions of, say, thirteen plaster to four white lead, which is a reasonable construction of his directions—and this is an exaggerated raising and a fat unctuous appearance after burnish.

It is difficult to temper the asiso thin enough without using so much water as to reduce adhesiveness too far. But this fat look spoils much modern work, which is otherwise brilliant enough. The letters often are seen to be actually squeezed out laterally under the burnisher, and this assists by its disfigurement the oiled appearance of the surface.

In the Aristotle's *Ethics* the gold is redder than usual, for in nearly all cases of mediaeval use the gold has evidently been ' fine ' gold, though in some thirteenth- and fourteenth-century work I have noticed cases in which the gold has become coppery in places or been rendered coppery intentionally.[1] The goldbeaters tell me that gold with a small amount (Cuxon's alloy) of copper alloy is safe to use as regards permanence. And certainly the slightly redder tinge imparted may be considered an improvement, and may have been given, therefore, in the book mentioned, upon which no expense was spared ; so that economy is not in question, though possibly fraud.

Pure gold is always the same colour and untarnishable, and a difference of colour cannot be produced by colouring the asiso—unless, indeed, the leaf be full of holes. But a

[1] Possibly by means of a varnish applied afterwards.

fictitious difference may be given to it by outlining with different colours. A gilded letter, outlined in red, or yellow, or black, will appear of a different colour each time. But this is optical delusion.

Gold being the scribe's most valuable ' element ' needs to be given the post of honour in his work—as suggested by the placing of it mentioned above. To use it as background for a plainly coloured letter seems inappropriate. The coloured letter needs to be so further elaborated as to become a gem set in the gold, as may be seen in much fourteenth and fifteenth-century work, where gold is used for backgrounds. As a background for figures of saints the same justification applies. And here the gold is often patterned with a pointed tool. The crewel or knitting-needle mentioned above answers admirably for this purpose ; and the patterning should be done immediately after the final burnish. After which no extra burnish must be attempted, or the pattern will be spoilt.

A student once brought me a recipe for an asiso from Italy. I tried it but had not the same success with it as with Cennino's, though it is not unlike his. In case others care to use it I give it here, and should be glad to hear of success with it.

15 grammes plaster (gesso sottile).
5 grammes white lead.
3½ grammes white crystal sugar.
4 grammes Armenian bole (!).
3½ grammes powdered gum Arabic.
½ to ¾ gramme ground lead, like that in pencils.

The whole to be ground with water for use as with Cennino's, kept, and then a piece tempered with water for the occasion. The last ingredient is the black lead which is not ' lead ' at all, but graphite. It is no doubt included to aid burnish.

EFORE concluding, I would venture to reassert the limited endeavour of this book, lest I seem to be overlooking the wider application of writing to the general purposes of modern life, either directly—with the free hand—or by means of the various processes of reproduction—of which we are apt to forget that the press, with its imitativeness and dependence, is also one.

Writing may be divided into four classes by reference to its intention :—

1. That which tells only, without consideration of pleasing, its primary intent being to ' put its meaning across.' And this includes all block letter, although block letter may sometimes please also, by the very audacity or efficiency with which it carries out its intent.

2. That which tells and pleases, to which class all book-work belongs, or should belong : all the work which is not primarily decorative, and yet has regard to pleasant, which means largely conventional, methods of expression.

3. That which pleases and tells, primarily decorative and only secondarily informative. For writing has been found to be of such assistance in design generally that it is often imported as an integral part of this, performing at once the function of decorating as well as explaining. Of this class perhaps an ordinary ' monogram ' brooch might be cited as an extreme example, where the letters are tangled into a decorative whole, and their meaning almost hidden thereby, and yet present for the initiated or inquiring. Of the same order are coins and medals and

an endless variety of objects to which we apply explanatory writing, even the name of a person portrayed becoming part of the design in a portrait painting; and the actual decoration of letters themselves is to be naturally included.

And this class lapses into a possible fourth class of those uses of writing where there is no real necessity for telling, but the decorative value of writing has been recognised and invoked to supply deficiency of other inspiration. The blotting-book with the word ' Blotter ' sprawled upon its cover has been already mentioned, and the ink-pot needlessly labelled ' Ink,' these being excuses for touching the things with some idea of ornamenting them, but with a fussiness unwarranted, and so failing even to ornament. Worse still can be sham inscriptions.

Of these classes this book has only attempted to deal with the second, reserving the third, or some small portion of it, ' illumination ' for a further attempt. Illumination may indeed be regarded equally from the point of view of the beautiful-legible or the legible-beautiful, and so comes half-way between the suggested second and third classes. But its decorativeness draws it rather to the latter. It is legibility in ' party ' clothes, as compared with the decent dress of every day, which is rather what the second class comprises.

This ordinary sort of legibility, the method of telling and pleasing by the expression of the writing itself, I have endeavoured to analyse in Chapters XXI–XXIV, having regard to those conventional expectations of the reader which help his enjoyment, while their neglect hinders this ; but without treating of the decoration of the letters themselves or considering the addition of decoration to them. I have not even mentioned line-terminals. And I have endeavoured the while to reconcile the various sorts of writing to one standard, by reference to degree of detail, rather than difference of character ; that the

hope of pleasing may be rendered the easier of realisation by the very limitation of the methods of telling suggested. For so with a settled aim one may have a better chance of success than by experimenting dubiously with the endless varieties of past centuries—or modern imaginations.

And in conclusion I would make a plea for the honour of the MS. book for appropriate occasion. The war disclosed such an important and unique occasion ; and in our cathedrals and churches and chapels are resting now many examples of work which could not have been rendered with dignified efficiency otherwise than by written books. The names therein inscribed will outlast the walls about them—or the cenotaph itself.

The assumption is too generally made that since the printing press has given us the means of cheap multi-plication, we are no longer justified in weighing any other matter. The making of a *single* book superlatively is consequently an anachronism. So far are we removed from the mind of that Duke Frederick of Urbino, in whose library you could not find a single printed volume, ' for the Duke would have been ashamed to own one ' ; and kept thirty to forty copyists continuously employed for fourteen years. So far are we also passed beyond the mind of Aldus, to whom indeed each author remained a prisoner, though gilded his cage, so long as he existed only in manuscript form, that we can hardly imagine paying the honour to our greatest of putting even one copy of him back into the superlative beauty of manuscript once more. Five hundred years of the printing press and the immensity of its gift to the world have put out of reckoning by now any consideration of a loss, so trifling as to be forgotten in comparison,—the beauty of a manuscript book.

Photography may afford a parallel. We have not yet had one hundred years of photography. But it has already killed the ' special artist.' There may be other artists to go in its second hundred. The hand-made portrait is at

present comparable to the MS. of the sixteenth century, but for how much longer ? And what of painting generally by its fifth ?

Or again, our machine-made music is already reducing, to the satisfaction of the cynic, the vocal and instrumental endeavour of the child and the ' home.' The invention of a machine seems even to lead to substitution, never to partnership. Nor are any precautions ever taken with reference to standard on the supersession of a craft by a machine.

At present our painters do not think in ' editions ' when painting a panel. Only when they ' illustrate ' a book do they consider methods of reproduction rather than a single beautiful creation—and this, although with a book there is scope for more creation than the limitations of any panel allow. Even considered from the point of view of common convenience the portability of a book and its unassertiveness, the mood misfitting, give it the advantage over the picture fixed and familiar on the wall. Our chief performers, however, never think of investigating this superlative method of expression, owing to the supersession by a machine not only of the hand-made, but of the appreciation of the hand-made, even the remembrance of it. In respect of books we are content with the mechanical substitute. And at the Musée Condé, Chantilly, can be seen the treatment our predecessors also have accorded to the exquisite Jean Fouquet, turning his book into a series of panel pictures, suitable for lining a wall !

In these five hundred years we have experienced a further change with regard to books of which we are hardly aware. We are in truth book-readers rather than book-lovers. Since we have made no demand upon this completion of their beauty for centuries our regard for them is become almost entirely intellectual. The Duke's sense of *infra dignitatem* is unintelligible. That the author's thought should be conveyed to us clearly with

decent print in a decent cover is about all we require.
Even the illustrator can be a disturbance, an intrusion.
Another personality, who should endeavour to decorate as
well as explain pictorially, would be liable to resentment.
Or perhaps the change is more fairly comparable to that
of men's clothes from mediaeval splendour (or extrava-
gance) to the drab uniformity (or occasional eccentricity)
of our day. Our books are good enough for the purposes
we require of them.

For all ordinary purposes, maybe. But our heedless-
ness has included also purposes which are not ordinary.
And we no longer provide for those occasions for which
nothing but the very best is appropriate ; although we
still acknowledge that the best possible is, in every craft,
that which is made throughout by hand.

This superiority of the hand-made, when well made by
hand, is a matter of experience to all of us, and does not
negative the fact that a machine product may be well made
also. But we recognise that, where technically the
machine- and hand-made things are both well made, the
latter will still be superior for another than the technical
reason. It will be preferable for its individuality, the
personal expression of its creator. It will be more humanly
interesting in that it will have that eternal variety of nature,
which is her gift to every man, and to every work he
performs. Repetition, at once the *raison d'être* and the
justification of the machine—the mould—seems almost
capable of destroying beauty to our eyes. The smile of
Monna Lisa has withered under reproduction, and Alfred
Stevens' lion grown stiff in all his sizes.

And this preference rises to the attribution of sanctity
to handwork, so that when a benefactor bestows gifts upon
his church he gives handwork because of this sanctity
also. Linen, lace, embroidery, hangings, stone, wood, and
metal-work must all have been handwrought to be deemed
appropriate. There remains the anomaly that the words

of the services of the church, which might be supposed to demand the chief respect, since upon them all else hangs, should be read from machine-made books (with hand-work too enclosing them as covers or invading them as book-markers!), without anyone being so much as aware of an inconsistency or defect.

The Hindus are more fastidious, who, I read, have such religious prejudice against printed substitutes that they will not use in their temples or for sacred purposes anything but manuscript. Are they more religious or more perceptive than ourselves? Or do these qualities belong to a more primitive civilisation than our own?

The argument of expense is not fairly to be alleged. The best is the best, no matter what it costs. We do not consider cost when we mean to have the best, when we imagine the best 'matters.' The possession of a hand-painted fan is not reckoned an absurdity nor an enormity. The whole affair is rather one of fashion or forgetfulness. And the very quality of 'uniqueness,' which prompts the collector to give £10,000 for a copy of the first folio of Shakespeare (in itself not a work of great technical distinction) is left out of account in regard to a sort of rarity, the encouragement of which might be well worth while again.

Recognition of the value of rarity is present in the very productions of our modern machines. The 'limited edition' is expressly designed to cater for the connoisseur, not seldom having a still more limited edition within itself, that of half a dozen copies on vellum; while the 'first edition' in general has now a club of its own, both here in England and in New York also. A very great interest in the better production of books is indeed a marked feature of our time. Can it reach as far as MS.?

For church books one might instance at once the three volumes for the communion service, the first containing the services with all the collects for the year, the second

HILE JESUS spake these things unto Johns disciples, behold, there came a certain ruler, and worshipped him, saying, My daughter is even now dead; but come and lay thy hand upon her, & she shall live. And Jesus arose, and followed him, and so did his disciples. (And behold, a woman, which was diseased with an issue of blood twelve years, came behind him, and touched the hem of his garment; for she said within herself, If I may but touch his garment, I shall be whole. But Jesus turned him about, &, when he saw her, he said, Daughter, be of good comfort, thy faith hath made thee whole. And the woman was made whole from that hour.) And when Jesus came into the ruler's house, and saw the minstrels and the people making a noise, he said unto them, Give place; for the maid is not dead, but sleepeth. And they laughed him to scorn. But when the people were put forth, he went in, & took her by the hand, and the maid arose. And the fame thereof went abroad into all that land.

HEN JESUS then lift up his eyes, & saw a great company come unto him, he saith unto Philip, Whence shall we buy bread that these may eat? (And this he said to prove him; for he himself knew what he would do.) Philip answered him, Two hundred penny-worth of bread is not sufficient for them, that every one of them may take a little. One of his disciples, Andrew, Simon Peter's brother, saith unto him, There is a lad here, which hath five barley loaves, and two small fishes; but what are they among so many? And Jesus said, Make the men sit down. Now there was much grass in the place. So the men sat down, in number about five thousand. And Jesus took the loaves, and, when he had given thanks, he distributed to the disciples, and the disciples to them that were set down, and likewise of the fishes, as much as they would. When they were filled, he said unto his disciples, Gather up the fragments that remain, that nothing be lost. Therefore they gathered them together, & filled twelve baskets with the fragments of the five barley-loaves, which remained over & above unto them that had eaten. Then those men, when they had seen the

Fig. 369.

A SMALL FOLIO 'GOSPELLER.'

Executed by the author and his assistants, decorated throughout in gold and colours. Reduced.

the epistles, and the third the gospels; a lectionary containing at least the lessons for the chief holy days; a litany; choir books, again, such as have helped Siena's fame! Or, for private devotion the communion service, with and without the rubrics; the Psalter; the morning and evening services. The confirmation service would be the appropriate gift of a godparent. And the marriage service, containing the actual names of bride and bridegroom, the name of the church where the wedding is celebrated, and blank leaves for subsequent entries, would make a present which might easily become fashionable at St. Margaret's, Westminster.

And again, since Chaucer not any of that literature we regard as second to none in the world may be said, in a general way, to have received treatment beyond the mechanical best of print. Even where an illuminator has arisen, now and again, the work has been granted him rather as an opportunity for him to find expression for himself than for the reason that the literary content demanded superlative or unique distinction. One of the compliments, however, we pay to distinguished persons is to give them their portraits. But we have not yet presented a hand-made copy of his work to any poet laureate.

The spirit which should prompt the making of manuscripts needs to be that of the girl I once had the honour of meeting, who wrote out the whole of Charles Kingsley's *Water Babies* to give her sister as a wedding-present— making it thus the more sweet and intimate.

The technical ability is not lacking. Such work certainly cannot be made superlative as yet, owing to this general widespread neglect and mental attitude, to the loss of tradition, as well as the devotion of the best artists to other objects. But for the last twenty-five years a school of modern scribes has been growing amongst us, whose script at least can compare not unfavourably with that of the fifteenth century in general. But at present

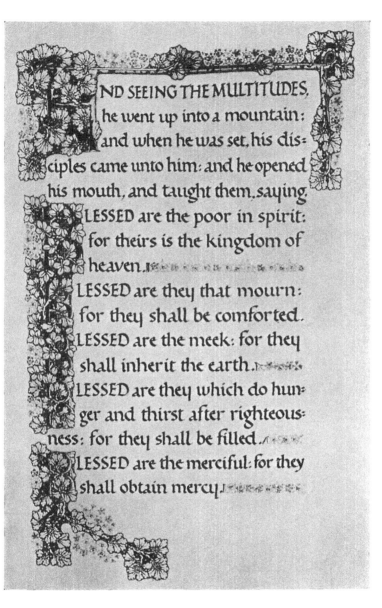

AND SEEING THE MULTITUDES, he went up into a mountain: and when he was set, his disciples came unto him: and he opened his mouth, and taught them, saying.

BLESSED are the poor in spirit: for theirs is the kingdom of heaven.

BLESSED are they that mourn: for they shall be comforted.

BLESSED are the meek: for they shall inherit the earth.

BLESSED are they which do hunger and thirst after righteousness: for they shall be filled.

BLESSED are the merciful: for they shall obtain mercy.

Fig. 370.

THE SERMON ON THE MOUNT.

Executed by the author and Miss I. D. Henstock, decorated throughout with initial letters and part borders, in gold and colour. Reduced.

THE WOODS DECAY.

THE WOODS·DECAY AND FALL,
The vapours weep their burthen to the ground,
Man comes and tills the field and lies beneath,
And after many a summer dies the swan.
Me only cruel immortality
Consumes: I wither slowly in thine arms,
Here at the quiet limit of the world,
A white-hair'd shadow roaming like a dream
The ever-silent spaces of the East,
Far-folded mists, and gleaming halls of morn.

las! for this gray shadow, once a man —
So glorious in his beauty and thy choice,
Who madest him thy chosen, that he seem'd
To his great heart none other than a God!
I ask'd thee, 'Give me immortality.'
Then didst thou grant mine asking with a smile,
Like wealthy men who care not how they give.

Fig. 371.

A TREATMENT OF POETRY.

Page from a book of the poems relating to the Greek mythology, of Tennyson. Executed by the author and Miss I. D. Henstock, decorated with initial letters in gold and colour. Reduced.

they have to give their very respectable ability to the writing of advertisements or window-tickets and other tradesmen's requirements for want of the nobler commissions which a fuller understanding of their possibility for books might bestow.

Of this beauty of MS. books it is difficult to write to the unacquainted. Seeing mediaeval examples in the glass cases of museums is of too little service towards appreciation. At best they are antiques, and divided from our familiar welcome by time. And besides, a single opening is all you may so see. And the delight lies much in the handling, and the sense of treasure, as one turns over the richness of substance, with its burnished gold, its beauty of ink and colour ; with ever the human quality of the hand-made thing, instead of the inanimate regularity of the printing machine, enhancing and, when truly sympathetic, even interpreting the author to us anew ; as a fine executant may interpret his master's music.

In this book I have endeavoured to display the standard of writing of an age and a nation in which perception and craftsmanship were supreme, and to suggest that the adoption of such a standard, with its appropriate method, would certainly better our performance of a still necessary personal function ; would guide us safely in the application of lettering in much of the business of life, owing to its fitness and adaptability ; and yet further, might draw us to the cultivation once more of handwriting's noblest expression—the superlative production of books for sacred and superlative occasions.

APPENDIX

THE following pages contain a summary of the method advocated in this book, with illustrations of the hands (or variations of the hand) needed for everyday use or sufficient for the practice of writing as a craft; together with short directions for the formation of the letters :

Figs. 372 and 373 : a cursive hand (minuscules).

Figs. 374 and 375 : a semiformal hand (minuscules).

Figs. 376 and 377 : a formal hand (minuscules).

Figs. 378 and 379 : capitals for ordinary use with these hands, or alone, inscriptionally.

Figs. 380 and 381 : compound capitals, more elaborately drawn, for use as initials, or otherwise decoratively.

Figs. 382 and 383 : an example of the combination of the several alphabets in a set piece of work, as a panel, or a page in an important book. In this the compound capitals might well be red and blue.

A cursive hand, the letters formed thus:

1 stroke, aa bb c e gg h i j k l m n oo qq r s u vorv w y z

2 strokes, dd ee -fff pp -tt ∧x orɔcx.

Natural ligatures, ae ai aj am an ap ar at au av aw ax ay;

and the other letters ending similarly, as œ ci, dedi, ei em œ,

he hi, ie in, ke ki, me mn, ri m, ue um, xe xi, ze zy, &c.

Other letters are combined into words by close setting. The

bars of f and t may be often made after the stems, as in cat,

attend, afraid, affiance.

316

Fig. 372.

This hand is usually written at a slight slope, 5 to 10 degrees

from the vertical, with the pen's edge constantly 30 degrees

from the horizontal, ✗✗, and on lines 3 or 4 times the height

of the letter o apart.

The numerals may be made thus: 1 2 3 4 5 6 7 8 9 0; in massed

arithmetic more clearly thus: 1234567890: "Punctuation",.;:.?!—

hyphen ~ (brackets) & or & &.

A broad pen should be used; and not pressed upon, but allow-

ed to provide contrast and gradation of stroke 'of itself.'

317

Fig. 373.

Semiformal minuscules.

A more formal hand may be written with letters as for cursive, but without the use of ligatures. Finish may be given by an extra touch to the ascenders of b d h k l, made before the stem stroke; and certain letters may be now allowed more than one stroke, as bb ee hh kk mm nn oo qq rr ss uu vv ww yy or yy.

The hand may be written with the cursive slope and also upright, as a formal hand. It is well adapted for poet=

318

Fig. 374.

ry, especially where this occurs in company with prose. Thickness of stem, and proportions, may be slightly varied, with discretion.

Glory of warrior, glory of orator, glory of song,
Paid with a voice flying by to be lost on an endless sea—
Glory of Virtue, to fight, to struggle, to right the wrong—
Nay, but she aim'd not at glory, no lover of glory she:
Give her the glory of going on, and still to be.

Fig. 375.

319

Formal minuscules.

An upright hand, derived from the book hands of the Italian

Renaissance, and serviceable for all purposes. The letters

may be constructed as follows, the pen held, as for cursive,

with its edge constantly 30 degrees ∠x from the horizontal:

aa 'bb (head magnified, �49 ᵱᵱ) cc cᶜld ee ~ſſf ᶜᵍg

'hh i j 'kk 'll ᴨm(not m) nn oo pp qq rr ss

~tt uu(not u) ᴠᴠor ᴠᴠ ᴡᴡ ⋀x or ⋊⋉ ᵧᵧ zz.

320

Fig. 376.

Our Father, which art in heaven,
Hallowed be thy Name. Thy king=
dom come. Thy will be done in
earth, As it is in heaven.
Give us this day our daily bread
And forgive us our trespasses,
As we forgive them that trespass
against us. And lead us not into
temptation; But deliver us from
evil. A M E N.

Fig. 377.

CURSIVE AND SEMIFORMAL CAPITALS.

LETTERS OF 1 STROKE: CEIJLOSUVZ, M.N.

LETTERS OF 2 STROKES: A-A BB DD J-J GG

KK MM NN PP QQ RR TT WorW XX YYY.

LETTERS OF 3 STROKES: A-A EE FF I-IH.

THESE CAPITALS SHOULD BE LESS THAN TWICE

THE HEIGHT of Minuscule o, as in 'Glad Tidings.'

Fig. 378.

322

FORMAL CAPITALS, UPRIGHT.

AA BB CC DD EE FF GG HH I JJ KK L
MM NN OO PP QQ RR SS TT UU VV
W XX YY ZZ, The Height of Minuscule Ascenders.

Epitaph at Aberdeen.

HERE LIES I, MARTIN ELGINBROD,
HAVE MERCY ON MY SOUL, LORD GOD,
AS I WOULD HAVE GIN I WERE GOD
AND THOU WERT MARTIN ELGINBROD.

323

Fig. 379.

COMPOUND Capitals (Gothic manner) for initials; to be usually made in colour.

Details of construction, the pen's edge in position + or +,
as occasion calls: stems to be made of 2 pen-strokes touch-
ing at centre, at head 3 pens', at centre 2 pens', and at foot
2½ pens' breadth; lobes at centre 3 pens' breadth,— ‖) (,
other strokes,— Λ Ι Ξ Ζ ∧. Interspaces are then flooded to-
gether, and thin strokes (serifs) added with pen's edge, D Ⅼ Ⅎ 4.

Fig. 380.

324

A A B B C C D E E F G G

H I J K L M N N O O P

Q R S S T U V W X Y Z &

(Alternative forms :—

A A ꝋ ꝭ ꝼ ꞅ ᵹ h

R L ꟿ ꟿ ꟿ ꟿ ꟿ

Fig. 381.

BLESSED BE THE LORD

BGOD OF ISRAEL: for he hath visited, and redeemed his people;

And hath raised up a mighty salvation for us: in the house of his servant David;

As he spake by the mouth of his holy Prophets: which have been since the world began;

That we should be saved from our enemies: & from the hands of all that hate us;

Fig. 382.

To perform the mercy promised to our forefathers: and to remember his holy Covenant;

To perform the oath which he sware to our fore= father Abraham: that he would give us;

That we being delivered out of the hands of our enemies: might serve him without fear;

In holiness and righteousness before him: all the days of our life.

Saint Luke's Gospel 1. 68–75.

327

INDEX

A CATALOG OF SELECTED DOVER
BOOKS IN ALL FIELDS OF INTEREST

100 BEST-LOVED POEMS, Edited by Philip Smith. "The Passionate Shepherd to His Love," "Shall I compare thee to a summer's day?" "Death, be not proud," "The Raven," "The Road Not Taken," plus works by Blake, Wordsworth, Byron, Shelley, Keats, many others. 96pp. 5⁵⁄₁₆ x 8¼. 0-486-28553-7

100 SMALL HOUSES OF THE THIRTIES, Brown-Blodgett Company. Exterior photographs and floor plans for 100 charming structures. Illustrations of models accompanied by descriptions of interiors, color schemes, closet space, and other amenities. 200 illustrations. 112pp. 8⅜ x 11. 0-486-44131-8

1000 TURN-OF-THE-CENTURY HOUSES: With Illustrations and Floor Plans, Herbert C. Chivers. Reproduced from a rare edition, this showcase of homes ranges from cottages and bungalows to sprawling mansions. Each house is meticulously illustrated and accompanied by complete floor plans. 256pp. 9⅜ x 12¼.
0-486-45596-3

101 GREAT AMERICAN POEMS, Edited by The American Poetry & Literacy Project. Rich treasury of verse from the 19th and 20th centuries includes works by Edgar Allan Poe, Robert Frost, Walt Whitman, Langston Hughes, Emily Dickinson, T. S. Eliot, other notables. 96pp. 5⁵⁄₁₆ x 8¼. 0-486-40158-8

101 GREAT SAMURAI PRINTS, Utagawa Kuniyoshi. Kuniyoshi was a master of the warrior woodblock print — and these 18th-century illustrations represent the pinnacle of his craft. Full-color portraits of renowned Japanese samurais pulse with movement, passion, and remarkably fine detail. 112pp. 8⅜ x 11. 0-486-46523-3

ABC OF BALLET, Janet Grosser. Clearly worded, abundantly illustrated little guide defines basic ballet-related terms: arabesque, battement, pas de chat, relevé, sissonne, many others. Pronunciation guide included. Excellent primer. 48pp. 4⁵⁄₁₆ x 5¾.
0-486-40871-X

ACCESSORIES OF DRESS: An Illustrated Encyclopedia, Katherine Lester and Bess Viola Oerke. Illustrations of hats, veils, wigs, cravats, shawls, shoes, gloves, and other accessories enhance an engaging commentary that reveals the humor and charm of the many-sided story of accessorized apparel. 644 figures and 59 plates. 608pp. 6⅛ x 9¼.
0-486-43378-1

ADVENTURES OF HUCKLEBERRY FINN, Mark Twain. Join Huck and Jim as their boyhood adventures along the Mississippi River lead them into a world of excitement, danger, and self-discovery. Humorous narrative, lyrical descriptions of the Mississippi valley, and memorable characters. 224pp. 5⁵⁄₁₆ x 8¼. 0-486-28061-6

ALICE STARMORE'S BOOK OF FAIR ISLE KNITTING, Alice Starmore. A noted designer from the region of Scotland's Fair Isle explores the history and techniques of this distinctive, stranded-color knitting style and provides copious illustrated instructions for 14 original knitwear designs. 208pp. 8⅜ x 10⅞. 0-486-47218-3

Browse over 9,000 books at www.doverpublications.com

CATALOG OF DOVER BOOKS

ALICE'S ADVENTURES IN WONDERLAND, Lewis Carroll. Beloved classic about a little girl lost in a topsy-turvy land and her encounters with the White Rabbit, March Hare, Mad Hatter, Cheshire Cat, and other delightfully improbable characters. 42 illustrations by Sir John Tenniel. 96pp. 5³⁄₁₆ x 8¼. 0-486-27543-4

AMERICA'S LIGHTHOUSES: An Illustrated History, Francis Ross Holland. Profusely illustrated fact-filled survey of American lighthouses since 1716. Over 200 stations — East, Gulf, and West coasts, Great Lakes, Hawaii, Alaska, Puerto Rico, the Virgin Islands, and the Mississippi and St. Lawrence Rivers. 240pp. 8 x 10¾. 0-486-25576-X

AN ENCYCLOPEDIA OF THE VIOLIN, Alberto Bachmann. Translated by Frederick H. Martens. Introduction by Eugene Ysaye. First published in 1925, this renowned reference remains unsurpassed as a source of essential information, from construction and evolution to repertoire and technique. Includes a glossary and 73 illustrations. 496pp. 6⅛ x 9¼. 0-486-46618-3

ANIMALS: 1,419 Copyright-Free Illustrations of Mammals, Birds, Fish, Insects, etc., Selected by Jim Harter. Selected for its visual impact and ease of use, this outstanding collection of wood engravings presents over 1,000 species of animals in extremely lifelike poses. Includes mammals, birds, reptiles, amphibians, fish, insects, and other invertebrates. 284pp. 9 x 12. 0-486-23766-4

THE ANNALS, Tacitus. Translated by Alfred John Church and William Jackson Brodribb. This vital chronicle of Imperial Rome, written by the era's great historian, spans A.D. 14-68 and paints incisive psychological portraits of major figures, from Tiberius to Nero. 416pp. 5³⁄₁₆ x 8¼. 0-486-45236-0

ANTIGONE, Sophocles. Filled with passionate speeches and sensitive probing of moral and philosophical issues, this powerful and often-performed Greek drama reveals the grim fate that befalls the children of Oedipus. Footnotes. 64pp. 5³⁄₁₆ x 8 ¼. 0-486-27804-2

ART DECO DECORATIVE PATTERNS IN FULL COLOR, Christian Stoll. Reprinted from a rare 1910 portfolio, 160 sensuous and exotic images depict a breathtaking array of florals, geometrics, and abstracts — all elegant in their stark simplicity. 64pp. 8⅜ x 11. 0-486-44862-2

THE ARTHUR RACKHAM TREASURY: 86 Full-Color Illustrations, Arthur Rackham. Selected and Edited by Jeff A. Menges. A stunning treasury of 86 full-page plates span the famed English artist's career, from *Rip Van Winkle* (1905) to masterworks such as *Undine, A Midsummer Night's Dream*, and *Wind in the Willows* (1939). 96pp. 8⅜ x 11. 0-486-44685-9

THE AUTHENTIC GILBERT & SULLIVAN SONGBOOK, W. S. Gilbert and A. S. Sullivan. The most comprehensive collection available, this songbook includes selections from every one of Gilbert and Sullivan's light operas. Ninety-two numbers are presented uncut and unedited, and in their original keys. 410pp. 9 x 12. 0-486-23482-7

THE AWAKENING, Kate Chopin. First published in 1899, this controversial novel of a New Orleans wife's search for love outside a stifling marriage shocked readers. Today, it remains a first-rate narrative with superb characterization. New introductory Note. 128pp. 5³⁄₁₆ x 8¼. 0-486-27786-0

BASIC DRAWING, Louis Priscilla. Beginning with perspective, this commonsense manual progresses to the figure in movement, light and shade, anatomy, drapery, composition, trees and landscape, and outdoor sketching. Black-and-white illustrations throughout. 128pp. 8⅜ x 11. 0-486-45815-6

Browse over 9,000 books at www.doverpublications.com

THE BATTLES THAT CHANGED HISTORY, Fletcher Pratt. Historian profiles 16 crucial conflicts, ancient to modern, that changed the course of Western civilization. Gripping accounts of battles led by Alexander the Great, Joan of Arc, Ulysses S. Grant, other commanders. 27 maps. 352pp. 5⅜ x 8½. 0-486-41129-X

BEETHOVEN'S LETTERS, Ludwig van Beethoven. Edited by Dr. A. C. Kalischer. Features 457 letters to fellow musicians, friends, greats, patrons, and literary men. Reveals musical thoughts, quirks of personality, insights, and daily events. Includes 15 plates. 410pp. 5⅜ x 8½. 0-486-22769-3

BERNICE BOBS HER HAIR AND OTHER STORIES, F. Scott Fitzgerald. This brilliant anthology includes 6 of Fitzgerald's most popular stories: "The Diamond as Big as the Ritz," the title tale, "The Offshore Pirate," "The Ice Palace," "The Jelly Bean," and "May Day." 176pp. 5⅜ x 8½. 0-486-47049-0

BESLER'S BOOK OF FLOWERS AND PLANTS: 73 Full-Color Plates from Hortus Eystettensis, 1613, Basilius Besler. Here is a selection of magnificent plates from the *Hortus Eystettensis,* which vividly illustrated and identified the plants, flowers, and trees that thrived in the legendary German garden at Eichstätt. 80pp. 8⅜ x 11. 0-486-46005-3

THE BOOK OF KELLS, Edited by Blanche Cirker. Painstakingly reproduced from a rare facsimile edition, this volume contains full-page decorations, portraits, illustrations, plus a sampling of textual leaves with exquisite calligraphy and ornamentation. 32 full-color illustrations. 32pp. 9⅜ x 12¼. 0-486-24345-1

THE BOOK OF THE CROSSBOW: With an Additional Section on Catapults and Other Siege Engines, Ralph Payne-Gallwey. Fascinating study traces history and use of crossbow as military and sporting weapon, from Middle Ages to modern times. Also covers related weapons: balistas, catapults, Turkish bows, more. Over 240 illustrations. 400pp. 7¼ x 10⅛. 0-486-28720-3

THE BUNGALOW BOOK: Floor Plans and Photos of 112 Houses, 1910, Henry L. Wilson. Here are 112 of the most popular and economic blueprints of the early 20th century — plus an illustration or photograph of each completed house. A wonderful time capsule that still offers a wealth of valuable insights. 160pp. 8⅜ x 11. 0-486-45104-6

THE CALL OF THE WILD, Jack London. A classic novel of adventure, drawn from London's own experiences as a Klondike adventurer, relating the story of a heroic dog caught in the brutal life of the Alaska Gold Rush. Note. 64pp. 5³⁄₁₆ x 8¼. 0-486-26472-6

CANDIDE, Voltaire. Edited by Francois-Marie Arouet. One of the world's great satires since its first publication in 1759. Witty, caustic skewering of romance, science, philosophy, religion, government — nearly all human ideals and institutions. 112pp. 5³⁄₁₆ x 8¼. 0-486-26689-3

CELEBRATED IN THEIR TIME: Photographic Portraits from the George Grantham Bain Collection, Edited by Amy Pastan. With an Introduction by Michael Carlebach. Remarkable portrait gallery features 112 rare images of Albert Einstein, Charlie Chaplin, the Wright Brothers, Henry Ford, and other luminaries from the worlds of politics, art, entertainment, and industry. 128pp. 8⅜ x 11. 0-486-46754-6

CHARIOTS FOR APOLLO: The NASA History of Manned Lunar Spacecraft to 1969, Courtney G. Brooks, James M. Grimwood, and Loyd S. Swenson, Jr. This illustrated history by a trio of experts is the definitive reference on the Apollo spacecraft and lunar modules. It traces the vehicles' design, development, and operation in space. More than 100 photographs and illustrations. 576pp. 6¾ x 9¼. 0-486-46756-2

A CHRISTMAS CAROL, Charles Dickens. This engrossing tale relates Ebenezer Scrooge's ghostly journeys through Christmases past, present, and future and his ultimate transformation from a harsh and grasping old miser to a charitable and compassionate human being. 80pp. 5³⁄₁₆ x 8¼. 0-486-26865-9

COMMON SENSE, Thomas Paine. First published in January of 1776, this highly influential landmark document clearly and persuasively argued for American separation from Great Britain and paved the way for the Declaration of Independence. 64pp. 5³⁄₁₆ x 8¼. 0-486-29602-4

THE COMPLETE SHORT STORIES OF OSCAR WILDE, Oscar Wilde. Complete texts of "The Happy Prince and Other Tales," "A House of Pomegranates," "Lord Arthur Savile's Crime and Other Stories," "Poems in Prose," and "The Portrait of Mr. W. H." 208pp. 5³⁄₁₆ x 8¼. 0-486-45216-6

COMPLETE SONNETS, William Shakespeare. Over 150 exquisite poems deal with love, friendship, the tyranny of time, beauty's evanescence, death, and other themes in language of remarkable power, precision, and beauty. Glossary of archaic terms. 80pp. 5³⁄₁₆ x 8¼. 0-486-26686-9

THE COUNT OF MONTE CRISTO: Abridged Edition, Alexandre Dumas. Falsely accused of treason, Edmond Dantès is imprisoned in the bleak Chateau d'If. After a hair-raising escape, he launches an elaborate plot to extract a bitter revenge against those who betrayed him. 448pp. 5³⁄₁₆ x 8¼. 0-486-45643-9

CRAFTSMAN BUNGALOWS: Designs from the Pacific Northwest, Yoho & Merritt. This reprint of a rare catalog, showcasing the charming simplicity and cozy style of Craftsman bungalows, is filled with photos of completed homes, plus floor plans and estimated costs. An indispensable resource for architects, historians, and illustrators. 112pp. 10 x 7. 0-486-46875-5

CRAFTSMAN BUNGALOWS: 59 Homes from "The Craftsman," Edited by Gustav Stickley. Best and most attractive designs from Arts and Crafts Movement publication — 1903–1916 — includes sketches, photographs of homes, floor plans, descriptive text. 128pp. 8¼ x 11. 0-486-25829-7

CRIME AND PUNISHMENT, Fyodor Dostoyevsky. Translated by Constance Garnett. Supreme masterpiece tells the story of Raskolnikov, a student tormented by his own thoughts after he murders an old woman. Overwhelmed by guilt and terror, he confesses and goes to prison. 480pp. 5³⁄₁₆ x 8¼. 0-486-41587-2

THE DECLARATION OF INDEPENDENCE AND OTHER GREAT DOCUMENTS OF AMERICAN HISTORY: 1775-1865, Edited by John Grafton. Thirteen compelling and influential documents: Henry's "Give Me Liberty or Give Me Death," Declaration of Independence, The Constitution, Washington's First Inaugural Address, The Monroe Doctrine, The Emancipation Proclamation, Gettysburg Address, more. 64pp. 5³⁄₁₆ x 8¼. 0-486-41124-9

THE DESERT AND THE SOWN: Travels in Palestine and Syria, Gertrude Bell. "The female Lawrence of Arabia," Gertrude Bell wrote captivating, perceptive accounts of her travels in the Middle East. This intriguing narrative, accompanied by 160 photos, traces her 1905 sojourn in Lebanon, Syria, and Palestine. 368pp. 5⅜ x 8½. 0-486-46876-3

A DOLL'S HOUSE, Henrik Ibsen. Ibsen's best-known play displays his genius for realistic prose drama. An expression of women's rights, the play climaxes when the central character, Nora, rejects a smothering marriage and life in "a doll's house." 80pp. 5³⁄₁₆ x 8¼. 0-486-27062-9

DOOMED SHIPS: Great Ocean Liner Disasters, William H. Miller, Jr. Nearly 200 photographs, many from private collections, highlight tales of some of the vessels whose pleasure cruises ended in catastrophe: the *Morro Castle, Normandie, Andrea Doria, Europa,* and many others. 128pp. 8⅞ x 11¼. 0-486-45366-9

THE DORÉ BIBLE ILLUSTRATIONS, Gustave Doré. Detailed plates from the Bible: the Creation scenes, Adam and Eve, horrifying visions of the Flood, the battle sequences with their monumental crowds, depictions of the life of Jesus, 241 plates in all. 241pp. 9 x 12. 0-486-23004-X

DRAWING DRAPERY FROM HEAD TO TOE, Cliff Young. Expert guidance on how to draw shirts, pants, skirts, gloves, hats, and coats on the human figure, including folds in relation to the body, pull and crush, action folds, creases, more. Over 200 drawings. 48pp. 8¼ x 11. 0-486-45591-2

DUBLINERS, James Joyce. A fine and accessible introduction to the work of one of the 20th century's most influential writers, this collection features 15 tales, including a masterpiece of the short-story genre, "The Dead." 160pp. 5³⁄₁₆ x 8¼. 0-486-26870-5

EASY-TO-MAKE POP-UPS, Joan Irvine. Illustrated by Barbara Reid. Dozens of wonderful ideas for three-dimensional paper fun — from holiday greeting cards with moving parts to a pop-up menagerie. Easy-to-follow, illustrated instructions for more than 30 projects. 299 black-and-white illustrations. 96pp. 8⅜ x 11. 0-486-44622-0

EASY-TO-MAKE STORYBOOK DOLLS: A "Novel" Approach to Cloth Dollmaking, Sherralyn St. Clair. Favorite fictional characters come alive in this unique beginner's dollmaking guide. Includes patterns for Pollyanna, Dorothy from *The Wonderful Wizard of Oz,* Mary of *The Secret Garden,* plus easy-to-follow instructions, 263 black-and-white illustrations, and an 8-page color insert. 112pp. 8¼ x 11. 0-486-47360-0

EINSTEIN'S ESSAYS IN SCIENCE, Albert Einstein. Speeches and essays in accessible, everyday language profile influential physicists such as Niels Bohr and Isaac Newton. They also explore areas of physics to which the author made major contributions. 128pp. 5 x 8. 0-486-47011-3

EL DORADO: Further Adventures of the Scarlet Pimpernel, Baroness Orczy. A popular sequel to *The Scarlet Pimpernel,* this suspenseful story recounts the Pimpernel's attempts to rescue the Dauphin from imprisonment during the French Revolution. An irresistible blend of intrigue, period detail, and vibrant characterizations. 352pp. 5³⁄₁₆ x 8¼. 0-486-44026-5

ELEGANT SMALL HOMES OF THE TWENTIES: 99 Designs from a Competition, Chicago Tribune. Nearly 100 designs for five- and six-room houses feature New England and Southern colonials, Normandy cottages, stately Italianate dwellings, and other fascinating snapshots of American domestic architecture of the 1920s. 112pp. 9 x 12. 0-486-46910-7

THE ELEMENTS OF STYLE: The Original Edition, William Strunk, Jr. This is the book that generations of writers have relied upon for timeless advice on grammar, diction, syntax, and other essentials. In concise terms, it identifies the principal requirements of proper style and common errors. 64pp. 5⅜ x 8½. 0-486-44798-7

THE ELUSIVE PIMPERNEL, Baroness Orczy. Robespierre's revolutionaries find their wicked schemes thwarted by the heroic Pimpernel — Sir Percival Blakeney. In this thrilling sequel, Chauvelin devises a plot to eliminate the Pimpernel and his wife. 272pp. 5³⁄₁₆ x 8¼. 0-486-45464-9

AN ENCYCLOPEDIA OF BATTLES: Accounts of Over 1,560 Battles from 1479 B.C. to the Present, David Eggenberger. Essential details of every major battle in recorded history from the first battle of Megiddo in 1479 B.C. to Grenada in 1984. List of battle maps. 99 illustrations. 544pp. 6½ x 9¼. 0-486-24913-1

ENCYCLOPEDIA OF EMBROIDERY STITCHES, INCLUDING CREWEL, Marion Nichols. Precise explanations and instructions, clearly illustrated, on how to work chain, back, cross, knotted, woven stitches, and many more — 178 in all, including Cable Outline, Whipped Satin, and Eyelet Buttonhole. Over 1400 illustrations. 219pp. 8⅜ x 11¼. 0-486-22929-7

ENTER JEEVES: 15 Early Stories, P. G. Wodehouse. Splendid collection contains first 8 stories featuring Bertie Wooster, the deliciously dim aristocrat and Jeeves, his brainy, imperturbable manservant. Also, the complete Reggie Pepper (Bertie's prototype) series. 288pp. 5⅜ x 8½. 0-486-29717-9

ERIC SLOANE'S AMERICA: Paintings in Oil, Michael Wigley. With a Foreword by Mimi Sloane. Eric Sloane's evocative oils of America's landscape and material culture shimmer with immense historical and nostalgic appeal. This original hardcover collection gathers nearly a hundred of his finest paintings, with subjects ranging from New England to the American Southwest. 128pp. 10⅝ x 9. 0-486-46525-X

ETHAN FROME, Edith Wharton. Classic story of wasted lives, set against a bleak New England background. Superbly delineated characters in a hauntingly grim tale of thwarted love. Considered by many to be Wharton's masterpiece. 96pp. 5³⁄₁₆ x 8¼. 0-486-26690-7

THE EVERLASTING MAN, G. K. Chesterton. Chesterton's view of Christianity — as a blend of philosophy and mythology, satisfying intellect and spirit — applies to his brilliant book, which appeals to readers' heads as well as their hearts. 288pp. 5⅜ x 8½. 0-486-46036-3

THE FIELD AND FOREST HANDY BOOK, Daniel Beard. Written by a co-founder of the Boy Scouts, this appealing guide offers illustrated instructions for building kites, birdhouses, boats, igloos, and other fun projects, plus numerous helpful tips for campers. 448pp. 5³⁄₁₆ x 8¼. 0-486-46191-2

FINDING YOUR WAY WITHOUT MAP OR COMPASS, Harold Gatty. Useful, instructive manual shows would-be explorers, hikers, bikers, scouts, sailors, and survivalists how to find their way outdoors by observing animals, weather patterns, shifting sands, and other elements of nature. 288pp. 5⅜ x 8½. 0-486-40613-X

FIRST FRENCH READER: A Beginner's Dual-Language Book, Edited and Translated by Stanley Appelbaum. This anthology introduces 50 legendary writers — Voltaire, Balzac, Baudelaire, Proust, more — through passages from *The Red and the Black, Les Misérables, Madame Bovary,* and other classics. Original French text plus English translation on facing pages. 240pp. 5⅜ x 8½. 0-486-46178-5

FIRST GERMAN READER: A Beginner's Dual-Language Book, Edited by Harry Steinhauer. Specially chosen for their power to evoke German life and culture, these short, simple readings include poems, stories, essays, and anecdotes by Goethe, Hesse, Heine, Schiller, and others. 224pp. 5⅜ x 8½. 0-486-46179-3

FIRST SPANISH READER: A Beginner's Dual-Language Book, Angel Flores. Delightful stories, other material based on works of Don Juan Manuel, Luis Taboada, Ricardo Palma, other noted writers. Complete faithful English translations on facing pages. Exercises. 176pp. 5⅜ x 8½. 0-486-25810-6

Browse over 9,000 books at www.doverpublications.com

FIVE ACRES AND INDEPENDENCE, Maurice G. Kains. Great back-to-the-land classic explains basics of self-sufficient farming. The one book to get. 95 illustrations. 397pp. 5⅜ x 8½. 0-486-20974-1

FLAGG'S SMALL HOUSES: Their Economic Design and Construction, 1922, Ernest Flagg. Although most famous for his skyscrapers, Flagg was also a proponent of the well-designed single-family dwelling. His classic treatise features innovations that save space, materials, and cost. 526 illustrations. 160pp. 9⅜ x 12¼. 0-486-45197-6

FLATLAND: A Romance of Many Dimensions, Edwin A. Abbott. Classic of science (and mathematical) fiction — charmingly illustrated by the author — describes the adventures of A. Square, a resident of Flatland, in Spaceland (three dimensions), Lineland (one dimension), and Pointland (no dimensions). 96pp. 5³⁄₁₆ x 8¼. 0-486-27263-X

FRANKENSTEIN, Mary Shelley. The story of Victor Frankenstein's monstrous creation and the havoc it caused has enthralled generations of readers and inspired countless writers of horror and suspense. With the author's own 1831 introduction. 176pp. 5³⁄₁₆ x 8¼. 0-486-28211-2

THE GARGOYLE BOOK: 572 Examples from Gothic Architecture, Lester Burbank Bridaham. Dispelling the conventional wisdom that French Gothic architectural flourishes were born of despair or gloom, Bridaham reveals the whimsical nature of these creations and the ingenious artisans who made them. 572 illustrations. 224pp. 8⅜ x 11. 0-486-44754-5

THE GIFT OF THE MAGI AND OTHER SHORT STORIES, O. Henry. Sixteen captivating stories by one of America's most popular storytellers. Included are such classics as "The Gift of the Magi," "The Last Leaf," and "The Ransom of Red Chief." Publisher's Note. 96pp. 5³⁄₁₆ x 8¼. 0-486-27061-0

THE GOETHE TREASURY: Selected Prose and Poetry, Johann Wolfgang von Goethe. Edited, Selected, and with an Introduction by Thomas Mann. In addition to his lyric poetry, Goethe wrote travel sketches, autobiographical studies, essays, letters, and proverbs in rhyme and prose. This collection presents outstanding examples from each genre. 368pp. 5⅜ x 8½. 0-486-44780-4

GREAT EXPECTATIONS, Charles Dickens. Orphaned Pip is apprenticed to the dirty work of the forge but dreams of becoming a gentleman — and one day finds himself in possession of "great expectations." Dickens' finest novel. 400pp. 5³⁄₁₆ x 8¼. 0-486-41586-4

GREAT WRITERS ON THE ART OF FICTION: From Mark Twain to Joyce Carol Oates, Edited by James Daley. An indispensable source of advice and inspiration, this anthology features essays by Henry James, Kate Chopin, Willa Cather, Sinclair Lewis, Jack London, Raymond Chandler, Raymond Carver, Eudora Welty, and Kurt Vonnegut, Jr. 192pp. 5⅜ x 8½. 0-486-45128-3

HAMLET, William Shakespeare. The quintessential Shakespearean tragedy, whose highly charged confrontations and anguished soliloquies probe depths of human feeling rarely sounded in any art. Reprinted from an authoritative British edition complete with illuminating footnotes. 128pp. 5³⁄₁₆ x 8¼. 0-486-27278-8

THE HAUNTED HOUSE, Charles Dickens. A Yuletide gathering in an eerie country retreat provides the backdrop for Dickens and his friends — including Elizabeth Gaskell and Wilkie Collins — who take turns spinning supernatural yarns. 144pp. 5⅜ x 8½. 0-486-46309-5

HEART OF DARKNESS, Joseph Conrad. Dark allegory of a journey up the Congo River and the narrator's encounter with the mysterious Mr. Kurtz. Masterly blend of adventure, character study, psychological penetration. For many, Conrad's finest, most enigmatic story. 80pp. 5³⁄₁₆ x 8¼. 0-486-26464-5

HENSON AT THE NORTH POLE, Matthew A. Henson. This thrilling memoir by the heroic African-American who was Peary's companion through two decades of Arctic exploration recounts a tale of danger, courage, and determination. "Fascinating and exciting." — *Commonweal.* 128pp. 5⅜ x 8½. 0-486-45472-X

HISTORIC COSTUMES AND HOW TO MAKE THEM, Mary Fernald and E. Shenton. Practical, informative guidebook shows how to create everything from short tunics worn by Saxon men in the fifth century to a lady's bustle dress of the late 1800s. 81 illustrations. 176pp. 5⅜ x 8½. 0-486-44906-8

THE HOUND OF THE BASKERVILLES, Arthur Conan Doyle. A deadly curse in the form of a legendary ferocious beast continues to claim its victims from the Baskerville family until Holmes and Watson intervene. Often called the best detective story ever written. 128pp. 5³⁄₁₆ x 8¼. 0-486-28214-7

THE HOUSE BEHIND THE CEDARS, Charles W. Chesnutt. Originally published in 1900, this groundbreaking novel by a distinguished African-American author recounts the drama of a brother and sister who "pass for white" during the dangerous days of Reconstruction. 208pp. 5⅜ x 8½. 0-486-46144-0

THE HUMAN FIGURE IN MOTION, Eadweard Muybridge. The 4,789 photographs in this definitive selection show the human figure — models almost all undraped — engaged in over 160 different types of action: running, climbing stairs, etc. 390pp. 7⅞ x 10⅝. 0-486-20204-6

THE IMPORTANCE OF BEING EARNEST, Oscar Wilde. Wilde's witty and buoyant comedy of manners, filled with some of literature's most famous epigrams, reprinted from an authoritative British edition. Considered Wilde's most perfect work. 64pp. 5³⁄₁₆ x 8¼. 0-486-26478-5

THE INFERNO, Dante Alighieri. Translated and with notes by Henry Wadsworth Longfellow. The first stop on Dante's famous journey from Hell to Purgatory to Paradise, this 14th-century allegorical poem blends vivid and shocking imagery with graceful lyricism. Translated by the beloved 19th-century poet, Henry Wadsworth Longfellow. 256pp. 5³⁄₁₆ x 8¼. 0-486-44288-8

JANE EYRE, Charlotte Brontë. Written in 1847, *Jane Eyre* tells the tale of an orphan girl's progress from the custody of cruel relatives to an oppressive boarding school and its culmination in a troubled career as a governess. 448pp. 5³⁄₁₆ x 8¼. 0-486-42449-9

JAPANESE WOODBLOCK FLOWER PRINTS, Tanigami Kônan. Extraordinary collection of Japanese woodblock prints by a well-known artist features 120 plates in brilliant color. Realistic images from a rare edition include daffodils, tulips, and other familiar and unusual flowers. 128pp. 11 x 8¼. 0-486-46442-3

JEWELRY MAKING AND DESIGN, Augustus F. Rose and Antonio Cirino. Professional secrets of jewelry making are revealed in a thorough, practical guide. Over 200 illustrations. 306pp. 5⅜ x 8½. 0-486-21750-7

JULIUS CAESAR, William Shakespeare. Great tragedy based on Plutarch's account of the lives of Brutus, Julius Caesar and Mark Antony. Evil plotting, ringing oratory, high tragedy with Shakespeare's incomparable insight, dramatic power. Explanatory footnotes. 96pp. 5³⁄₁₆ x 8¼. 0-486-26876-4

THE JUNGLE, Upton Sinclair. 1906 bestseller shockingly reveals intolerable labor practices and working conditions in the Chicago stockyards as it tells the grim story of a Slavic family that emigrates to America full of optimism but soon faces despair. 320pp. 5³⁄₁₆ x 8¼. 0-486-41923-1

THE KINGDOM OF GOD IS WITHIN YOU, Leo Tolstoy. The soul-searching book that inspired Gandhi to embrace the concept of passive resistance, Tolstoy's 1894 polemic clearly outlines a radical, well-reasoned revision of traditional Christian thinking. 352pp. 5³⁄₁₆ x 8¼. 0-486-45138-0

THE LADY OR THE TIGER?: and Other Logic Puzzles, Raymond M. Smullyan. Created by a renowned puzzle master, these whimsically themed challenges involve paradoxes about probability, time, and change; metapuzzles; and self-referentiality. Nineteen chapters advance in difficulty from relatively simple to highly complex. 1982 edition. 240pp. 5⅜ x 8½. 0-486-47027-X

LEAVES OF GRASS: The Original 1855 Edition, Walt Whitman. Whitman's immortal collection includes some of the greatest poems of modern times, including his masterpiece, "Song of Myself." Shattering standard conventions, it stands as an unabashed celebration of body and nature. 128pp. 5³⁄₁₆ x 8¼. 0-486-45676-5

LES MISÉRABLES, Victor Hugo. Translated by Charles E. Wilbour. Abridged by James K. Robinson. A convict's heroic struggle for justice and redemption plays out against a fiery backdrop of the Napoleonic wars. This edition features the excellent original translation and a sensitive abridgment. 304pp. 6⅛ x 9¼. 0-486-45789-3

LILITH: A Romance, George MacDonald. In this novel by the father of fantasy literature, a man travels through time to meet Adam and Eve and to explore humanity's fall from grace and ultimate redemption. 240pp. 5⅜ x 8½. 0-486-46818-6

THE LOST LANGUAGE OF SYMBOLISM, Harold Bayley. This remarkable book reveals the hidden meaning behind familiar images and words, from the origins of Santa Claus to the fleur-de-lys, drawing from mythology, folklore, religious texts, and fairy tales. 1,418 illustrations. 784pp. 5⅜ x 8½. 0-486-44787-1

MACBETH, William Shakespeare. A Scottish nobleman murders the king in order to succeed to the throne. Tortured by his conscience and fearful of discovery, he becomes tangled in a web of treachery and deceit that ultimately spells his doom. 96pp. 5³⁄₁₆ x 8¼. 0-486-27802-6

MAKING AUTHENTIC CRAFTSMAN FURNITURE: Instructions and Plans for 62 Projects, Gustav Stickley. Make authentic reproductions of handsome, functional, durable furniture: tables, chairs, wall cabinets, desks, a hall tree, and more. Construction plans with drawings, schematics, dimensions, and lumber specs reprinted from 1900s *The Craftsman* magazine. 128pp. 8⅛ x 11. 0-486-25000-8

MATHEMATICS FOR THE NONMATHEMATICIAN, Morris Kline. Erudite and entertaining overview follows development of mathematics from ancient Greeks to present. Topics include logic and mathematics, the fundamental concept, differential calculus, probability theory, much more. Exercises and problems. 641pp. 5⅜ x 8½. 0-486-24823-2

MEMOIRS OF AN ARABIAN PRINCESS FROM ZANZIBAR, Emily Ruete. This 19th-century autobiography offers a rare inside look at the society surrounding a sultan's palace. A real-life princess in exile recalls her vanished world of harems, slave trading, and court intrigues. 288pp. 5⅜ x 8½. 0-486-47121-7

THE METAMORPHOSIS AND OTHER STORIES, Franz Kafka. Excellent new English translations of title story (considered by many critics Kafka's most perfect work), plus "The Judgment," "In the Penal Colony," "A Country Doctor," and "A Report to an Academy." Note. 96pp. 5³⁄₁₆ x 8¼. 0-486-29030-1

MICROSCOPIC ART FORMS FROM THE PLANT WORLD, R. Anheisser. From undulating curves to complex geometrics, a world of fascinating images abound in this classic, illustrated survey of microscopic plants. Features 400 detailed illustrations of nature's minute but magnificent handiwork. The accompanying CD-ROM includes all of the images in the book. 128pp. 9 x 9. 0-486-46013-4

A MIDSUMMER NIGHT'S DREAM, William Shakespeare. Among the most popular of Shakespeare's comedies, this enchanting play humorously celebrates the vagaries of love as it focuses upon the intertwined romances of several pairs of lovers. Explanatory footnotes. 80pp. 5³⁄₁₆ x 8¼. 0-486-27067-X

THE MONEY CHANGERS, Upton Sinclair. Originally published in 1908, this cautionary novel from the author of *The Jungle* explores corruption within the American system as a group of power brokers joins forces for personal gain, triggering a crash on Wall Street. 192pp. 5⅜ x 8½. 0-486-46917-4

THE MOST POPULAR HOMES OF THE TWENTIES, William A. Radford. With a New Introduction by Daniel D. Reiff. Based on a rare 1925 catalog, this architectural showcase features floor plans, construction details, and photos of 26 homes, plus articles on entrances, porches, garages, and more. 250 illustrations, 21 color plates. 176pp. 8⅜ x 11. 0-486-47028-8

MY 66 YEARS IN THE BIG LEAGUES, Connie Mack. With a New Introduction by Rich Westcott. A Founding Father of modern baseball, Mack holds the record for most wins — and losses — by a major league manager. Enhanced by 70 photographs, his warmhearted autobiography is populated by many legends of the game. 288pp. 5⅜ x 8½. 0-486-47184-5

NARRATIVE OF THE LIFE OF FREDERICK DOUGLASS, Frederick Douglass. Douglass's graphic depictions of slavery, harrowing escape to freedom, and life as a newspaper editor, eloquent orator, and impassioned abolitionist. 96pp. 5³⁄₁₆ x 8¼.
 0-486-28499-9

THE NIGHTLESS CITY: Geisha and Courtesan Life in Old Tokyo, J. E. de Becker. This unsurpassed study from 100 years ago ventured into Tokyo's red-light district to survey geisha and courtesan life and offer meticulous descriptions of training, dress, social hierarchy, and erotic practices. 49 black-and-white illustrations; 2 maps. 496pp. 5⅜ x 8½. 0-486-45563-7

THE ODYSSEY, Homer. Excellent prose translation of ancient epic recounts adventures of the homeward-bound Odysseus. Fantastic cast of gods, giants, cannibals, sirens, other supernatural creatures — true classic of Western literature. 256pp. 5³⁄₁₆ x 8¼.
 0-486-40654-7

OEDIPUS REX, Sophocles. Landmark of Western drama concerns the catastrophe that ensues when King Oedipus discovers he has inadvertently killed his father and married his mother. Masterly construction, dramatic irony. Explanatory footnotes. 64pp. 5³⁄₁₆ x 8¼. 0-486-26877-2

ONCE UPON A TIME: The Way America Was, Eric Sloane. Nostalgic text and drawings brim with gentle philosophies and descriptions of how we used to live — self-sufficiently — on the land, in homes, and among the things built by hand. 44 line illustrations. 64pp. 8⅜ x 11. 0-486-44411-2